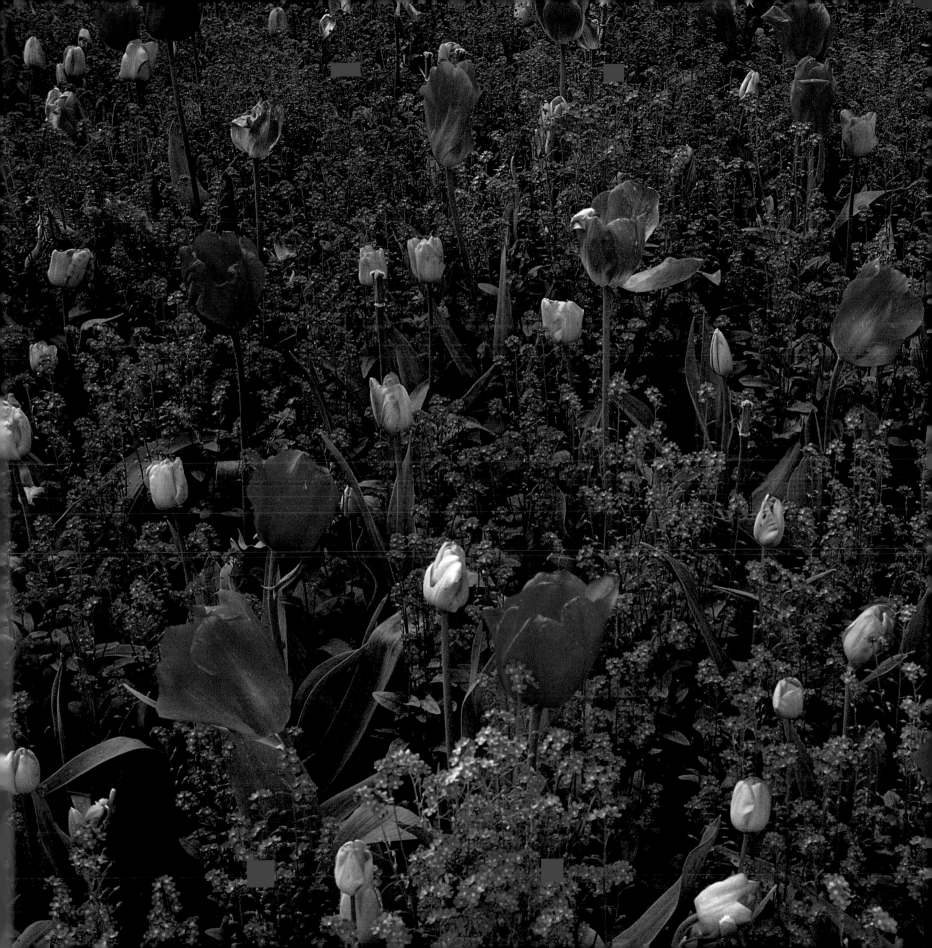

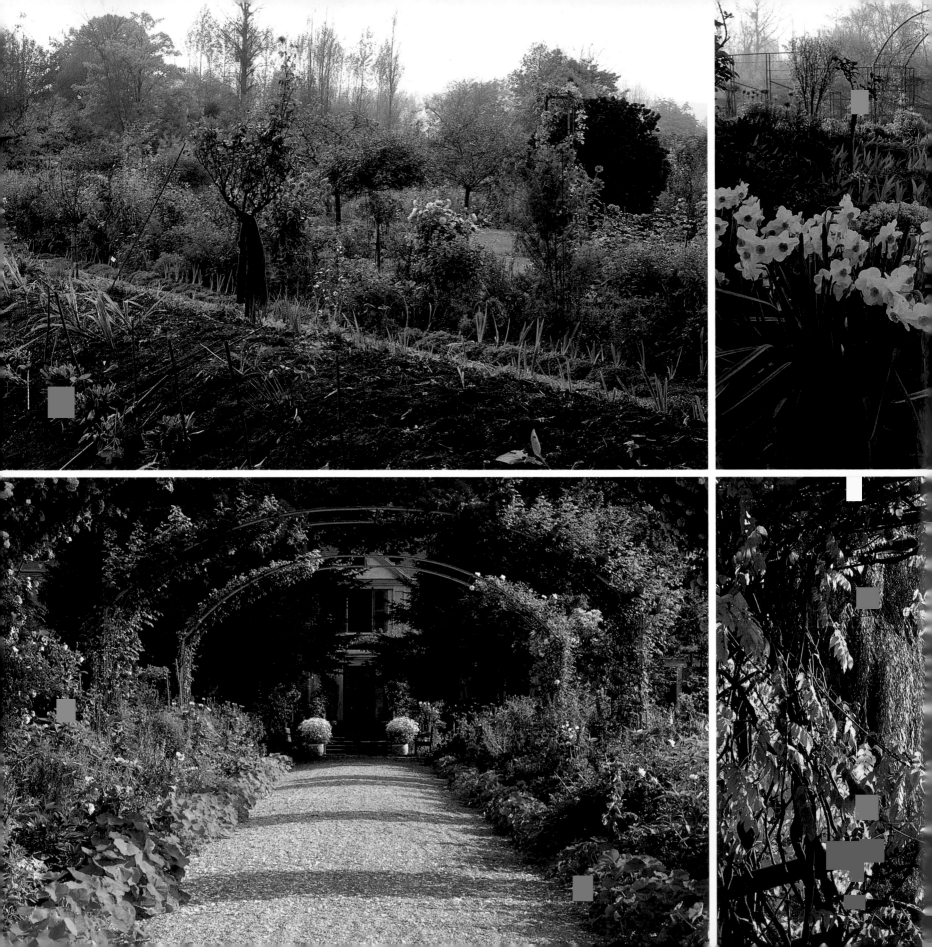

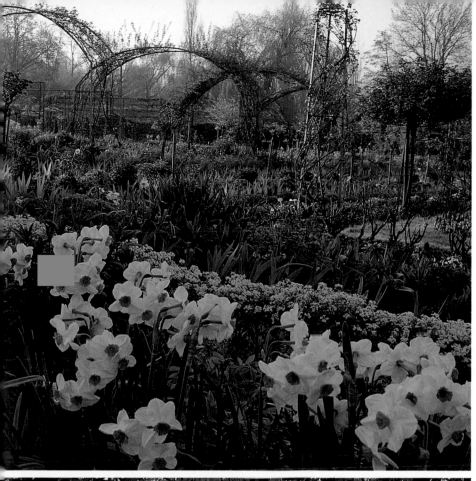

MONET'S GARDEN

Through the Seasons at Giverny

VIVIAN RUSSELL

Stewart, Tabori & Chang
New York

To my great aunt Tante Là, Zelah Rameil, who lived and painted in the next village to Giverny in a small and simple garden she shared with her ducks. She died well into her nineties, and was already quite an old lady when I first toddled amongst the irises and roses, but it was she who gave me my first, and sweetest, garden memories. V.R.

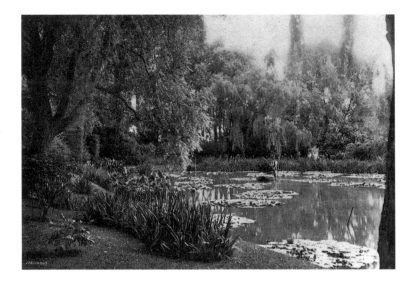

Published in 1995 by Stewart, Tabori & Chang
575 Broadway, New York, New York 10012

Distributed in Canada by
General Publishing Co. Ltd
30 Lesmill Road, Don Mills, Ontario,
Canada M3B 2T6

First published 1995
A Frances Lincoln Limited Book
Copyright © 1995 Frances Lincoln
Text copyright © 1995 Vivian Russell Inc. Ltd.
All photographs © 1995 Vivian Russell Inc. Ltd., except
those listed on page 168
The copyright of the photographs is the property of the
photographer unless otherwise stated.
Artwork © 1995 Frances Lincoln Limited

Library of Congress Catalog Card Number:
94-80066

ISBN 1-55670-415-1

First Edition
3 5 7 9 8 6 4

Printed and bound in Italy by New Interlitho Italia S.p.A

PAGE 1 *In spring, the island beds in front of the house glow with a mass of pink tulips and blue forget-me-nots.*

PAGES 2-3 *Through the seasons in the garden at Giverny.*

ABOVE AND OPPOSITE *Some of the gardening tasks at Giverny have changed little since Monet's day. In a photograph that appeared in the magazine* Jardinage *in 1924 (above), a gardener tends the water lilies in Monet's water garden just as his modern counterpart does today (opposite).*

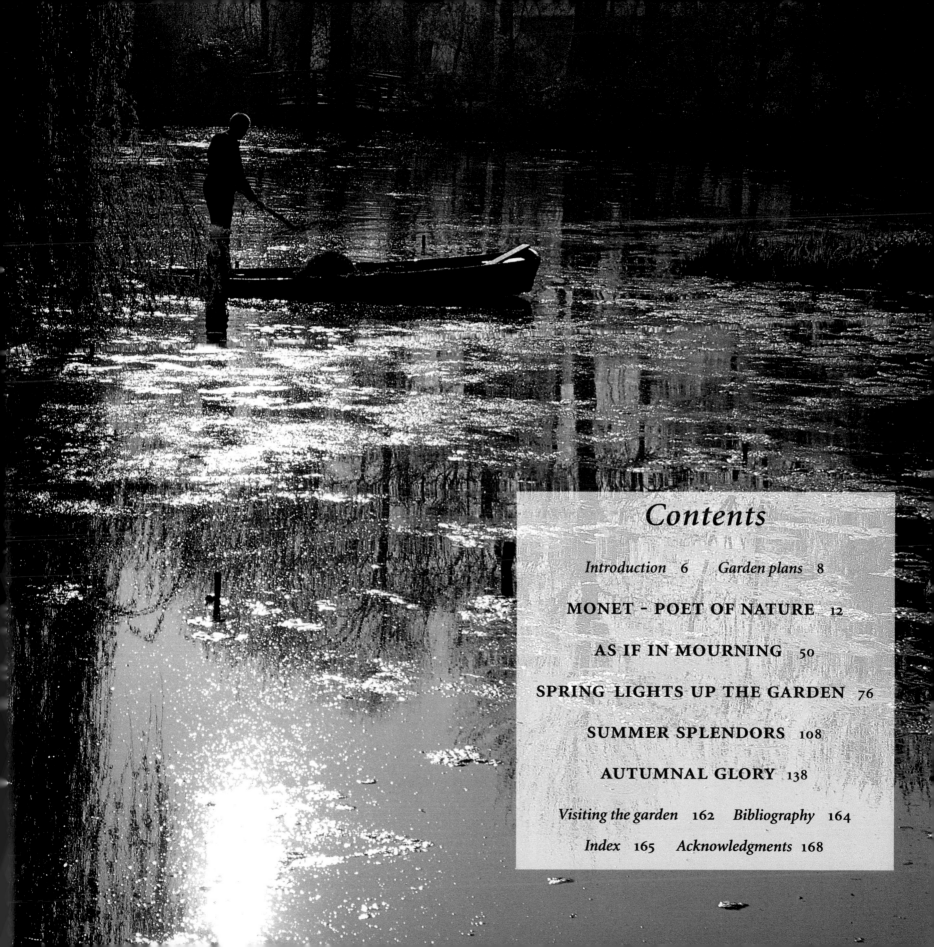

Contents

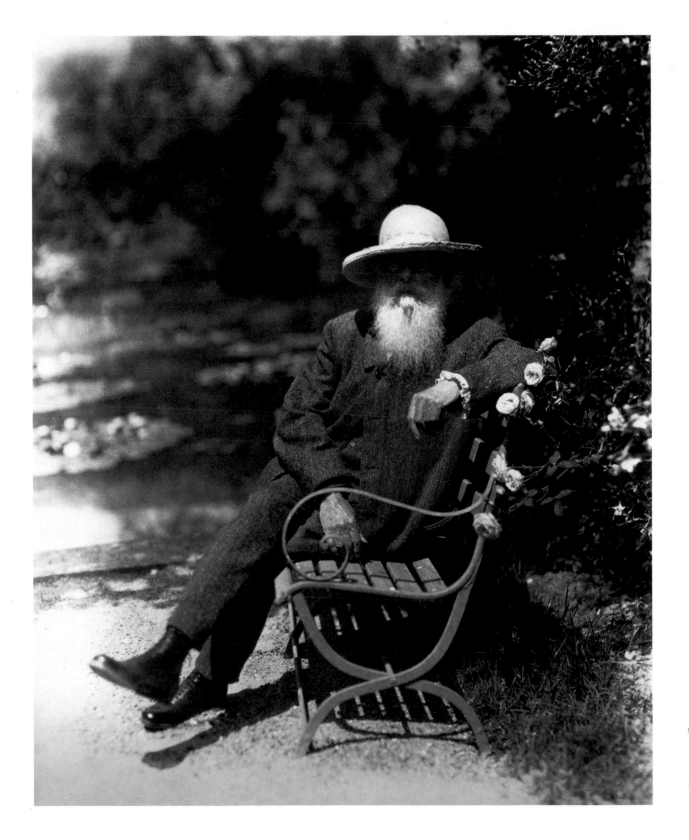

The Grand Old Man, the very incarnation of Impressionism, photographed in 1926, enjoys what was to be a last summer among the roses beside his water-lily pond.

Introduction

He was a painter who loved his garden, a garden which became so famous that, absorbed into the popular subconscious, images of it hang like wallpaper the world over. And still the dream has not faded. Nearly half a million visitors arrive each year to immerse themselves in the unique world created by Claude Monet, a world he honed into perfection over the last forty-three years of his very productive life, and where he celebrated the real art of gardening. Monet will never paint again, and his canvases will never change. But the garden rising as new every year from the bare earth loses none of its wonder. The little bridge draped in white and mauve, swathes of irises a symphony in blue, green waves of bright nasturtiums, galaxies of poppies and roses, all combine to make a visual feast that each year is reinvented.

Photographed in the last year of his life, the artist who had become the Grand Old Man, the very incarnation of Impressionism, sits on a bench beside his pond as inscrutable as a sphinx. Surrounded by his own horticultural wizardry that became the motif of his artistic genius, Claude Monet the image-maker has himself become the image. Eyes that are shaded by a large straw hat and dark glasses, and a mouth camouflaged by a long white beard tell us nothing, but his hands are exquisitely expressive – hands that interpreted the visions of a man whose whole life was in his eyes – eyes that defined his life and then almost took it away, hands that painted with difficulty but gardened with joy. The life and soul of a garden are inextricably bound up with that of a gardener and the journey that Monet and his garden took through life is one they took together. So inseparable did these two become that, as one writer put it, "Monet's two gardens are really 'Monet's'."

Monet wove all the strands of his creative life into Giverny, so that they became the very fabric of the garden, always imaginative, often unique. It was before anything else, a painter's garden, conceived and planted in the spirit and ethos of the Impressionists who, perhaps more than any other art movement, explored new ways of interpreting the world. Individual expression, spontaneity, and a celebration of nature were their leitmotifs and inspired Monet to bring sensuality to painting which had known only style, brilliance to palettes that had known only sobriety. Impressionism brought painting out of the Dark Ages and infused it with sunlight and fresh air, introducing it to the great outdoors and pouring light onto canvases where none had shone before. Easels that had sat for centuries indoors were set up in all weathers, positioned to capture light which, Monet was the first to realize, transforms everything. At a time when compositions were invented, themes heroic, Monet and his fellow-Impressionists studied the Japanese woodblock prints that had begun to arrive in France with the opening of trade in the 1850s. The drama of light, of dimension, of bold composition, and exquisite color all fused in his painting and many years later were refined as principles and as plantings at Giverny.

Treated like heretics by the Establishment, the Impressionists were sneered at, snubbed, their paintings were refused at the Paris salons and they starved. With a singleness of purpose which never wavered and only grew more difficult as it became more ambitious, Monet spent seventy years challenging himself to perfect the art of rendering on some three thousand canvases the ephemeral nature of what he "saw" – in Norwegian snow and Riviera heat; on the façades of monuments, on haystacks, poppies and poplars, the infinite permutations of light on sea, sky and rock. "Nature never stops" was a favorite saying and, with each of his broad swift strokes, he came nearer to closing the gap between the dreamer and the dream, the picture glimpsed but just out of reach, a process he described himself as "the obsession, the joy and torment of my days."

But the struggle for technical perfection in his art was only part of the larger view in the life of this esthete for whom the process of creation was as important as the result. He compared his work to monks illuminating their manuscripts in a close union of solitude and silence. Notoriously reticent to talk about his painting, he did tell one journalist this: "If you absolutely must find an affiliation for me, select the Japanese of olden times; their rarefied taste, their esthetic that evokes a presence by means of a shadow, and the whole by means of a fragment . . . They are a profoundly artistic people. I once read something that struck me: a bricklayer was building a wall, and he placed a rose in front of him so that from time to time he could look at it and inhale its scent as he worked, and as his wall progressed, he would move the rose so that it was always there before him. Don't you find that charming?"

"For me," he wrote, "the subject is secondary. What I want to reproduce is that which is in between the subject and me." He painted atmosphere, noted the art historian John Rewald, "the way other men painted nudes: it gave him a physical thrill." Atmosphere is also the key to a great garden, and Monet was master of both. But Monet wouldn't agree: "They are short-sighted those who call me a master: of good intentions, yes, but that's all."

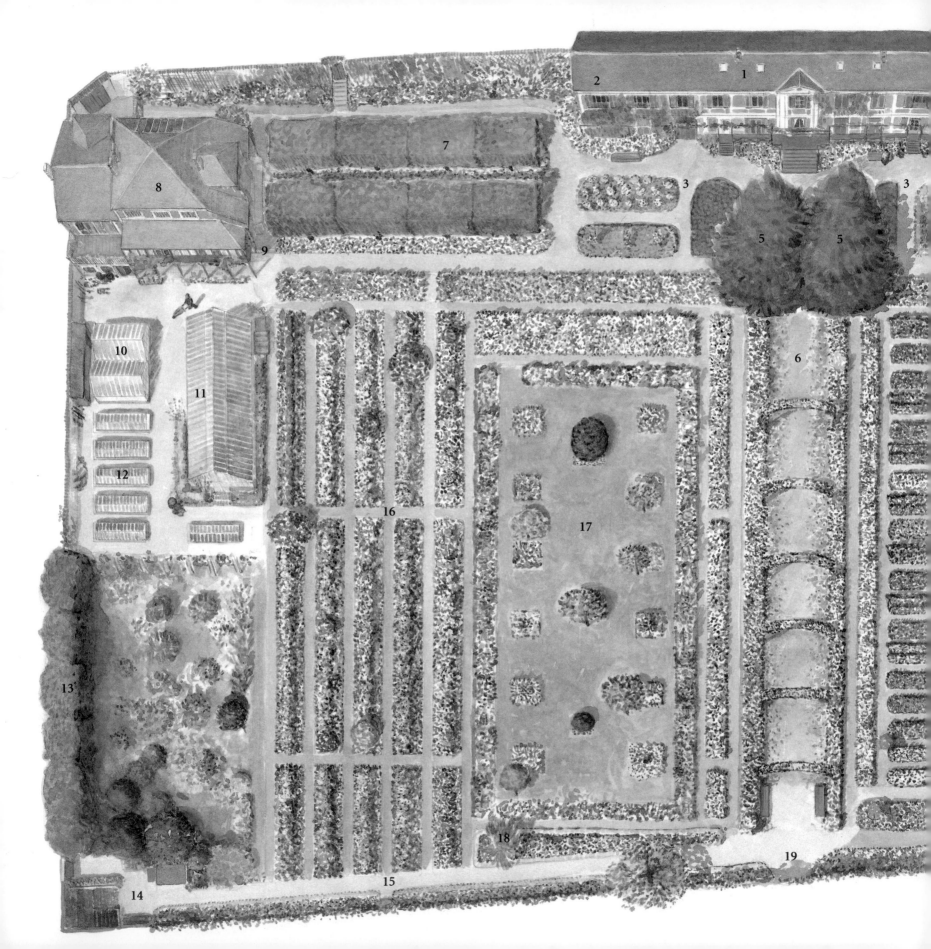

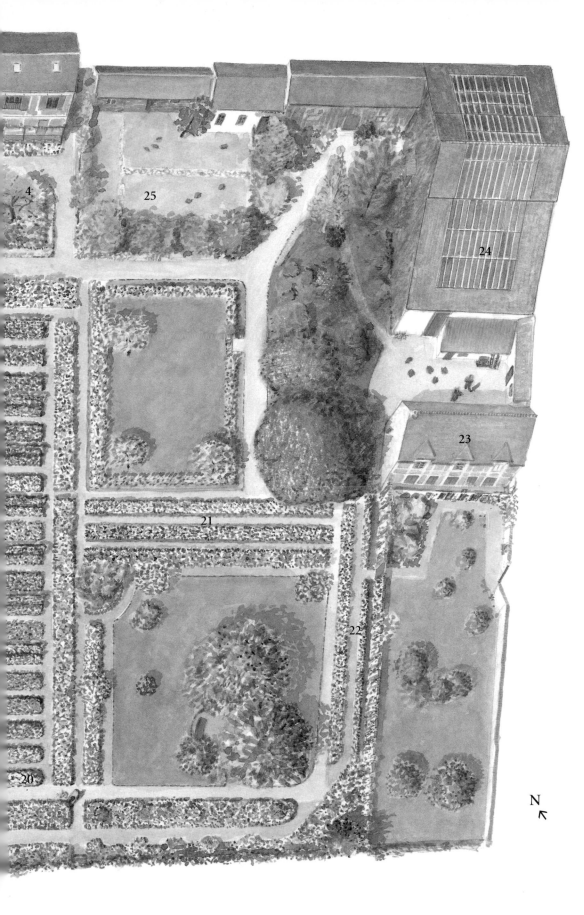

THE FLOWER GARDEN

In 1883, the garden of the house Monet first rented and later bought consisted of a kitchen garden and orchard, with a somber tree-lined pathway leading from the house to the road, and a few uninspiring traditional flowerbeds. Monet planted his favorite flowers and transformed the garden into an inspiring experiment in color.

1 Monet's house
2 Monet's bedroom (above the first studio)
3 Island beds
4 Monet's original crabapple tree
5 Twin yews
6 Grande Allée with rose arches
7 Pleached limes, mostly original
8 Monet's second studio
9 Dovecote
10 Small greenhouses
11 Large greenhouse
12 Warm frames
13 Hedge of horse chestnut
14 Entrance to underground passage leading to the water garden
15 Boundary wall planted with pyracantha and climbing roses
16 15 monochromatic and polychromatic flowerbeds
17 Lawn with roses, fruit trees and square flowerbeds
18 Spring tamarisk tree
19 Former main gate
20 38 paintbox beds ('les tombes'), 7 pairs with clematis frames above
21 Monochromatic perennial flowerbeds
22 Espaliered apple trees
23 House formerly lived in by Monet's head gardener
24 Third studio, where the water-lily panels were painted
25 Chicken and turkey yard

N

THE WATER GARDEN

In 1893 Monet bought a piece of land beyond the road at the bottom of his garden. It was here that he created his water garden, accessible today via a passage that leads under the road.

Monet's water garden, with its curved Japanese-style bridge and its water lilies, brought a new dimension to his gardening and to his painting. Captured on canvas in its many moods and seasons, the water garden is one of the most enduring of Monet's legacies. The plan (right) shows the position of the flower garden in relation to the water garden.

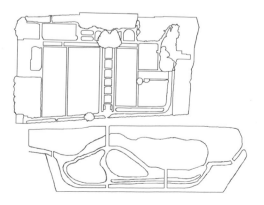

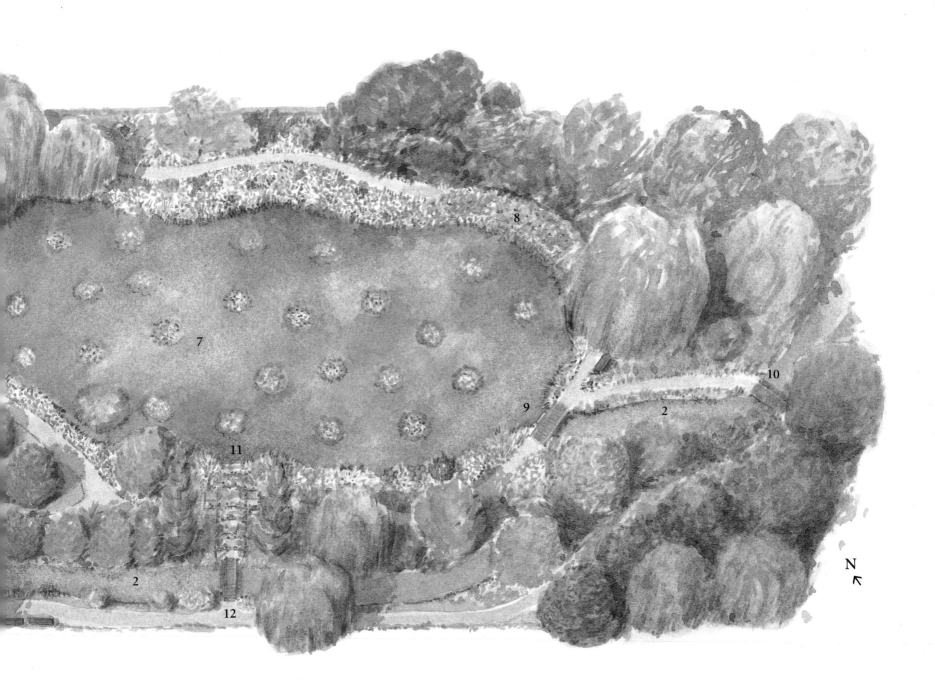

N

1 Entrance to underground passage leading from the flower garden

2 The Ru, diverted by Monet to create the pond

3 Bridge

4 Former main gate on the axis of the Grande Allée, now only used by the gardeners

5 The wisteria-covered Japanese bridge

6 Monet's original weeping willow

7 The pond with water lilies

8 Original wisteria, now supported on trellis

9 Bridge over old sluice gate

10 Bridge

11 Rose arches

12 Bridge

13 Copper beech, the site of Monet's tree peonies

14 Bridge

15 Bamboo thicket, planted by Monet

MONET - POET
OF NATURE

*"How can one live in Paris? It's hell.
I prefer my flowers and this hill that
surrounds the Seine to all your noises
and nocturnal lights."*

CLAUDE MONET

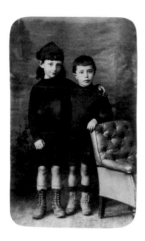

The story of Giverny begins on April 5, 1883, when Monet was served with one of the many eviction notices that regularly plagued him. A widower with two children, he was living with Alice Hoschedé, the estranged wife of a former patron, and her six children, in a rented house near the Seine in Poissy. Monet set off and would not return, he said, until he had found a house where they would stay put. The intrepid explorer headed by train downstream, looking for a home near Vernon, where he knew he would find decent schools for the older children. He followed the sinewy swathe of the River Epte, a tributary of the Seine. The jagged limestone escarpment towering over it formed a dramatic backdrop to the picturesque villages of La Roche Guyon and Giverny. The Seine, with its banks lined with poplars, had been a favorite haunt of the painter, and he had explored its many tributaries, rivulets, islands, and marshes in every kind of weather and time of day.

PREVIOUS PAGE *The flower garden from Monet's bedroom window.*
ABOVE *The two youngest children at Giverny, Jean-Pierre Hoschedé,
Monet's stepson (left), and next to him, Michel Monet.*
RIGHT *A late October mist hangs heavily over the River Epte as it
winds its way toward Rouen and Le Havre.*

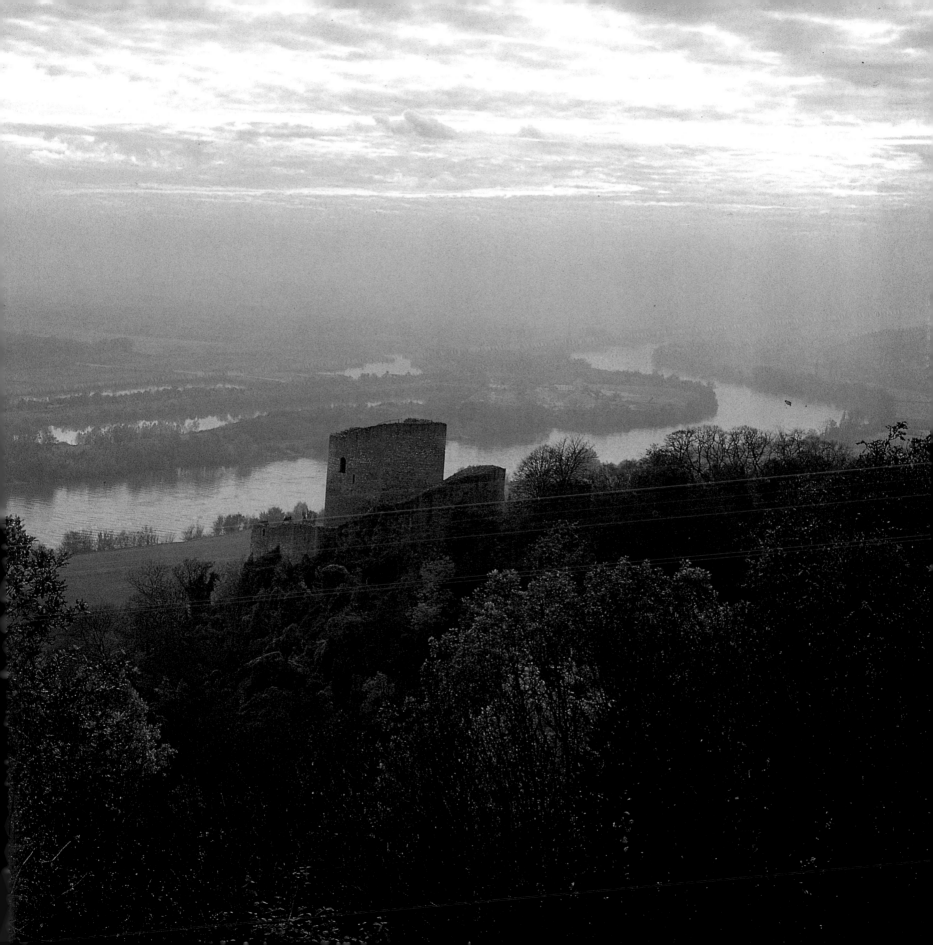

Monet had always loved the water and often painted from his boat. Brought up in Le Havre, with early painting expeditions in Étretat, and homes in Argenteuil and Vétheuil, Monet had, in a sense, lived all his life by this one great river, so unpolluted and clear that you could see the fish nibbling and the reflections of the trailing clouds of smoke of the little steam-powered cargo boats.

Here in Normandy, a region long famous for its cider, all the apple trees were in blossom. Monet walked along the embankment and then along the little road through Giverny, a village of three hundred inhabitants less than two miles from Vernon. To the north, the rounded contours of a hill rose behind the village,

cultivated with vines and crops. To the south were flowering meadows bordered with poplars, and beyond, down to the river, marshland which would be covered in yellow and mauve flag irises in summer. To the east and west, hayfields, all of it countryside Monet would make his own.

An abandoned cider farm – Le Pressoir – came into view, a long pink stucco house with gray shutters set back on the edge of a large orchard. It had been painted its unusual pink by a former owner homesick for the colors of his native Guadeloupe. The white blossom against the pink house made an enchanting sight. An imposing if somewhat inappropriately grandiose avenue of spruces, cypresses,

MONET - POET OF NATURE

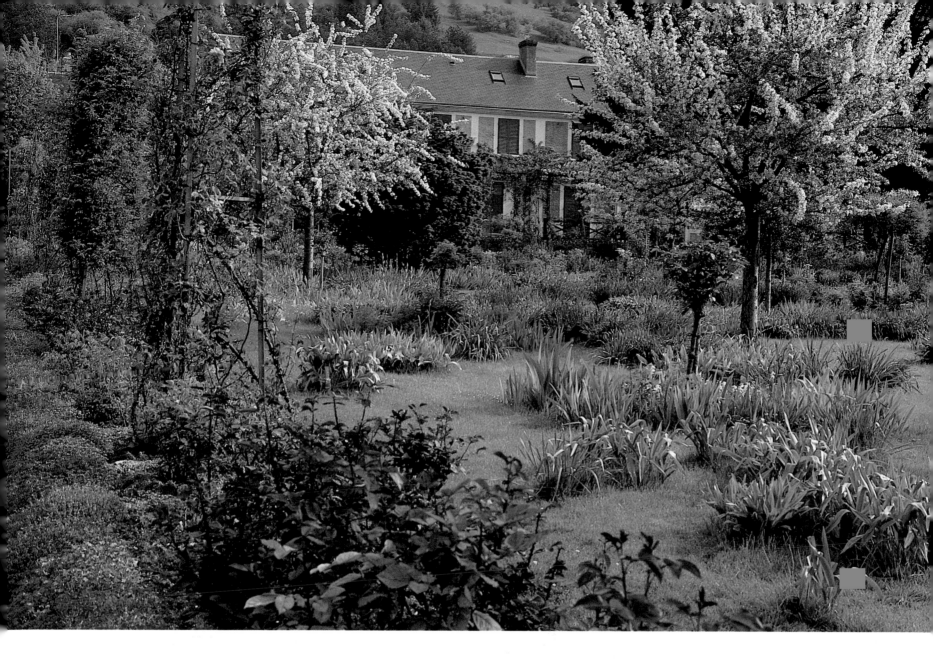

and yews led to the front door. Seduced by the charm and potential of Le Pressoir, and by its size and proximity to a river whose moods he knew as well as his own, Monet made inquiries.

The house belonged to Louis Singeot – "P'tit Louis" as he was known – a member of a family of *cultivants* (a local word for farmer) made wealthy by several inheritances. There was no problem in renting it. Monet signed the lease and on May 3, 1883, the family moved in – so impoverished that Monet's dealer, Paul Durand-Ruel, had to buy Alice's train ticket from Poissy. On the day they arrived, the painter Manet, Monet's friend and mentor, died.

In an ironic twist of fate, Monet was forty-three years old when

OPPOSITE Spring at Giverny *(1886)*, *a vision of the village of Giverny clothed in the softest of pinks. It was probably this first impression of a region full of magic light and charm that seduced Monet and held him captive for the rest of his life.*

ABOVE *The April garden today – a sea of fresh green dotted with the pale pink foam of cherry blossom – owes its transformation to Monet's horticultural wizardry.*

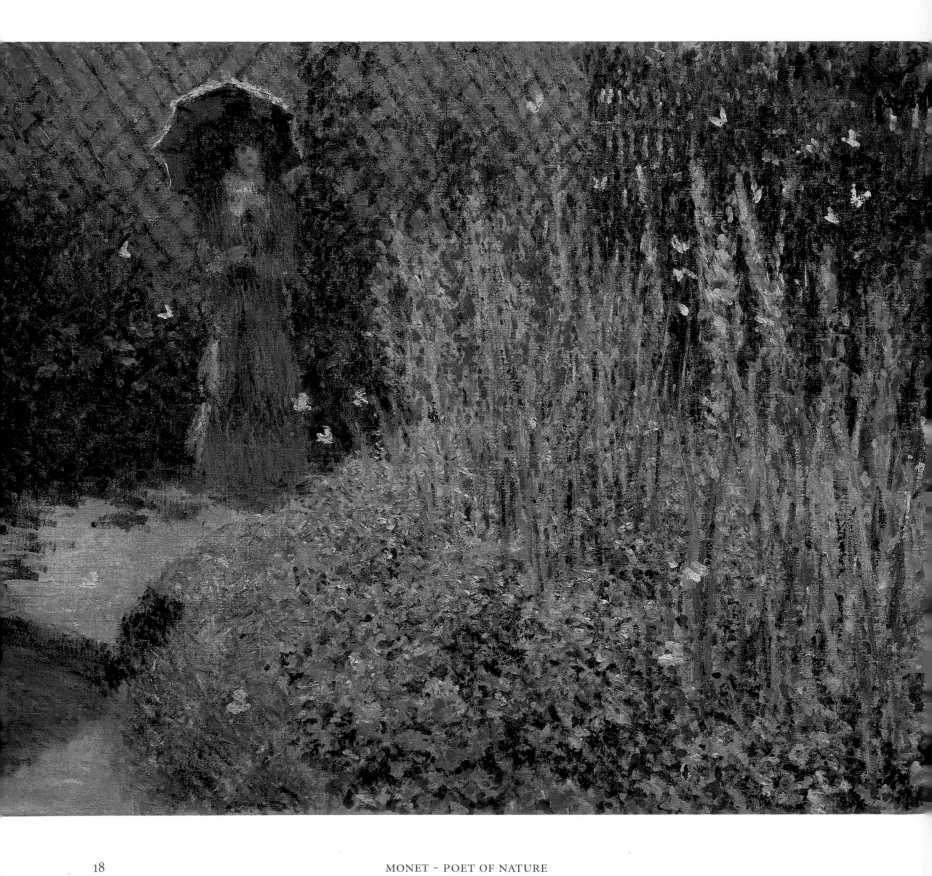

MONET - POET OF NATURE

he beat the path to the door of a house where he would die exactly forty-three years later. It had been a journey fraught with anxiety, marred by tragedy, a nomadic existence. Too poor to live in Paris or to buy a house, he had, he said, "rented peasant cottages with pleasant gardens" with his wife Camille and son Jean. These gardens he always embellished with the simplest of flowers – seasonal clumps of gladioli, dahlias, or hollyhocks that were easy to grow and eminently paintable. He had begun in his youth with faithful pictorial representations of conventional parks and gardens *à la française*, although (unlike Manet who adored the austerity of André Le Nôtre), when it came to painting the gardens of the Tuileries in 1876, he cunningly placed the branches of chestnut trees in the foreground to camouflage the angles.

The more he painted the modest gardens that he made, the stronger and more personal his garden pictures became, until they began to reflect his state of mind. There are no photographs or gardening letters which survive before Giverny, so to understand the development of Monet as the great gardener he became, one has to look at the way in which he portrayed his gardens. Toward the end of his life, he made a revealing comment: "Gardening was something I learned in my youth when I was unhappy. I perhaps owe having become a painter to flowers." For Monet, his garden, his art, and his emotions were essentially part of the same experience.

His much-loved bright and breezy *The Terrace at Sainte-Adresse* (1867) was painted in the garden of the local sailing club near Le Havre. Monet's father sits with his back to us looking out to sea. It is a windy day, with a piercing blue sky. The garden is alive with reds and yellows, one of Monet's favorite color themes in spring, summer, and fall. Here the garden is planted with the ordinary flowers, many of them bicolored, that would brighten Monet's late summer garden for fifty years – gladioli, nasturtiums, and geraniums. In another characteristic touch that would later be seen at Giverny, the edges of the paths are softened with planting.

The atmosphere in Monet's early garden paintings was invariably sunny, golden and joyous. His canvas for *Women in the Garden* (1866–7) was so large that he had to dig a trench through the flowerbeds of his garden and lower the canvas into it by means of a pulley so that he could reach the top to paint it. Like his enormous *Déjeuner sur l'Herbe* (1866), *Women in the Garden* was a pantheist hymn to dappled, filtered light which infused and transformed a conventional garden into something magical.

Drama and atmosphere which had been the domain of his sky and sea paintings with the wind lashing against rocks, or of his powerfully expressive paintings of steam engines in the Gare Saint-Lazare, began to creep stealthily and in a quietly surreal way into his garden paintings. Now he began to explore height, volume, and dimension. Lilacs, sunflowers, dahlias, and gladioli become larger than life. Camille looks snug under a canopy of lilac boughs. Late summer dahlias and other tall perennials loom protectively over his three-year-old son Jean, who lies stretched out on a garden path as soporifically as a contented cat. The figures become increasingly diminutive as the flowers assume greater importance. They would eventually fade completely from his garden canvases. In his *Women Among the Dahlias* (1875) the women are only two little heads bobbing inside an enormous wave of yellow and orange flowers.

His gardens are happy places, surreal places, but they could also be sad. In 1876, he painted two portraits of his doomed, waiflike Camille, who was already ill with cancer. One shows her dressed in blue in a garden that is sober and still; lost and wistful, she stands by tall pink and red gladioli pointing like swords. Later that year, she is in white beside a large clump of menacing dahlias with dark brown foliage and angry red flowers, their stakes sticking out from their midst like spears. The background is bathed in a Seurat-like beatific light as if she is already an angel in heaven.

In 1880, a year after Camille's death, we have a scene in the Vétheuil garden – *The Artist's Garden at Vétheuil* – of an almost Mediterranean luminous gaiety, of rebirth perhaps. This is certainly his sunniest, most joyful garden picture. A riot of sunflowers rising up on either side of a garden path. A brilliant blue sky. A symphony in yellow and blue, a combination that would become another favorite and that Monet would later use to paint his dining room and kitchen at Giverny. The figures now are smaller than ever, as though they are merely ghosts in the garden.

In 1881 his red and yellow theme returns with a portrait of his future wife Alice Hoschedé in a white dress – *Alice Hoschedé in the Garden*. Now there are kinder-looking red dahlias, this time planted along a fence, and the whole is radiant with golden light.

OPPOSITE *Gladioli (1876), was painted during the long illness that ended with Camille's death three years later. Despite the bright colors, an air of melancholy prevails.*

OVERLEAF *Joy returns to the garden with* The Artist's Garden at Vétheuil *(1880). A sunny golden galaxy of sunflowers – harbingers of Giverny today – seems to reach to the eaves of the house.*

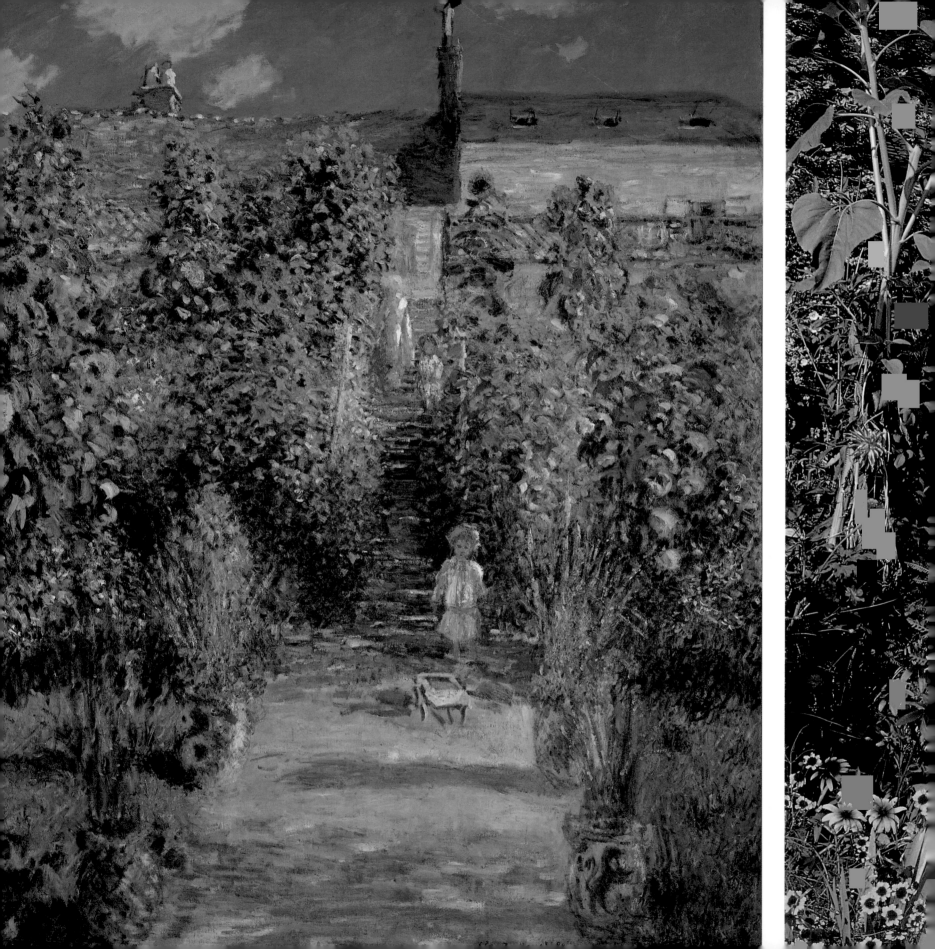

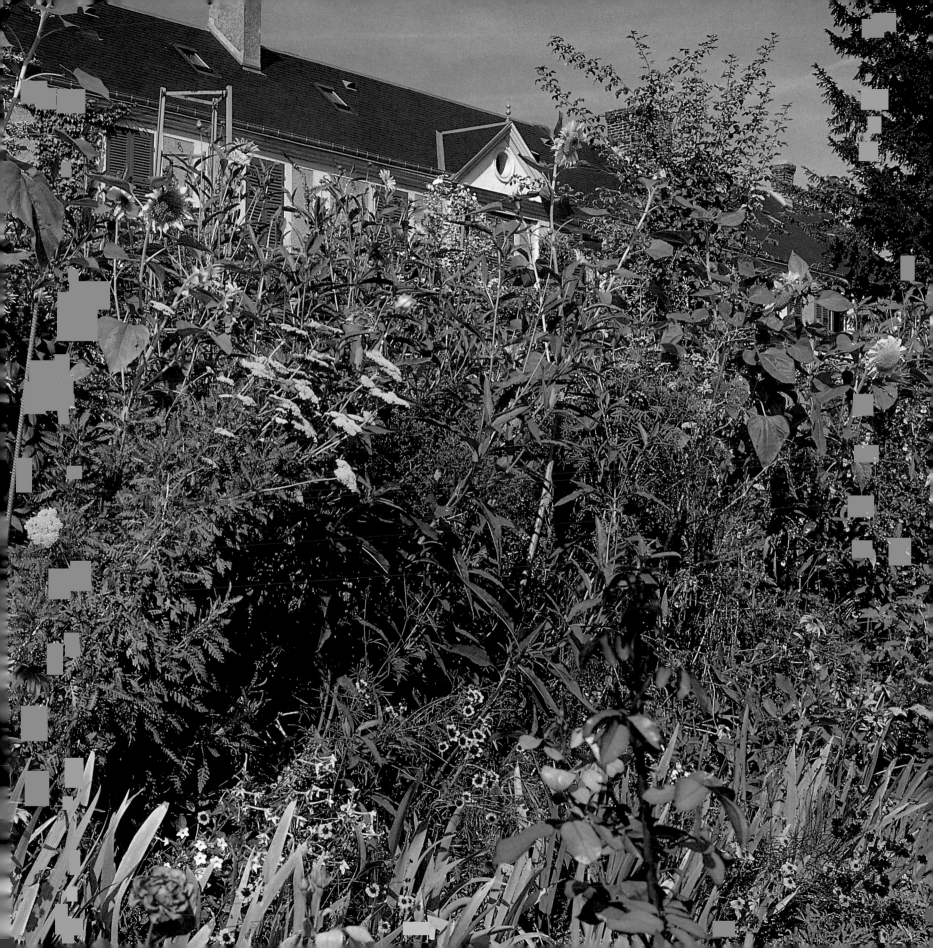

When the 2½-acre garden of Giverny finally stood before him, it was on a grander scale than he had ever known. Now he could put into practice what previously he had only explored with paint – his perception of dimension, color and atmosphere. A new garden is often compared to a canvas waiting to be painted. Giverny was less a canvas, more a huge piece of rock to be wielded, fashioned, and sculpted into the sensual, immediate, intimate garden it became.

To begin with, the garden of this cider farm consisted of nothing more than a substantial apple orchard – the *Clos Normand* – and a potager, "a small mixed plot of flowers and vegetables." It was bisected by a broad path, the Grande Allée, sloping down from the front door of the house to the gate onto the road. The flowerbeds on each side of the Grande Allée had two yews at the end nearest the house, and were planted along their length with alternating cypresses and spruce trees. There was an edging of clipped box. In front of the house, a few island beds in decorative shapes were also edged in box; to the west were six pairs of lime trees and, beyond, a vegetable garden. The alkaline soil on a bed of clay was poor, badly drained, and would need constant enriching.

Reporting himself to be *dans l'éblouissement, dans le ravissement* ["dazzled and ecstatic"] Monet threw himself into working and tending the garden. In June he welcomed a three-day visit from his wealthy friend, patron, and fellow-gardener, the painter Gustave Caillebotte. Caillebotte arrived by boat from Petit-Gennevilliers just across the Seine, where the previous year he had bought a house after the deaths of his mother, father, and brother. For both Monet and Caillebotte, bereavements marked the start of new gardens as well as new chapters in their lives. They wasted no time in getting started on their gardening projects.

Busy planting vegetables so the family could eat, Monet spoke of it many years later: "My *salon* was the barn. All of us worked in the garden. I dug, planted, weeded, and hoed myself; in the evenings the children watered. As my [financial] situation improved, I expanded, until one day I was able to cross the road and start the water garden."

He ripped out the clipped box and planted flowers around the house and in the beds in front of it, writing to Durand-Ruel that he was too busy gardening to do any painting, but adding hastily that "it will give me flowers to paint on rainy days." He was referring to the thirty-six decorative panels of flowers and fruits that Durand-Ruel had commissioned in 1882 for the dining-room doors of his Paris apartment. They were to take four years to complete. Each panel had a different flower theme – the simple flowers that Monet never tired of – poppies, sunflowers, Christmas roses, and jonquils. He painted them from the sowings he made when he first arrived, next to the house and in the borders he dug around the orchards. These flowers were growing there when he died, and are there still.

Over the years he removed many apple trees and replaced those that fell down with Japanese cherries and apricots, in smaller numbers. The rough grass became an English-style lawn that was abundantly watered, regularly mowed, and as his collection of plants grew, was dotted with clumps of daffodils, irises, oriental poppies, and peonies.

Only the double row of pleached limes remained untouched in the sweeping transformation of the garden that took place over the years. There was no dispute with or interference from Alice – except for the matter of the cypresses and spruces along the Grande Allée. Alice liked the funereal aspect of this long, sober, darkened tunnel, and she opposed the removal of the trees. Eventually, she relented and agreed that the cypresses could come down – but not the spruces. The spruces, Monet said, "ruined my plantings of flowers," but Alice was adamant. According to Jean-Pierre Hoschedé in his memoirs, his mother loved all trees and said that it pained her to see a tree cut down.

The arguments that raged about the spruces were described by Hoschedé as "epic" and the resolution was at best bizarre. With Alice's permission, all their lower branches were cut off, but she protested vigorously when their tops were sawn off, and the now-denuded poles became hosts to the climbing "pillar" roses that were all the rage. In 1923, long after Alice's death when Monet could have had them out, the tall stumps were still there, tokens of her resistance, her mark on the garden. Weakened even further by the roses strangling their roots, their bases rotted, and they eventually fell down. So instead of being swiftly removed, they were mutilated, killed off slowly, the only sinister episode in the otherwise felicitous story of this garden. As for the cypresses, metal arches eventually took their place, reported in 1920 by the art collector the Duc de Trévise and art dealer René Gimpel as having recently been erected over the Grande Allée and still there today.

The Grande Allée today. The somber foreground gives some idea as to how it must have looked when it was lined with spruces. Now only the original yews still stand, a hundred years older and taller.

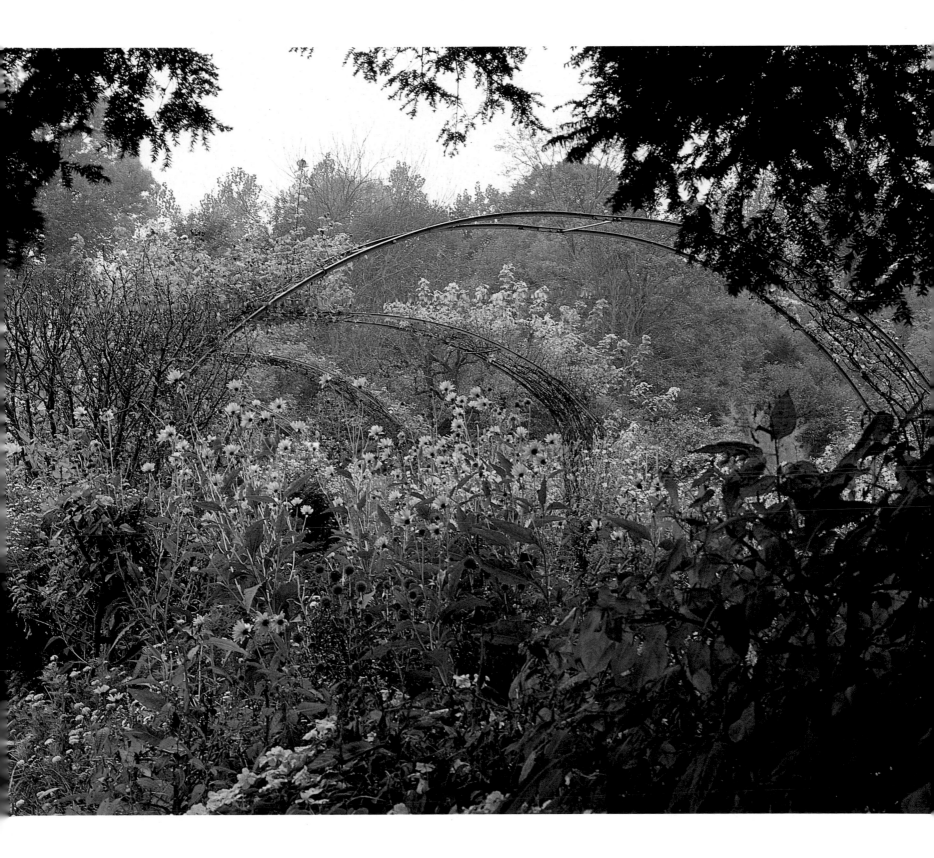

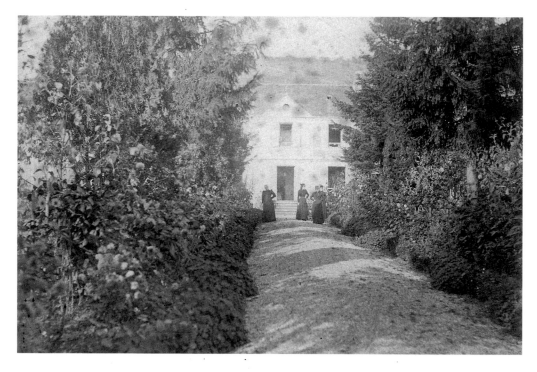

The Grande Allée underwent many transformations during Monet's lifetime. LEFT *One of the earliest photographs shows it drenched in shade before the cypresses were removed and the spruces mutilated. The veranda was still to be built, and the Virginia creeper that later draped the façade of the house had yet to make its appearance.*

RIGHT The Garden, Giverny *shows the Grande Allée at the height of summer in 1902. The interplay of light and shade caused by the shadows of the trees on the brightly lit path is beautifully captured in this painting of the flower garden. The asters and nasturtiums that appear in the painting still feature in the garden today.*

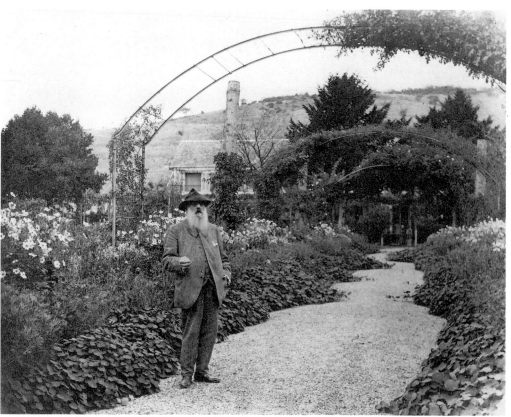

LEFT *Compared to the first photograph above, the Grande Allée now, in about 1924, is a picture of openness and light. The arches show off their climbing roses while the nasturtiums creep toward the center of the path. In the background, the remains of the spruces are clearly visible.*

MONET - POET OF NATURE

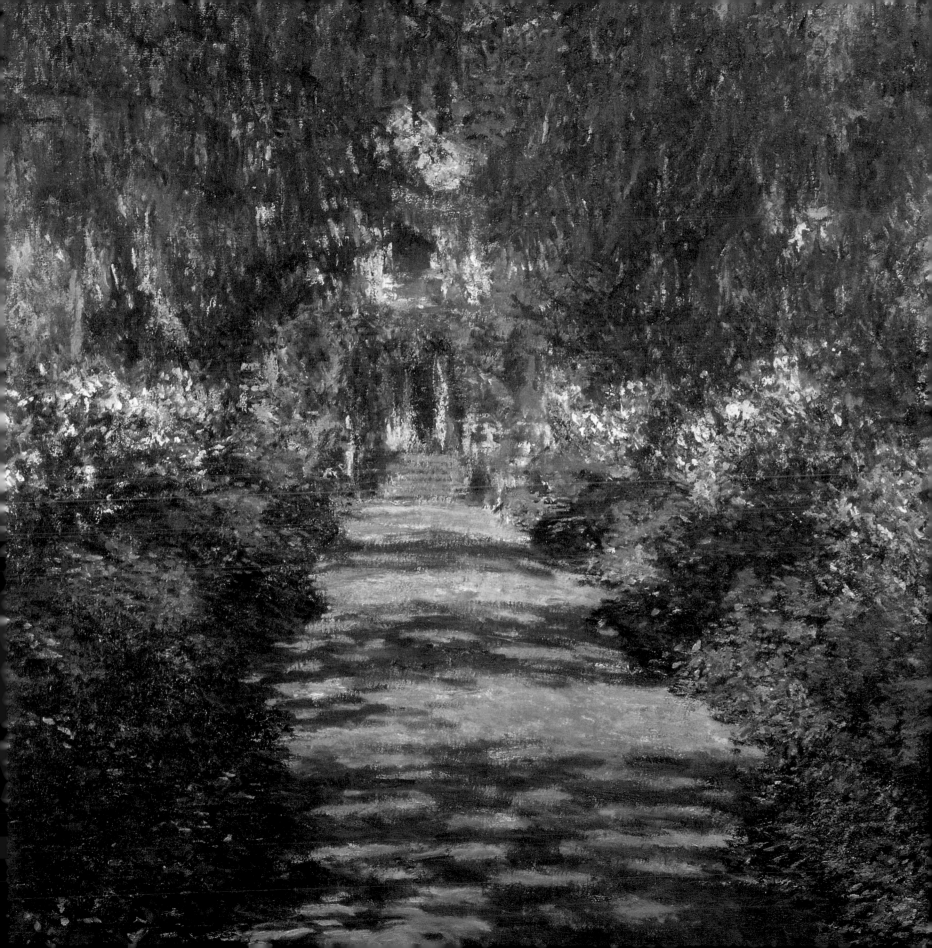

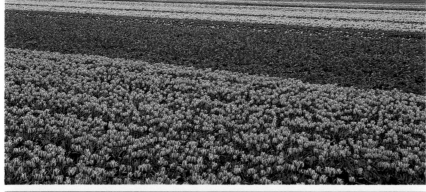

In 1886, an invitation to Holland to see the bulb fields near The Hague was to affect Monet's use of structure, design and color in the flower garden. Monet had first visited Holland in 1871 and there became more familiar with the Japanese *estampes* or woodblock prints. These changed the way he used composition, light, and color in his painting and would later also inspire his water garden. Now the Dutch tulip fields stretched before him in sheets and blocks of color that formed a bold, brilliant mosaic that no painter, Dutch or otherwise, had ever attempted to capture on canvas before. In a letter, Monet spoke of these "enormous fields in full bloom; it's admirable, but enough to drive a poor painter crazy – impossible to render with our poor colors." Not one to let a challenge pass, he took up his brushes and in twelve days produced five canvases. Infused with sunlight, blue sky, and white clouds, his red and yellow tulip fields shone luminously.

The bulb growers' technique of strengthening the bulbs by picking off the flower heads just at their peak also impressed him. There were piles of these blooms on the banks of the canals. What struck Monet was that "on these little canals we see spots of yellow, like colored rafts in the blue reflection of the sky." The image of flowers floating on a mirror of water would obsess him for the rest of his life.

Using the tulip fields as a point of departure, he began recreating the effect of these concentrated splashes of color by making long rectangular beds planted with one variety of flower giving a solid block of color. Occasionally he would mix flowers to give various color harmonies. This became the theme and variations of the flower garden, with new plants and color schemes being added all the time – blocks of yellow marigolds, for instance; long, wide lines of blue irises; gladioli in one color or a mixture of two; Japanese anemones in whites and pinks; mauve and orange snapdragons together. To allow him to expand and experiment with an even greater variety of colors and plants all at once, he created smaller versions of these long beds, his famous "paintbox beds," thirty-eight in all, laid out in pairs from the top of the garden to the bottom. The gardeners always refer to them affectionately as *les tombes* because they are the same size and shape as a grave, but it is not known whether that was Monet's nickname for them, too. Each one was planted seasonally with different annuals or biennials in specifically chosen colors, laid side by side, like daubs of color on a palette or on one of his canvases.

Just as on his canvases he never mixed his paints, but laid them side by side, or superimposed them; so equally in his garden, his

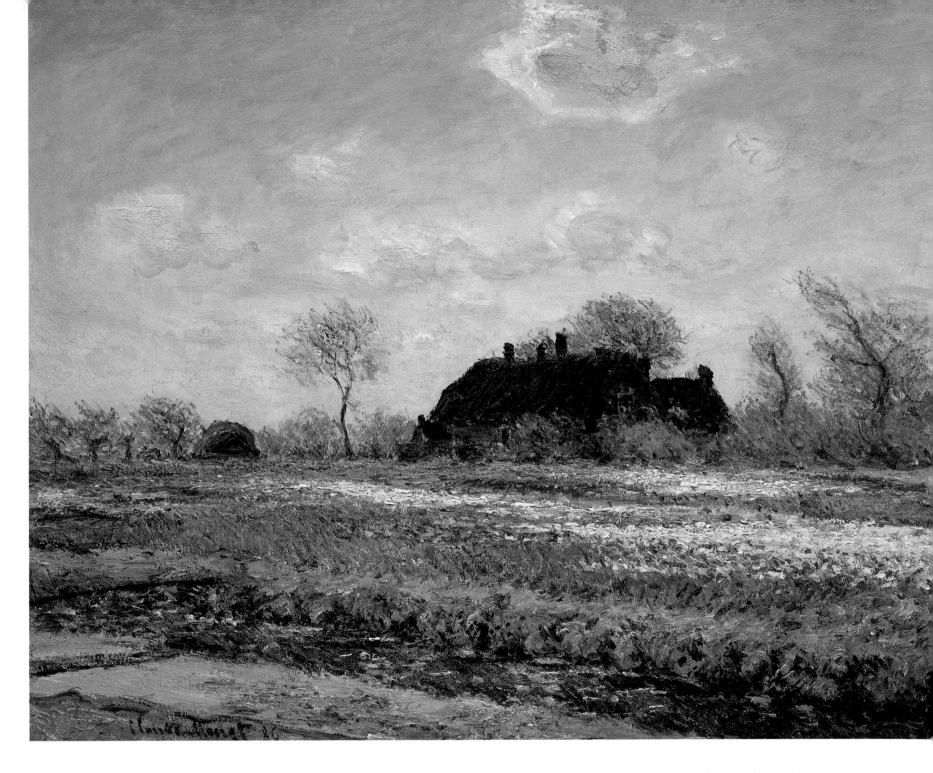

Complaining that the "poor palettes" of the painter could not capture fully the color of flowers, Monet made a "living palette" of flowers in his gardens instead. In daubs of color that were smaller and less regimented than they are today, the bulb fields of Holland (opposite) probably gave him the novel idea of a garden as blocks of color surrounding a house.
Tulip Fields at Sassenheim near Leiden *(above) is one of five paintings Monet did of the Dutch bulb fields during his visit to Holland in 1886.*

colors weren't pinkish or blueish, they were either pink or they were blue. Bulbs, perennials, shrubs, annuals, and flowering trees, all strategically positioned, bloomed in their appointed harmonies. He was especially fond of collecting blue plants, which he said nature provided in lesser numbers than reds, whites, or yellows. He liked placing monochromatic runs of blues across the path from a bed of reds. The combination of yellow with blue or yellow with violet, likened in 1904 by the English artist and writer Wynford Dewhurst to the "gold and sapphire of an artist's dreams," and a favorite combination of the Impressionists, appeared again and again in Monet's home, on his canvases and rising from his soil.

The bicolored flowers which he had first painted at Sainte-Adresse appeared throughout the Giverny garden in the shape of bearded irises in violet with brown or violet with blue, burgundy Cactus dahlias with gold-tipped petals, or pale cream peonies with pink-tinged centers. He loved true colors and loathed black or bitumen. In his painting he never used black or ocher – "to sum it up," he said, "no earth-colors" – and this was a policy he adopted in the garden, too.

He also used color to set off the house. The deep pink stucco with its distinctive green shutters – he had changed them from gray to apple green, known in the village as *le vert Monet* – was a color scheme repeated in the flowerbeds, where deep pink and red geraniums or pink and red roses were set off by green foliage.

He was as conscious of perspective in his garden as in his painting, using strong, vibrant, deeper colors in the foreground of the borders and repeating them in softer colors in the background to make the borders seem longer. The way he used light was as important in his garden as it was seminal to his painting. Planting blue flowers under trees enhanced the natural blue cast given off by the shadow of the trees. Orange, red, and yellow flower borders that were planted deliberately on the west side of the garden caught the long golden rays of the setting sun and heightened their glow.

The color combinations of an Impressionist garden are recreated at Giverny. A rhododendron with Excelsior foxgloves (near right, above), their trumpets flecked with black, red, pink, and cream, make a rich combination. A red and yellow spring border (near right, below) consists of yellow and orange Lily-flowered tulips with red Darwin and pink tulips. Yellow and purple irises (far right, above) – a favorite Impressionist color scheme – make a bold contrast. Purple and wine-red pansies (far right, below) mingle with pale blue forget-me-nots.

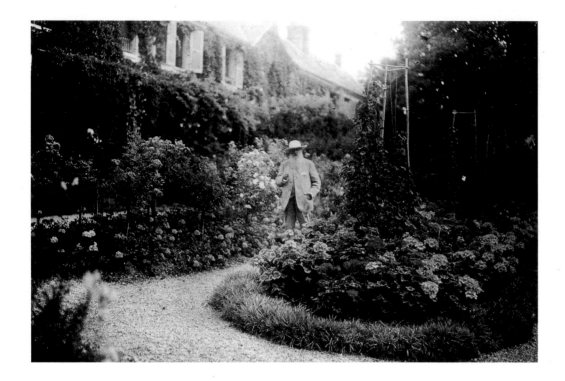

The beds and borders of the garden often had a distinctive planted edging. The island beds in front of the house, the only beds that were not rectangular or square, were edged with pinks. *Iris pumila* made an effective edging to the beds of gladioli, but most famous of all were the blue and mauve aubrietas, synchronized for color and flowering time with the blue bearded irises whose beds they edged. Monet also used saxifrage, bellflower, nasturtiums and *Ceratostigma plumbaginoides* (*Plumbago larpentiae*) as edgings.

He capitalized on walls, trees, and trellises. Anything that could be anchored, hitched, or draped to these was duly planted and trained upward. He constructed *tuteurs* for the island beds – tripod-like structures of bamboo poles up which he grew dark-red climbing nasturtiums. He himself designed sloping frames erected over every other pair of paintbox beds, specifically to support his collection of white and pale pink *Clematis montana*. They made the most marvelous effect in spring when, according to nurseryman Georges Truffaut writing in the magazine *Jardinage* in 1924, "hundreds of small white and pink blooms hung in garlands as delicate and airy as lace hanging over the paths and blowing freely about in the wind."

As original and iconoclastic in his planting as he was in his painting, Monet became an extremely inventive gardener, who incorporated conventions if it suited him to do so, and invented others to satisfy his unquenchable appetite for visual delight and the nuances of color. By the end of the nineteenth century in France, there was a movement against the formal dictates of André Le Nôtre's style of gardening, a movement of which Monet was a part. In his book of 1920, *Jardins: Carnets de Plans et de Dessins,* J.C.N. Forestier, eminent landscape architect and restorer of the Bagatelle gardens, condemned Le Nôtre's gardening style. To support his views, Forestier quoted the English Arts and Crafts architect John Sedding, who had died more than twenty years earlier. According to Sedding, "He [the Frenchman] overdoes design. He gives you the impression that he is far more in love with his own ideas about Nature than with Nature herself; that he uses her resources not to interpret them or perfect them along their own lines, but to express his own interesting ideas . . . Hence a certain unscrupulousness towards Nature in the French garden . . ."

Born in the same year as Monet and sharing Forestier's views and Monet's sensibility was Édouard André, who was something of a Renaissance man, botanist, plant-hunter, landscape architect – there was no aspect of horticulture that he had not mastered. Four years before Monet moved to Giverny, André published his famous treatise *L'Art des jardins: traité générale de la composition des parcs et jardins,* in which he called for a more natural look and encouraged

people to use and adapt indigenous flowers in their gardens. Monet must have been influenced by all these ideas.

His pet hates encompassed most of the popular conceits of the era. In his memoirs, Jean-Pierre Hoschedé recorded the artifice that Monet considered particularly loathsome: "rocks with cascades, giant cement mushrooms, columns, statues, topiary, Victorian bedding in floral mosaic patterns composed with pansies, daisies, heliotrope, ageratum." According to Hoschedé, he hated cannas, heliotrope, veronicas, French marigolds (*Tagetes patula*), sweet Williams (*Dianthus barbatus – œillet de poète*) and everlasting helichrysum (*les immortelles*) – all of which he banned from the garden. "The garden," wrote Arsène Alexandre, the prolific and eminent critic and art historian, "has none of the picturesque style that is the glory of specialists who are all more or less Le Nôtre's heirs ... One cannot see any rounded flower beds arranged to look like bouquets or Italian mosaics."

While retaining a Victorian formality near the house (albeit a casual one), with his standard roses and geranium bedding schemes, Monet made abundant use of wild flowers at Giverny. His clematis arches were underplanted with a biennial native to England, *Verbascum thapsus*. People found it surprising that he should use such a common plant, but he frequently mixed the ordinary with the exotic. Common willow herb for instance, Stephen Gwynn noted in *Country Life* in 1933, had been "brought in for its tall shafts of pure colour; they were ranged in clumps at intervals." Poppies and verbascum were allowed to self-seed and grew where they fell, and together with Monet's dense planting contributed to the garden's cottagey jungle of beauty effect. In a letter to Caillebotte, Monet asked him to save his foxglove seeds, adding that if he wanted to get rid of them all he could send Monet as many as he wanted.

Monet was also quite modern in his use of roses. In 1920 J.C.N. Forestier wrote: "Barely twenty years ago, the much-disdained roses were hardly admitted to our gardens; they were rejected from our public gardens. Often, in the parks of large country houses, they were exiled to the potager, along with the multitude of perennials grown solely for their cut flowers." Monet, together with others in the vanguard of garden design, brought the outcast potager, her flowers, and her roses back from exile and used them rather than the shrubberies and nineteenth-century formal bedding that were fashionable at the time. In 1901, Arsène Alexandre picked up on this in an article for *Le Figaro*, comparing Monet's garden to an adaptation of the "common truck garden," with flowers planted instead of carrots and lettuce.

Monet's taste in flowers tended toward the simple. He loved garden flowers that most closely resembled wild ones, roses that looked like the sweet briar, and single roses such as his favorite, the climber "Mermaid," with its large yellow flowers, which he planted outside his bedroom window. He did not like double flowers or variegated foliage, which he thought looked hybridized and unnatural, but though he preferred the single Japanese tree peonies, he made an exception for herbaceous peonies.

Monet liked simplicity, but he had his idiosyncrasies, too. The man who supplied the household with asparagus remembered that Monet insisted all faded flowers be deadheaded at once. Nor did he care for vegetables in his garden, so in the early 1900s, when he had the means, Monet moved his vegetable garden to the other end of the village, renting a house called La Maison Bleue with a walled garden as large as his own. There he installed one of his gardeners – Florimond – with the vegetables well out of sight. Mushrooms were cultivated in the dark recesses of the cellar, and in cold frames Florimond grew the tender herbs, spices, and vegetables for which Monet had developed a taste during the two years he served as a young soldier in Algeria and later through the many winter months he spent in Antibes and Bordighera with his friends, the Morenos.

It was natural that an art movement so bound up with nature should turn to the garden for its motifs, but while the Impressionists painted gardens and still-lifes of fruits and flowers, only Caillebotte and Monet were real gardeners. Renoir is said to have dug potatoes with Monet, but it was Aline, Madame Renoir, who masterminded Renoir's garden at Les Collettes in Cagnes. Madame Pissarro, having filled her house with seven children in conditions of abject and sometimes suicidal poverty, went on to fill her garden with hundreds of her favorite pink peonies – the subject of Pissarro's most remarkable still-life. Visiting Monet's garden, she spotted some irises that pleased her. Monet promptly dispatched them to her by train.

In Monet's garden, every flower, every effect had been sifted through his painter's sensibility, for it was above all else a painter's garden and, even more specifically, an Impressionist painter's garden. On his visit in 1933, seven years after Monet's death, Stephen Gwynn saw the garden from the road and described his first impression:

> one saw a long, low farmhouse, having in front of it a dazzle
> of flowers, all common, all chosen for their brilliancy:
> snapdragon, African marigold, campanula, gladiolus and
> the like. What struck me at once was that there was no
> arrangement in masses. The painter had his garden before

him like a canvas some fifty yards wide and rather more than half as deep; and the effect he aimed at was the effect of the whole. All was a flicker of bright colour; form was given by the use of trees . . . nothing was let stray, yet the whole effect seemed as carelessly variegated as a wheat field where poppies and corn cockles have scattered themselves. All fell together like a pheasant's plumage or a peacock's; and remembering how many colours this master had found in the shimmering warmth of a sunlit haystack, one could feel a little what he was after in creating that ordered space of vibrant light and life . . .

Monet was above all a sensualist, a lover of life and light. His appetite for the physical world permeated everything. He was exacting in the food he ate, in the painting and furnishing of his house, the clothes he wore. His art and his garden were both unpretentious, yet extremely sophisticated. But while his artistic masterpieces could delight the eye, could challenge and meet him intellectually, his garden was all sensuality – it had fragrance, delicate petals, an infinite variety of hues and nuances, exquisitely formed flowers, bold shapes, and curious textures. Best of all, he could fantasize and fuss over it without feeling that compelling desire to paint it; it remained a pleasure because it did not become a duty; a mistress where his painting was a wife. "It was," said his stepdaughter Blanche, "his only relaxation and distraction after the exhausting draining process of his work."

Monet read all the gardening magazines and nursery catalogs, went to flower shows, visited many gardens, and swapped plants with friends. The leading horticultural magazine of the time was *Jardinage,* edited by nurseryman Georges Truffaut who also supplied many of the plants for the garden. It was a combination of practical gardening tips with articles about gardens – Giverny among them. Even Monet's head gardener, Félix Breuil, wrote about irises for *Jardinage.* Many of the nurseries Monet used, such as Nonin and Moser & Fils, advertised heavily in the magazine, and in later years

Unusually for a French garden of the time, informality is the theme at Giverny. Self-seeding poppies and other wild flowers were encouraged and are now so invasive that they need thinning, but they are unwelcome only when they appear among the irises and aubrieta.

Truffaut often came to Giverny for lunch and a tour of the garden.

Monet obtained his plants not only from the Truffaut nursery, but also capitalized on the growing trade in mail-order horticulture and patronized local nurseries along with the more specialist ones. He frequently asked Caillebotte's friend Godefroy, who had a nursery in Argenteuil, to supply his more unusual requests. He of course ordered water lilies from the Latour-Marliac nursery, where Joseph Bory Latour-Marliac had successfully produced a hybrid pink water lily in 1879, at a time when only white ones were available. Monet obtained some of his peonies from Kelways in England, and there is a note to Pissarro's son Lucien, asking him if he would find out the addresses of two nurseries – Barret & Son and Thomas Ware – on his next trip to England. Japanese friends, the dealer Kuroki and his wife Princess Matsukata, brought tree peonies and lilies from Japan. Vegetable seeds came from Thiébaut, Place de la Madeleine, Paris. One order included the broad bean 'Aquadulce,' still popular today.

Monet also had a comprehensive botanical library which included *La Flore des Serres et des Jardins d'Europe* – a 26-volume set published in 1845 which he consulted regularly. Throughout his life he remained faithful to the stalwarts of any French garden – Hybrid Tea roses, dahlias, gladioli, geraniums, and so on – even though his taste widened to include rare collections of orchids and water lilies, and he collected plants on his travels. He marveled at what he saw in botanical gardens and flower shows, but did not collect for the sake of collecting. Instead, he acquired plants that he considered beautiful, plants that stood on their own merit. His sketch books were full of plant names jotted down on his travels and during promenades in the countryside. He was always on the lookout for new plants, reporting from one of his trips that he had finally found "*des ravenelles*" – the primrose-colored *Erysimum cheiri* wallflower that now flowers *en masse* at the same time as Monet's original crab-apple in front of the kitchen. The two youngest children, Michel Monet, who later inherited Giverny, and Jean-Pierre Hoschedé, also became keen amateur botanists, and Monet always had them in mind when he traveled, knowing that the present they would like best would be an unusual or sought-after plant. The local priest and family friend, the Abbé Anatole Toussaint, collaborated with Jean-Pierre Hoschedé on a book published in 1898 called *La Flore de Vernon et de la Roche Guyon.* The two of them experimented with hybridizing and crossing *Papaver orientale* with *Papaver rhoeas* to produce *Papaver × monetii*, which the present head gardener has never heard of. According to Georges Truffaut, Monet himself produced many varieties from the 'Étoile de Digoin' dahlia.

One of the last paintings of Monet's Vétheuil garden – *Flower Beds at Vétheuil* (1881) – looks out over a mass of sunflowers and then across the Seine to the shores of Petit-Gennevilliers where Caillebotte was to garden for the last twelve years of his life. According to an unfinished painting Caillebotte did of this garden when he had just bought the house in 1882, it is laid out according to the traditional potager crop-rotation system. Five years later, around 1887, a photograph shows it radically altered, with precisely positioned geometric beds all framed in edging plants identical to those at Giverny. These are laid out around a greenhouse of the same design as Monet's, but pre-dating his by five years. Monet was to take it as his model when he built his own and took Caillebotte on as his adviser. In fact, their gardens were to bear a striking resemblance; the two friends had the same taste in plants, swapped them regularly, and corresponded faithfully, all the while talking about gardens, and not a word about art.

Neither Monet's nor Caillebotte's garden was hidden behind high walls or locked away behind gates. Day-trippers out on a Sunday afternoon excursion by steamship along the Seine floated by Caillebotte's garden on the banks of the river, described in 1887 by a journalist as a garden "overflowing with roses and dahlias. The glass panes of the large greenhouse, in which the owner of this small suburban castle propagated his plants by cuttings, glittered in the sunlight." The bottom of Monet's garden had initially been bordered by a high stone wall, but Monet, who liked openness, had half the wall taken down (a gesture ascribed by one journalist to "generosity or coquetry, or both") and replaced by an iron railing through which clambered bright red *Tropaeolum speciosum* in late summer and fall. The garden was also visible from the little train that ran parallel to the road – and from which it is always erroneously claimed that Monet first laid eyes on the house. In 1901 Arsène Alexandre remarked that, although the view from outside was dazzling enough, the sensation on entering was even more intense. Even the local farmers were impressed with a garden that was not comestible, and they stopped to admire it. As cars became popular, many people slowed down as they drove past, but the cars kicked up clouds of dust that settled on the flowers and spoiled them. Rather than rebuild the wall, Monet had that stretch of road paved at his own expense. Even six years after Monet's death, Stephen Gwynn noted that "on a Sunday you will find many people staring into that crowded close of flowers."

Generous in allowing his garden to be viewed by anyone who cared to stop, Monet also shared his garden and plants. Visitors were always being told to hurry, lest they miss the glory of the irises in spring and in summer. If they arrived late on a summer's afternoon, they were immediately rushed to the water garden to admire the water lilies before their flowers closed at 5 o'clock. Particularly admired fruits or flowers that delighted his friends were subsequently dispatched to them by train at the first opportunity. Hundreds of plants from Giverny hurtled the length and breadth of France by rail from the little station of Vernon: dahlias to Caillebotte; the collection of irises to Madame Pissarro with instructions to plant them in clumps of three; vast quantities of gladioli and anthemis to friend and statesman Georges Clemenceau at his garden in La Vendée on the Atlantic coast; and as many to fill the garden of his friend the actor and playwright Sacha Guitry, whose garden, "Les Zoaques," Monet designed after Alice's death. No gift too small, it was a tradition for Monet to send a basket of a few choice plums to his friends Octave Mirbeau or Caillebotte. Caillebotte returned the favor by sending the family a large order of shrimp. When he was away on painting campaigns, Monet also sent flowers by rail from every corner of France for Alice, as well as baskets of hardy and tender plants for the garden with instructions as to how they should be looked after.

Monet also loved birds and enjoyed sharing his home and garden with them. He kept the French doors of his dining room open for the sparrows to fly in and help themselves to breadcrumbs from the table. There was a one-legged sparrow that came every day for three years. Even now, in memory of Monet's fondness for nature, at least a dozen bird boxes are distributed in the flower and water gardens when they close at the end of October, to be brought in again in summer.

Monet's close circle of friends during his Giverny years were all garden enthusiasts, and in between high-minded exchanges on politics, literature, and philosophy, there was talk of compost, of alcoholic gardeners, of garden marvels seen in this place or that, such as the water lilies Monet saw at a flower show and which, it is said, inspired the water garden. Besides Caillebotte, Monet's three best friends were the novelist Octave Mirbeau, the statesman Georges Clemenceau, and the critic Gustave Geffroy, who was a friend of all three and who became Monet's biographer. With a devotion unmatched even by Boswell's for Dr. Johnson, Geffroy expired in the same year as his subject. These friends queried each other about all sorts of plants from the most prosaic to the arcane. Monet wrote to Mirbeau one May to find out where he could obtain the annuals that had just caught his eye at a flower show because it

was too late to sow them. In another letter, he wrote to Caillebotte about a Japanese plant that had just arrived from Belgium called erythrochaete (*Ligularia japonica*), asking Caillebotte to "talk to Godefroy about it and tell me how to look after it."

The hypersensitive Octave Mirbeau worshipped Monet and took up gardening with such zeal that Monet referred to him as "*le maître jardinier,* for he talks of nothing else but gardening and the novelist Maeterlinck." Mirbeau wrote many whimsical letters and essays about his horticultural triumphs and disasters, as well as many overblown passages on Giverny. Monet, however, considered him as great as Tolstoy and forbade anyone in his household to cast the slightest doubt on this. Mirbeau persisted in his horticultural endeavors and went on to ghost-write for the horticultural journal *Le Jardin.* In one letter, he described the wild orchids he had found in a forest – "as beautiful as all the exotic specimens" – promising to try and give Monet a collection of some of the twenty-two species, and asking if Monet in turn could send him a few more dahlias. For the following year, Mirbeau promised him an absolutely choice collection of chrysanthemums from a gardener in Vaudreuil. Mirbeau gave Monet phlox, *Dianthus superbus* which Monet admired in his garden, and asters. Monet gave Mirbeau doronicums. They swapped dahlia cuttings. When Monet lost his head gardener because "his wife is bored in Giverny" he wrote to Caillebotte about it asking if he knew of anyone he could recommend but it was Mirbeau who found him Félix Breuil, the son of his father's head gardener. According to Jean-Pierre Hoschedé, "one of Félix's greatest qualities was to listen patiently to Monet's plans and never contradict him, which is not to say that Monet never took Félix's advice or opinions into consideration."

Monet would sometimes go for long periods without painting, but by all accounts, if he wasn't painting, he would either be walking around the garden, contemplating the garden, or working in the garden. Blessed with an iron constitution and vast reserves of energy, to the very end of his life he walked around the garden three or four times a day, his mind constantly thinking about improvements, new ideas. Mirbeau described him in shirt sleeves, sunburned and happy, his hands black with earth, a familiar figure pushing a wheelbarrow filled with plants one day, or trundling canvases around the next. As the garden gained fame, and journalists, art critics, and dealers arrived, he would receive them in one of his distinctive pleated pastel silk shirts with frilly cuffs, a tawny velvet hat, and a beige checked homespun tweed suit, or in the summery white linen suits typical of his understated sartorial style.

Monet was not a particularly sociable animal, and even his friends admitted that nobody really knew him. Comfortable with his family and close friends, respected in the village, he was nonetheless undemonstrative with his feelings and did not reveal what he thought about people. To those who didn't know him, he appeared severe: a laundry maid who helped Blanche said she used to see him in the garden, but "I never knew if he had any teeth because I never saw him smile." He would stay in his room sulking if his painting was not going well, but if it was, he would sit at the table and sing the toreador song from Bizet's opera *Carmen*.

His exhibition with Rodin in 1889 and Durand-Ruel's energetic efforts on his behalf in America brought prosperity, and in 1890, at the age of 50, Monet was at last able to buy his home. This milestone was commemorated with the construction of two greenhouses, the hiring of six gardeners, and the celebration of two weddings. The first was his own to Alice (with Caillebotte as best man), so that four days later he might give Alice's daughter Suzanne away when she married the American painter Theodore Butler. From then on, Monet poured his income into improving and expanding his house and garden, commenting some years later that "all my money goes into my garden." After a visit to Monet in July 1890, Mirbeau reported to Geffroy that "Monet was gardening like crazy."

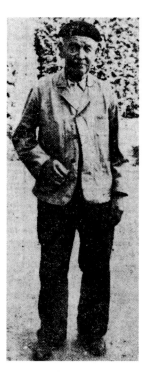

Félix Breuil, pictured here at the age of eighty-two, was Monet's gardener for nearly thirty years. His pessimistic nature did nothing to soothe Monet's already excitable and mildly depressive temperament. "Monet," he said in the interview during which this photograph was taken, "loved all flowers."

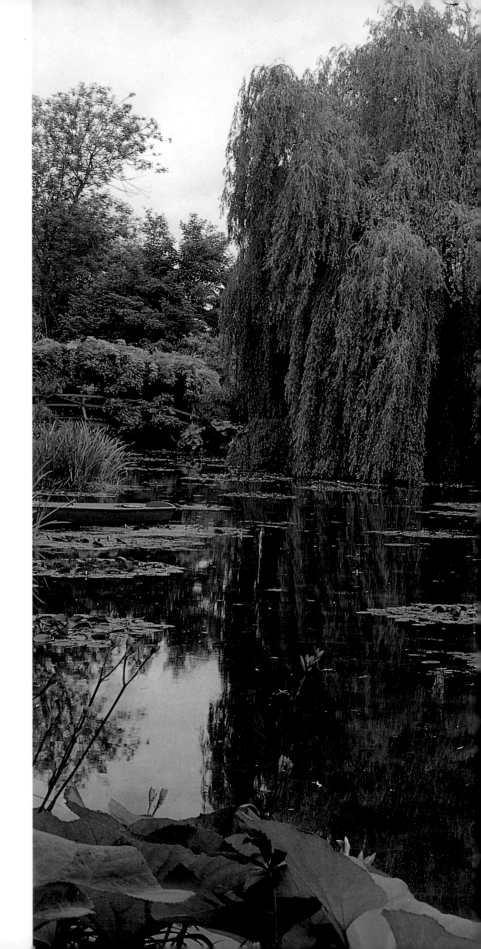

Monet, having achieved the ultimate flower garden – the yin – now dreamed of its perfect complement – the yang – water, greenery, mystery. "I am looking," he wrote to Mirbeau, "for something I have not done before, a *frisson* my painting has not yet given." He found it in the most elusive and challenging mystery of all – the flower-bedecked surface of a pond. After his flowery geometric beds, he yearned for winding paths; after his jumbled cottagey kaleidoscope, he hankered after gentle exoticism. Beyond the road and across the railroad track, he bought a tract of marshy land covered in aspens and poplars through which ran a small stream called the Ru, a tributary of the River Epte, itself a tributary of the Seine. "There was a stream," he said, "the Epte, which came down from Gisors on the boundary of my property. I opened up a ditch so that I could fill the little pond that I had dug in my garden. I love water, but I also love flowers. That's why, when the pond was filled, I wished to decorate it with plants. I took a catalog and made a choice off the top of my head. That's all."

In 1893 he applied for permission to fashion the stream into an elongated pond in order to cultivate aquatic plants so that he might paint them – water lilies, reeds, various irises that corresponded roughly to the species that grew naturally along the river. Permission was refused on the grounds that the locals were suspicious he might poison the water with his plantings. Monet was livid. Away from home on a painting trip, he ordered Alice to cancel all the excavation arrangements and throw the water lilies he had obtained in the river. Mirbeau wrote to the local *préfet* who was a personal friend pleading Monet's case, and a week later permission was granted. Monet then turned the arm of the Epte to fill his long pond and installed a system of sluices to clean the water daily. Knowing that the current would be too strong for the delicate blooms of the water lilies, he installed a comb-like grille to slow down the flow.

A simple little curved bridge went up two years later, on the same axis as the Grande Allée, evocative of Japan, but painted green instead of the traditional Japanese vermilion – a perfect example of Monet's use of the power of suggestion. He painted the Japanese bridge long before he concentrated on the flower garden. When permission was granted in 1901 to enlarge the pond on condition

The water garden with the flower garden beyond. The succession of rose arches descends the length of the Grande Allée and leads on a straight axis across the road to the Japanese bridge.

36

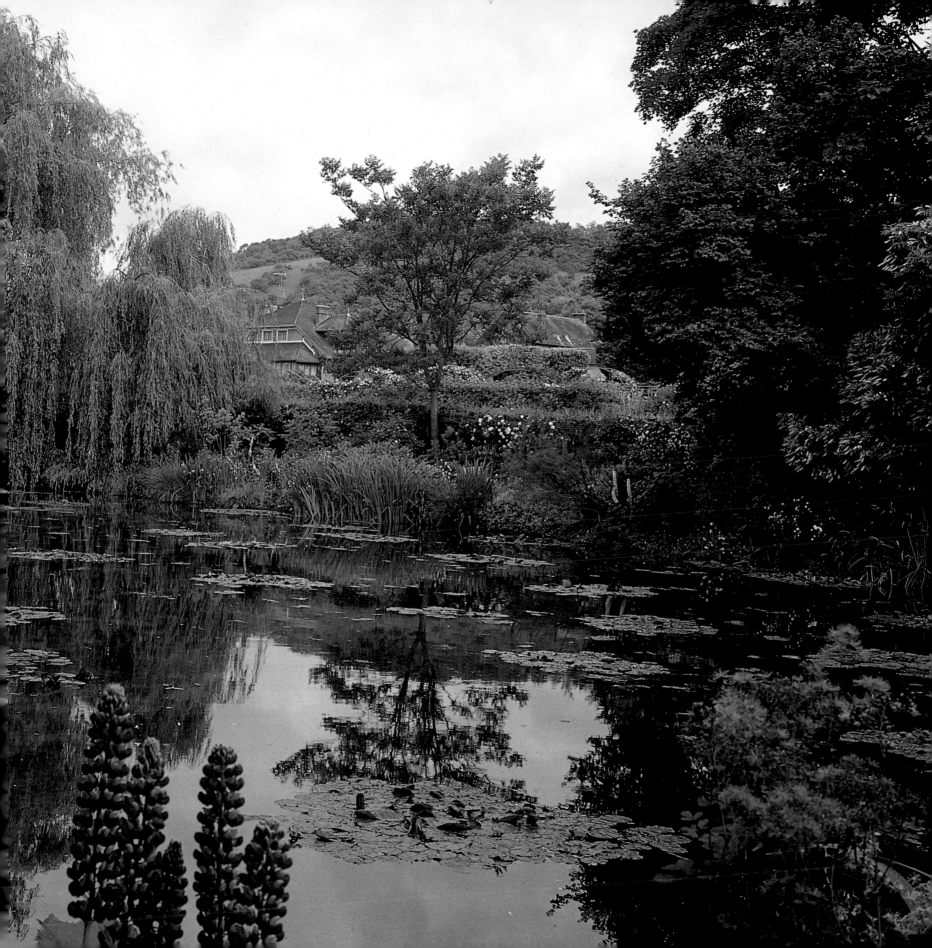

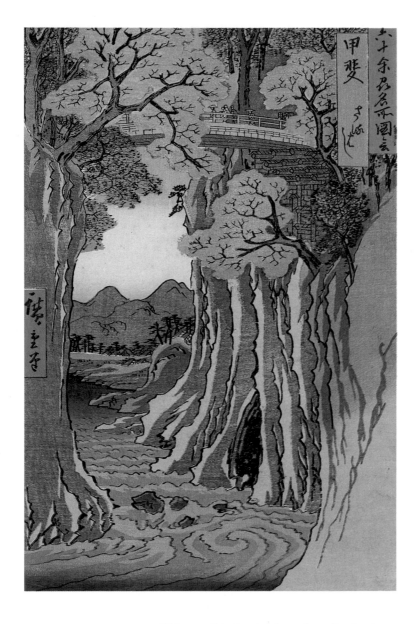

ABOVE AND OPPOSITE *This woodblock print from the collection in Monet's house is an example of the Japanese use of bold composition and surreal portrayal of nature, both great influences on Monet. The bridge is almost identical to the one Monet had built for the water garden, with trees partially masking it both in the print and in the photograph of the water garden today. In the fall the browns and golds of dying foliage in the photograph echo the print's autumnal tones.*

that the water was free-flowing, Monet capped the bridge with a trellis. He draped white wisteria on the top and mauve wisteria on the bottom, so fragrant that it was described by Marc Elder in *À Giverny chez Claude Monet* (1924) as "walking through a tube of vanilla."

The water garden became a garden of perspective and of the unexpected. It had an affinity with seventeenth-century Japanese gardens with their lakes, winding paths, and points of contemplation. Monet again designed the garden himself, making, according to critic and art historian Louis Vauxcelles, a "dreamlike setting that is extremely oriental." He enhanced its oriental atmosphere with a collection of bamboos, acers, Japanese tree peonies with large single flowers of red, dark red, pink, and white, weeping willows, and every known variety of water lily. A narrow border of grass framed the pond, and to soften its edges, he used indigenous plants from the marshes – calthas, trollius, saggitaria, pink and yellow thalictrum, agapanthus, rare species of Japanese lilies, gladioli, petasites with giant round leaves, and aquatic plants obtained from a specialist near Lyons, together with almost every species of iris. Pampas grass (*Cortaderia selloana*, in French *gynérion argenté*) and eulalias (*Miscanthus sinensis*) added their plumes to the foliage of the irises, and dripping willow branches enhanced the overall effect.

Where the flower garden was all straight lines, the water garden was all curves, arches over the paths, circular beds dug out of the lawn on the other side of the pond to echo the circular rafts of water lilies. In these beds Monet grew his Japanese tree peonies and the round-leaved petasites – again repeating the circle motif – that he planted by the bridge near the bamboos. And where the flower garden celebrated flowers, the water garden emphasized foliage. He left the poplars and aspens he found and added the now-famous weeping willows. The outer perimeters he planted with azaleas, rhododendrons, hydrangeas, and hedges of roses. He filled in the rest with acid-loving plants such as kalmias, azaleas, spiraea, holly, and huge ferns. According to J.C.N. Forestier in 1920, "At the end of the pond high Carolina poplars sheltered a clump of acid-loving plants – azaleas, rhododendrons, heathers, amongst which rose the proud blooms of *Lilium auratum*." Monet explained that the inspiration to grow the lily had come from seeing a portrait of a child among lilies (*Carnation Lily, Lily Rose*) painted by his friend John Singer Sargent. The background Sargent had chosen was composed of a mass of *Lilium auratum* that grew in the Cotswold garden of American society hostess Mrs. De Navarro. Over half a century, it had grown into one enormous trunk.

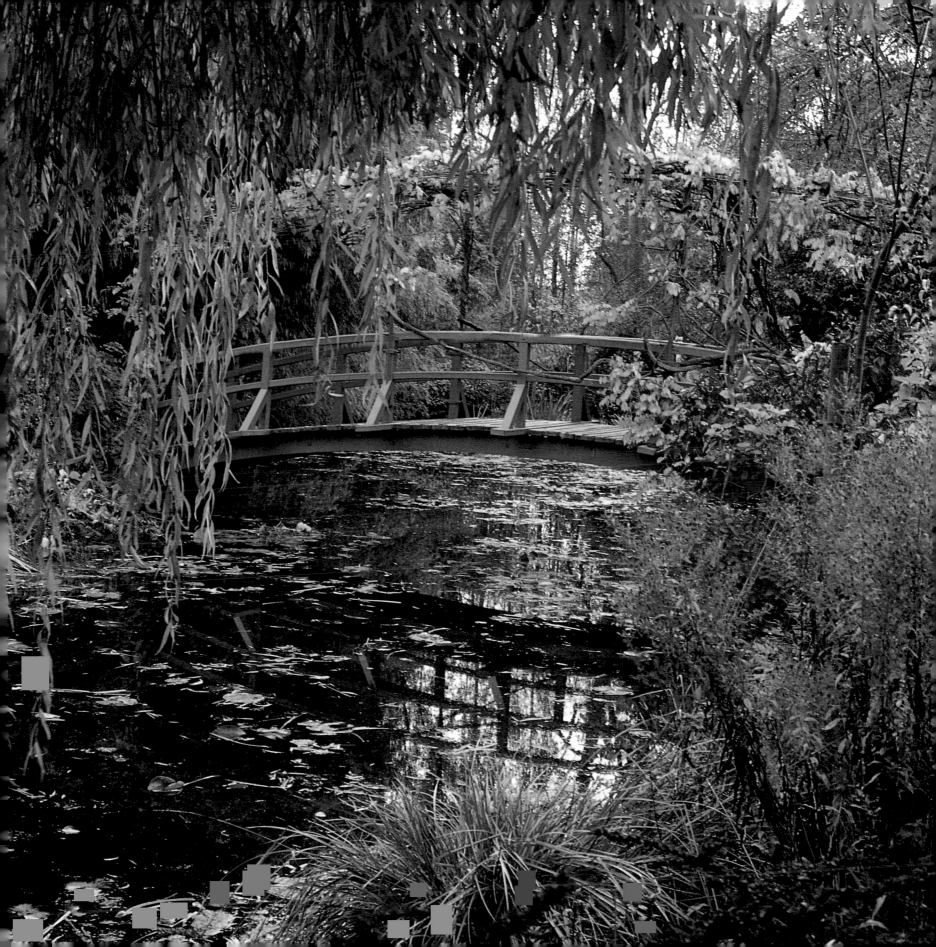

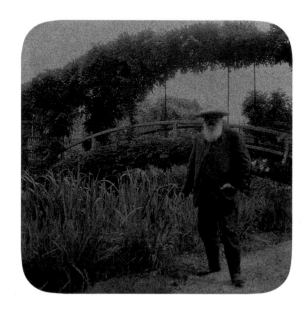

Yellow, white, purple, pink, and lavender water lilies bloomed from spring throughout summer. Rarer, tender water lilies were grown in a specially constructed cement basin at one end of the pond toward the smaller Japanese bridge, but without much success. Over the arches above the paths and up trees grew the roses 'Crimson Rambler' and the vigorous 'La Belle Vichysoise,' nine yards long, with clusters of small pink flowers, a rose that has disappeared from the catalogs of today, but is still grown in the garden. From stones taken from two benches which had previously stood opposite each other at the end of the Grande Allée, Monet made himself a bench that he placed on the far side of the bridge inside a semicircle of a bamboo thicket to protect him from the winds and from which he could contemplate the garden.

ABOVE *Monet regularly walked around his garden, at all seasons and in all weathers, keeping an ever-watchful eye on the progress of his plants and the work of his gardeners. Here he is photographed with the wisteria-covered Japanese bridge in the background, and clumps of irises bordering the pond in the foreground.*

RIGHT *As steamy as an overgrown jungle, the western part of the pond during a sudden summer storm with rain pelting down on it. To the left is the massive thicket of bamboos planted by Monet himself. Other "oriental" accents planted by him include the wisteria and the species irises along the banks.*

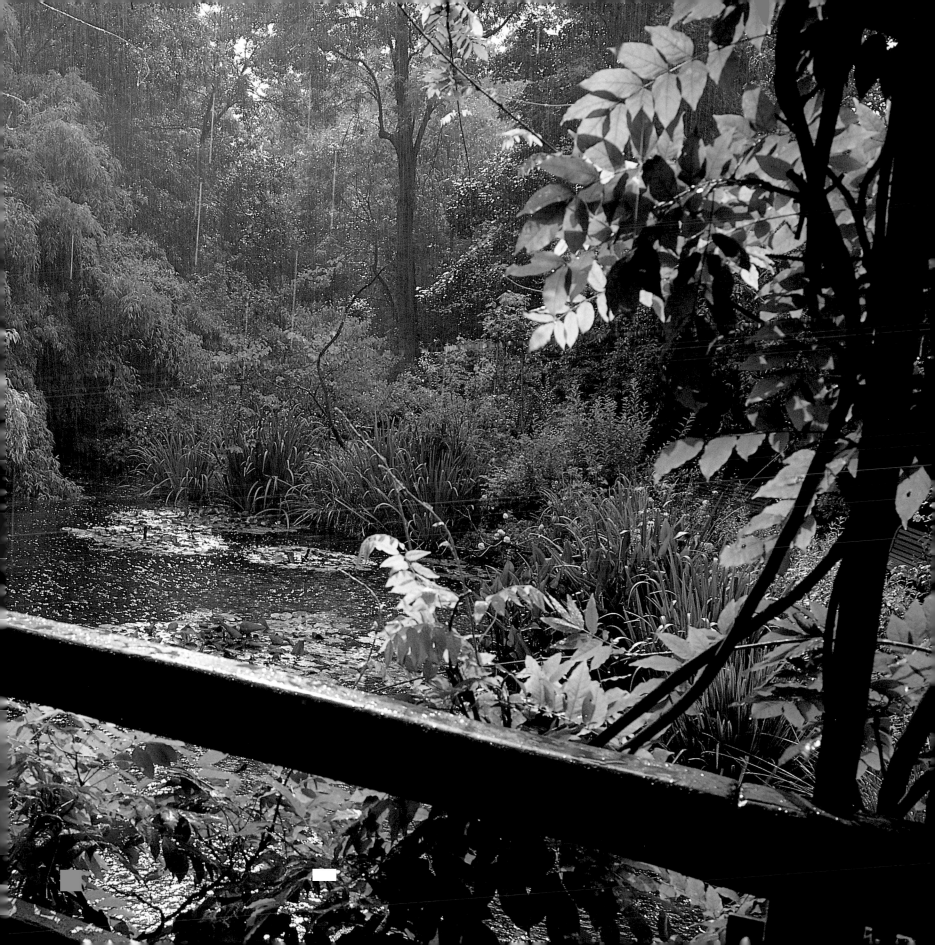

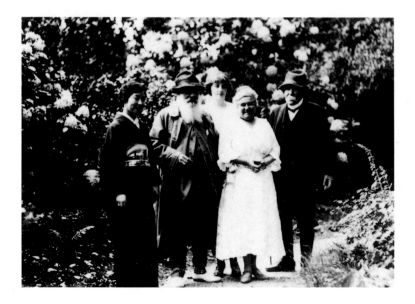

This watery setting was not only an artistic inspiration but also a social venue of which Monet was very proud. After lunch visitors were invariably escorted around the flowers, the greenhouses, and the garden, and on June 6, Monet's feast day, bonfires were built and lit by the pond. When the opera singer Marguerite Namara came to Giverny, she insisted on singing for Monet in the water garden, and a grand piano was dragged over from the other end of the village for the occasion.

One full-time gardener attended to the pond alone, aided at one stage by a boxing champion. Water lilies like having their feet warm, in other words to be planted near the pond surface. They also like their leaves to be spread out with plenty of room, so the gardener's job was to keep the clusters of leaves trimmed in circular rafts and, every morning, to clean the pond, remove the algae, deadhead the flowers, remove any dead leaves, and rinse the dust off the lily pads before Monet arrived with his easel and parasol. He is said to have spent hours day after day by the pond before picking up his brushes, in contemplation of the mystical centerpiece – those rafts of water lilies whose mysteries he sought to unravel. They were the real purpose of this garden: everything around was merely a decorative frame.

Monet's pond has perhaps been gazed into more than any other, by millions of eyes hoping to see what he saw. As a painter, he once described himself as a "hypersensitive receptor" and his painting a constant process of breaking down what he saw into particles of light and color. Clemenceau once said to him, "When I look at a

tree I see only a tree. But you, you look through half-closed eyes and think, 'How many shades of how many colors are there within the nuances of light in this simple tree trunk?'" For over thirty years Monet labored, setting himself that almost impossible task – to capture in paint the clear, luminous quality of an ephemeral atmosphere, to "produce the emotional and physical experience of being at the pond."

Having struggled his whole life to capture atmosphere filtered through air, he was now challenging himself to capture atmosphere filtered through water – even more elusive, for the surface of this trick mirror reflects and absorbs at the same time, the water lilies appearing to float both on clouds and on undulating rushes. It is gently psychedelic, a visual "trip." Monet himself put his "genius" down to a "submission to instinct." He wrote:

> It is because I rediscovered and allowed intuitive and secret forces to predominate that I was able to identify with creation and become absorbed in it . . . I have set up my easel in front of this body of water that adds a pleasant freshness to my garden; its circumference is less than 200 meters . . . soon I shall have passed my sixty-ninth year but my sensitivity, far from diminishing, has been sharpened by age, which holds no fears for me so long as unbroken communication with the outside world continues to fuel my curiosity, so long as my hand remains a ready and faithful interpreter of my perception.

What he did not anticipate then was that it was not his hands but his eyes that would fail him.

Fate deals out cruel ironies to geniuses to remind them that they are but ordinary men. Mirbeau developed circulation problems so severe that they prevented him from holding a pen. When Alice died in 1911, the light went out of Monet's life and began slowly to

ABOVE *A photograph shows Monet in the water garden with (from left to right) Madame Kuroki, his stepgranddaughter Lily Butler, his daughter-in-law (also his stepdaughter) Blanche Hoschedé-Monet, and Georges Clemenceau.*

RIGHT Water Lilies *(1903) – a tonal poem in soft yellows, blues, and greens. The feathery, filigree curtain of weeping willow trails delicately across the floating world of the water lilies.*

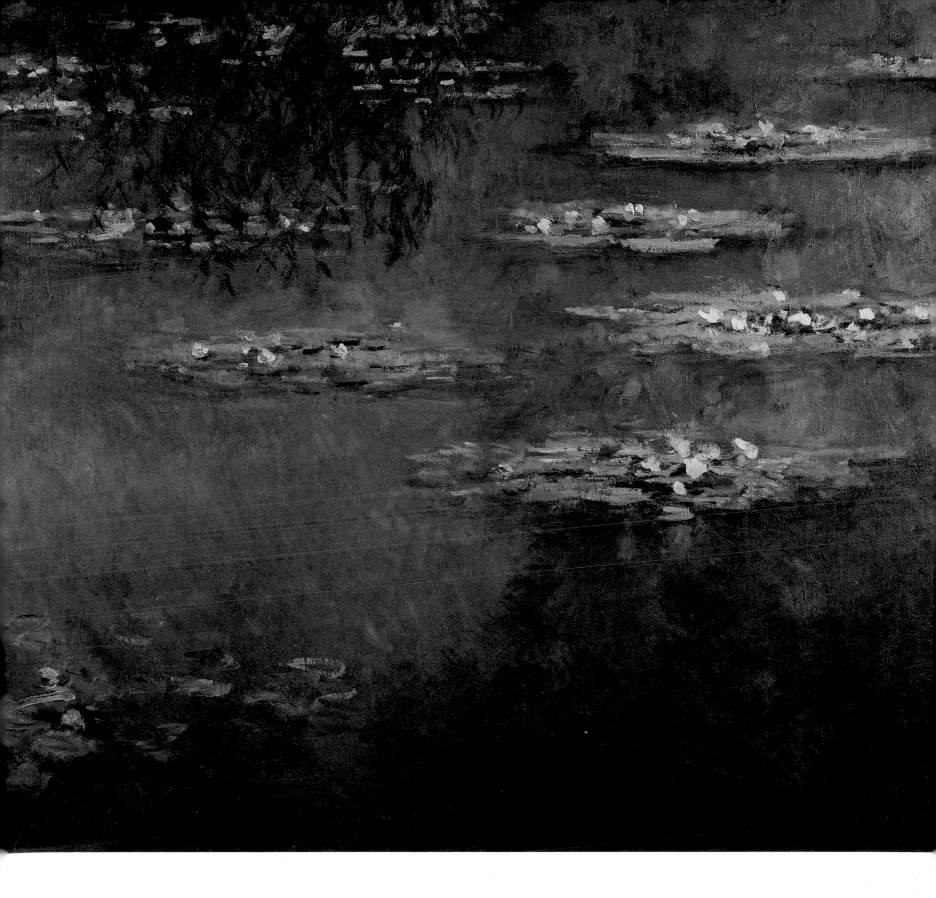

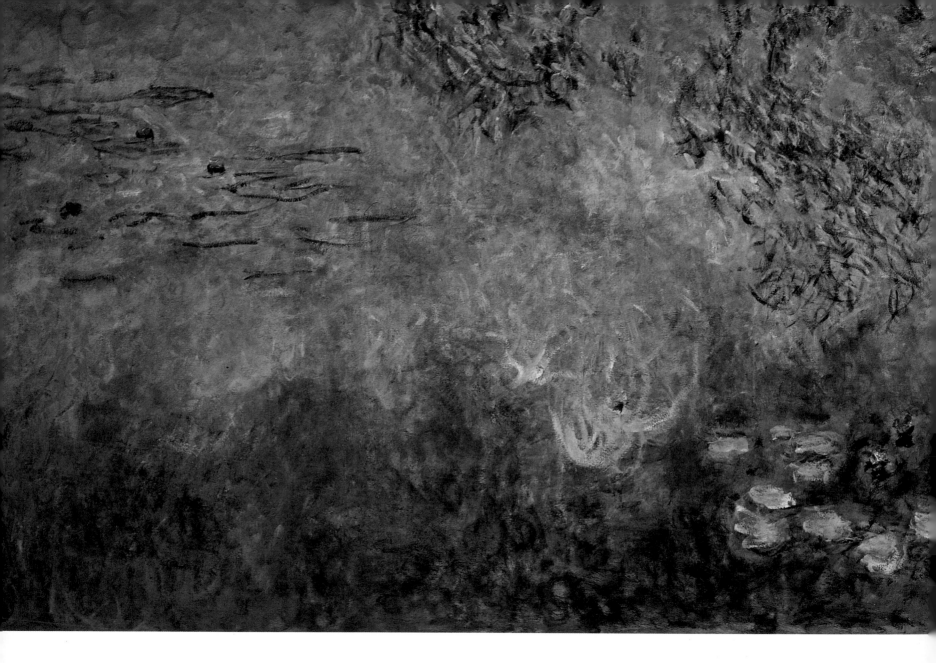

fade from his eyes. Diagnosed in 1908 with cataracts in both eyes which clouded his vision with a foggy, yellow-brownish filter, he deteriorated over the next fifteen years as he developed double cataracts. Until he finally agreed to have them operated on, his vision became as atmospheric and impressionistic as any scene he had ever painted. Crueler still was his inability to distinguish color – "my reds and pinks muddy and insipid, the rest of the tones escape me." He who had wooed, courted, and cultivated color began, to his horror, to paint like an "old picture," and flying into a rage would kick his boot through the canvases. For someone who described the process of painting in terms of wanting to "render what I feel,"

it was inevitable that an emotional reaction would follow if he could not. Refusing for many years to have the cataracts operated on, prophetically suspecting that an operation might fail and irrevocably destroy his vision or alter the way he perceived color, his life must have been a living torture. When, after his operation, Monet still complained about his vision, his oculist Dr. Coutéla wrote to Georges Clemenceau saying, "If he saw the way an ordinary bourgeois sees things, he would be more than satisfied with his vision." But Monet did not see the way other people see. One example of his hypersensitivity to light and color was described by Geffroy in an incident in London when Monet was painting and

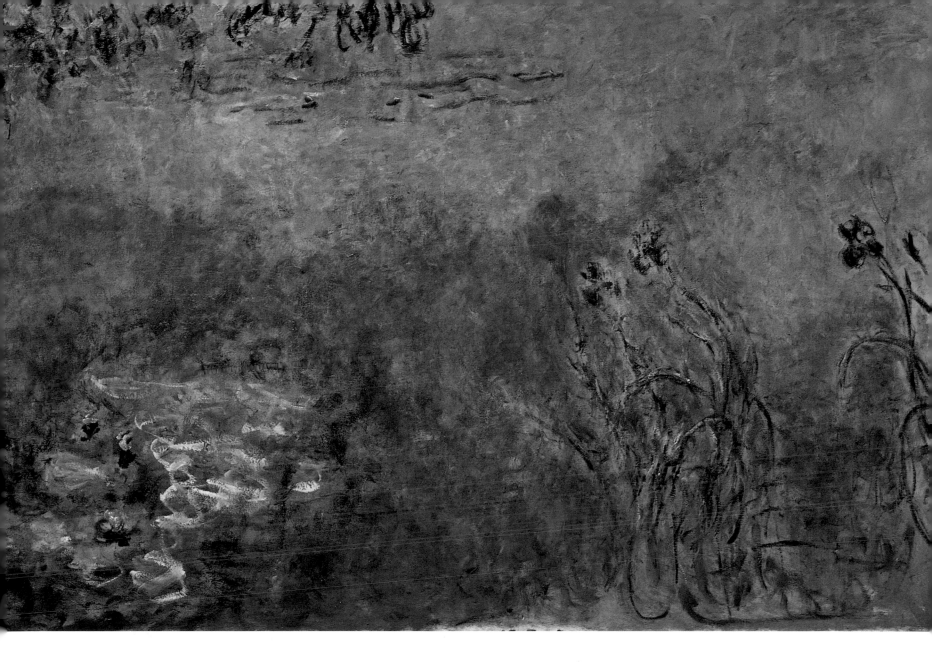

The Water Lily Pond with Irises *(c.1914–22) is one of the panels Monet offered to the French nation after the war.*

had to stop because the sun went in: "Suddenly Monet grabbed up his palette and brushes. 'The sun is out again,' he said, but at that moment he was the only one who knew it. Look as we might, we still saw nothing."

War broke out in 1914, the same year his son Jean died, but Monet would not leave Giverny. "If those savages are to kill me, it will be among my canvases – in front of my life's work," he wrote to Geffroy. Comforted, nursed, and looked after by Blanche, the two of them led a solitary existence gardening and painting. In the middle of the war, in 1916, he built a third studio, the Grand Atelier (when the first, the barn, had become the *salon,* he had a second

one built) to accommodate the large water-lily panels he had in mind. The yellow irises and agapanthus he painted at this time are delicate and spidery, and in the same serene and gentle blue and green tones as the water-lily panels would be – his "blue period" one might say. His wisteria of 1918–20 is reduced to light, airy streaks of mauve and yellow and pink, so abstract as to be barely identifiable.

At this time his friendships supported him. Clemenceau in

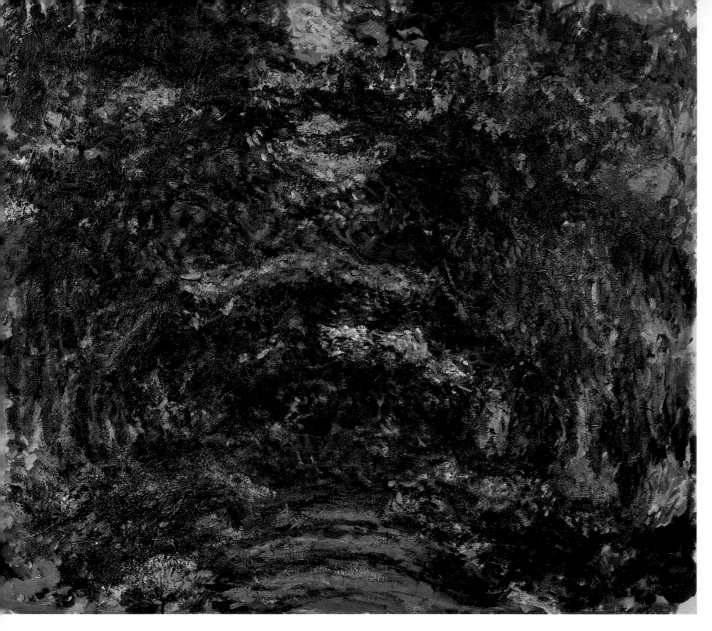

particular became his prop and stay. When they first met in the 1870s, the two men had nothing in common. Clemenceau remarked that, "I lived for politics and Monet lived solely for his art." Later though, through their mutual friend Geffroy, they became friends and valued, understood and appreciated one another as courageous men. "Fondness follows admiration," wrote Clemenceau about their friendship. Exactly the same age as Monet, Clemenceau also gardened, and the two shared a love of speed, of family life, gastronomy, and travel. The first time Arsène Alexandre visited Monet's garden in 1901, he noted the profusion, the teeming aspect that gave the garden its special quality. He had, he said, noticed this effect in another garden once: at Clemenceau's garden in Passy.

Prime Minister throughout the war, Clemenceau would slip away from the Front to spend an hour in the garden at Giverny with Monet where talk of war was forbidden. "I talked to him about his painting – he spoke to me about his flowers." When Clemenceau proclaimed the Armistice, Monet offered to give the water-lily panels he was working on to France as a "bouquet of flowers for victory and peace regained."

The year 1919 brought peace to the world, but chaos to Giverny, and for Monet, now nearly eighty and almost blind, much anxiety. He wrote to Bernheim Jeune, a dealer who had given him some "very pretty" Japanese trees. "All my gardeners who have been here for twenty years have left me – and it's complete chaos for me,

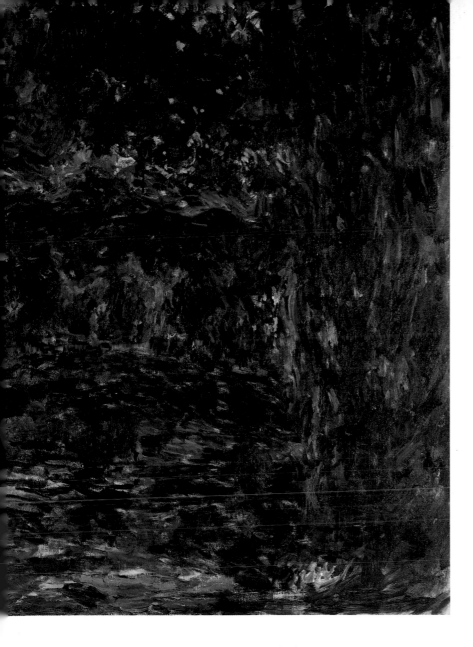

The Path with Rose Trellises, Giverny *(c.1922, far left) and* The Japanese Bridge at Giverny *(c.1923, left) are two examples of how, in the ten or so years following the deaths of Alice and Monet's elder son Jean, Monet's art and his garden were closely integrated with his emotional life. The garden seems at war with itself, the painter in turmoil, grieving and angry at a garden he can no longer clearly see.*

anthemis so large a "baby elephant could hide underneath," echinops, irises, stocks, and herbs – including, Clemenceau wrote to Monet, "five thousand gladioli all with beautiful green points and when they all shout Papa! maybe you'll hear them."

Raging against the dying of the light, the vigorous, fiery, abstract paintings Monet produced in the years immediately after the war were of a garden ablaze, full of vitality, a garden furiously distilled until only an arch remained – the curve of the Japanese bridge, the curve of the rose arches, the curve of the Grande Allée. The motif is repeated over and over in rich, dense colors. Long gone are the images of the domestic, quietly surreal gardens of his earlier years. Giverny is a garden in a gale, in a tempest.

Now Monet, who was sustained in his isolation only by his painting, was struggling, nearly blind, to finish the water-lily panels. Seated at his desk overlooking his glorious garden and the sea on an otherwise empty horizon, Clemenceau, knowing Monet's despair, wrote lyrical letters to him, propelling the old soldier on. In his rage and frustration at his failing eyesight, Monet destroyed parts of the water-lily panels he considered imperfect and altered others with disastrous results. By December 1922 he was screaming for the operation on his eyes, and in 1923 was operated on three times. Recovery was slow and, in another cruel twist of fate, he first saw everything in yellow and later, all in blue. Those very colors that he had loved all his life now mocked him. Finally, in 1924, he told Clemenceau that he could not deliver the panels he had promised to the nation after all. A furious Clemenceau withdrew his friendship. Monet, helped by corrective glasses obtained through his friend, the painter André Barbier, relented and in 1925 wrote to Clemenceau to say that France could have them no matter what state they were in, but only after his death. Now hanging in the Orangerie in Paris, they are arguably the most hauntingly serene poems to light ever painted – and perhaps to war, peace, and friendship, too. When Félix Breuil, whose domain at Giverny had been the water garden, retired, he never went back to look at his pond. He went instead to visit it in the Orangerie.

especially with the drought. I thought for a moment I was going to abandon my garden and Giverny. But all this is nothing. The signing of the peace treaty is a real relief." After the war, Félix Breuil went back to Mirbeau's father's property, Remalard, and was replaced by the very capable Léon Lebret, who would maintain the garden at Giverny as Monet did until his death in the next war.

Clemenceau returned to his roots in La Vendée and rented an isolated house on the Atlantic coast. Monet sent him plants by the thousand by train from Giverny, all of which he planted in the sand among the dunes by the sea. According to Clemenceau "it was a tempest of flowers; it is indescribable – roses by the billion." The garden was a jungle of simple flowers. There were clumps of

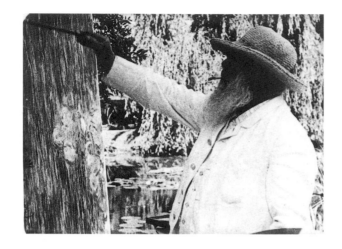

Monet began to fail in April of 1926. In November of that year, Clemenceau lunched with him. Monet, a smoker all his life and dying of a form of emphysema and a tumor of which he was unaware, had stopped painting and talked only of his garden. He told Clemenceau how he had just received a shipment of bulbs of his favorite flower, the Japanese lily, and that any day "two or three cases of very expensive seeds that would produce beautifully colored blossoms" would be arriving. "You will see all of this in the spring," he told Clemenceau. "I will no longer be here." But Clemenceau felt that, secretly, Monet didn't believe it. However, after two months of intense pain, Monet died at noon on December 5, with Clemenceau by his side. He had requested that he be buried without ceremony and that his gardeners should act as pallbearers. On the morning of December 8, Monet left his home for the last time. Clemenceau replaced the black shroud with a flowery cloth from the house, and the gardeners arrived, dressed in their work clothes. The coffin was hoisted onto the village's hearse cart, and Monet was taken down the road by his gardeners as dextrously as he himself had ever wielded wheelbarrows full of canvases or plants. The circle was almost complete. In the company of a few friends and family, Monet was lowered into the ground in silence. The soil of Giverny that he had worked half his life, and in his own way worshipped, now claimed him for her own.

ABOVE AND RIGHT *Monet strove to portray the endlessly changing moods of the water garden whose four quintessential elements are captured in a close-up – blue-green water alive with reflections, the delicate floating blooms of the water lily, their bold, distinctive rafts of leaves, and the delicate curtain of weeping willow.*

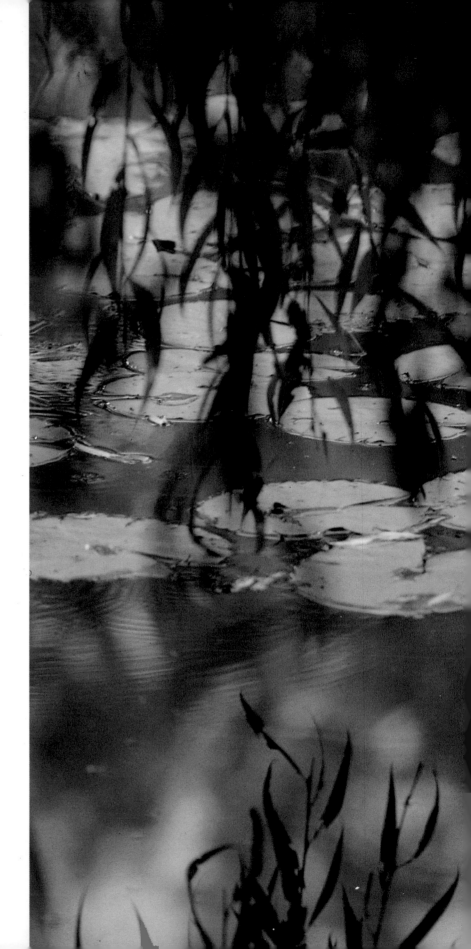

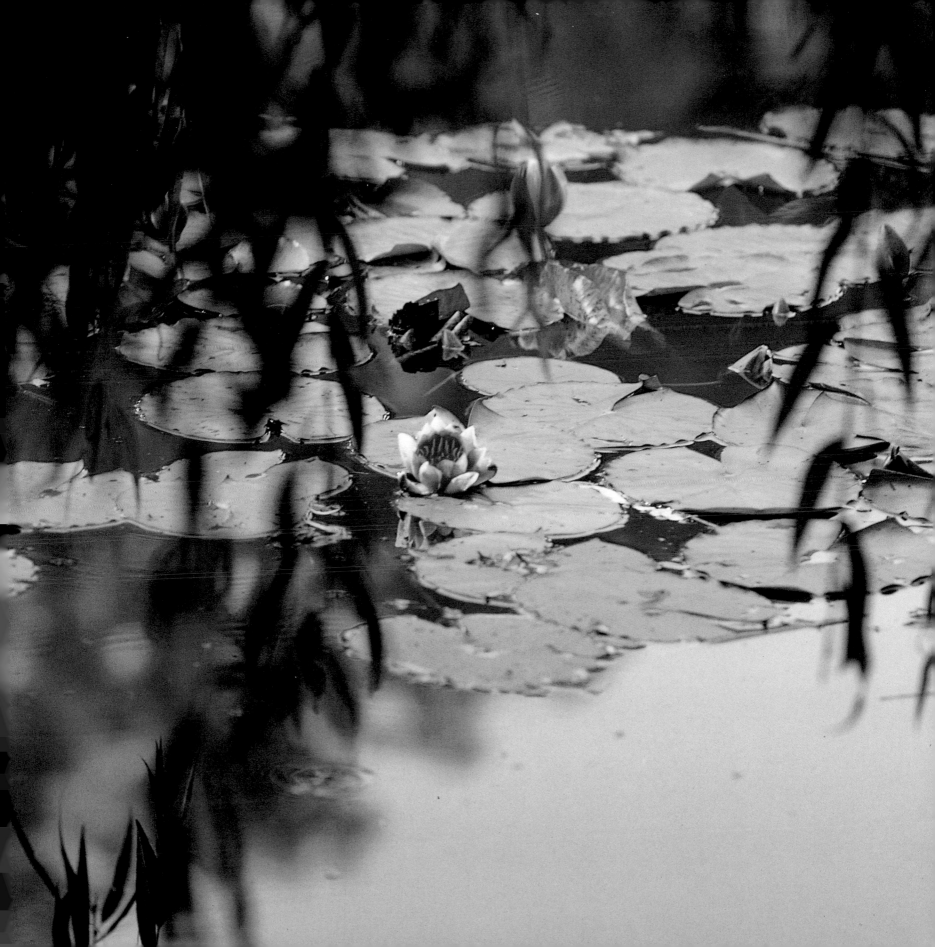

AS IF IN MOURNING

> *"The soul of the house has gone.
> Everything here emanated from him."*
>
> BLANCHE HOSCHEDÉ-MONET

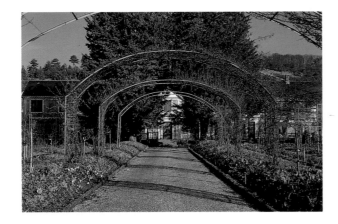

The garden drifted into its usual hibernation in the winter of 1926 unaware that Monet was no longer there to fret over it as he had for all of its forty-three years, and that he would not be present to orchestrate its reawakening in spring.

Monet was never tempted by what gardeners call "winter interest," so he did not plant his garden with berries or with trees with attractive bark to tide him over the flowerless months. He had the customary yellow winter jasmine, Christmas roses, snowdrops, and scillas dotted about the garden, and they were brought indoors to brighten up the rooms of the house. These were followed by crocuses and the first primroses, which he gathered from the nearby forest of Bizy and introduced to the garden. But they were only early harbingers of spring, and the garden would not get into its stride until much later, in March and April, with successive waves of narcissi, tulips, and irises.

PREVIOUS PAGE *It is November, but so warm still that a gardener hangs up his jacket on one of 'The Queen Elizabeth' standard roses while he works.*
ABOVE *Winter draws to a close. Green shoots begin to push through, and the earliest winter pansies are already in bloom.*
RIGHT *The water garden is garnished only with snowdrops. Willows specially planted along the banks of the stream provide excellent garden stakes.*

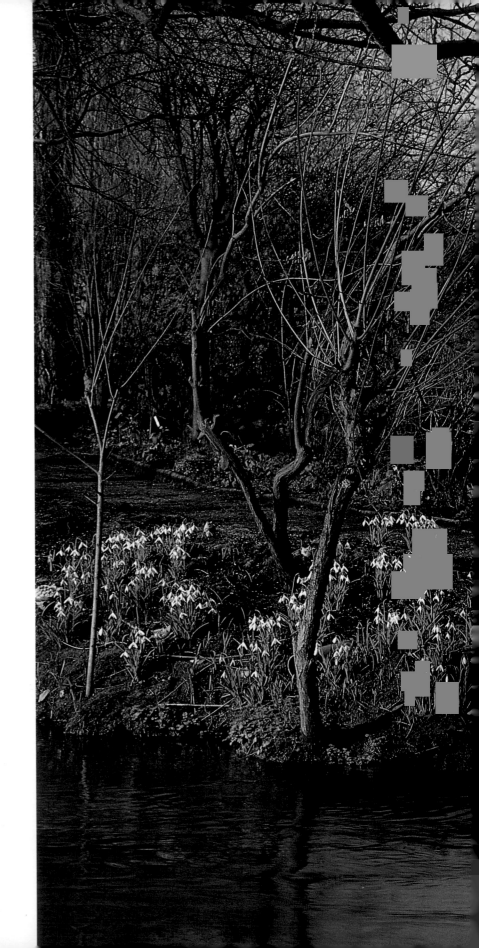

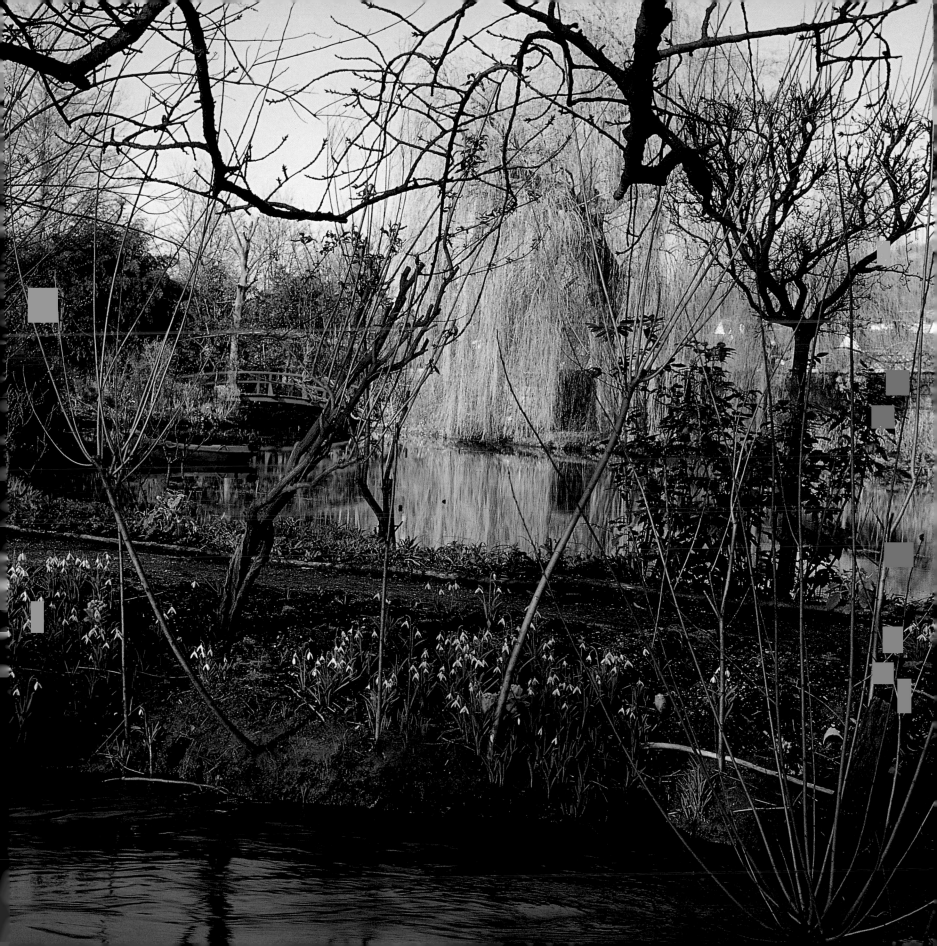

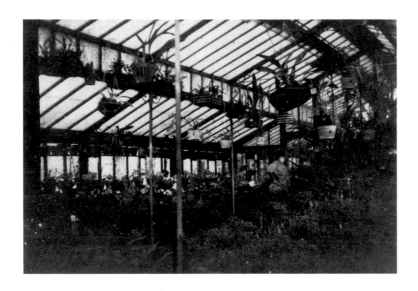

ABOVE *Whenever he was abroad painting in winter, Monet missed the delights of his greenhouse. In March 1895 he wrote to Alice from Norway of his longing to see it again: "I hope that she will still be beautiful. What a joy my return will be for me!"*

BELOW *The water garden was flooded for weeks when the Seine burst its banks in January 1910. "Monet's despair," reported his wife, "like the Epte, will not abate . . ."*

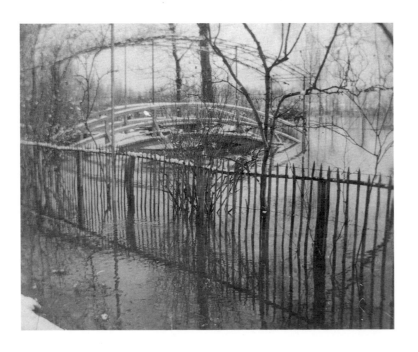

Winter in the garden at Giverny was never for Monet a season to be savored. The light was always too good elsewhere, and in the early years, he would disappear for the winter on various painting campaigns. After the death of his stepdaughter Suzanne in 1899, he felt he could no longer leave his inconsolable wife for lengthy periods, so he mostly stayed home. And then, after Alice's death in 1911, when he was free to travel again, his eyes had begun to fail him. The moment for long journeys had passed and he stayed put, soothing his rheumatic old bones in the warmth of the greenhouse.

Monet's real winter garden lay in that greenhouse, built in 1893. He first wrote about it to Caillebotte on June 11 that year:

> I looked for you at the flower show and thought I would meet Godefroy but saw nobody. I had some questions to ask about a greenhouse – never having had one, I don't know which builder to go to and if it's better to get one with double glass in wood or metal, or with single glass . . . my intention is to have a large enough one to have a cold and a temperate section . . . write to me and advise me on my greenhouse – approximately 12 meters by 6 – a Dutch greenhouse.

In September, another letter reports: "I am in full construction of the greenhouse. It's a difficult job and stops me from working. I will have done absolutely nothing this summer."

The new greenhouse allowed Monet to indulge his taste for the exotic, which added yet another string to his horticultural bow. Painting his Rouen Cathedral series in 1894 from the window of a millinery shop (where he worked squashed behind a screen because the sight of a man might deter ladies buying hats), Monet became acquainted with Monsieur Varenne, the director of the Rouen botanical garden whose display of orchids Monet found splendid. Varenne gave Monet advice and helped him fill his new greenhouse with "passifloras, two very curious nasturtiums, and a beautiful begonia," dispatched in the usual way to Giverny by train. The begonia proved so vigorous it had to be cut back regularly to stop it pushing through the roof of the greenhouse and breaking the glass. In the temperate area of his greenhouse, Monet had an impressive collection of orchids and exotic ferns.

Despite the comfort and interest he derived from his greenhouses – a second smaller one was built later – winter for Monet was synonymous with worry. When he was at home, he worried about his garden, and when he was absent, he worried even more. His

painting campaigns took him away, sometimes for months, yet scarcely a letter arrived home without some reference to the garden – a query, a small anxiety, a gentle reminder. All the minutiae of running a garden preoccupied and worried him when he was not there to supervise it personally. He fretted about his bulbs, his tender plants, his greenhouses. Had they been heated during cold weather? Had his dahlias, tree peonies, and tigridias been protected from frost? Had anyone thought to water during a dry sunny spell, or to shade the greenhouse? Winter was all about protecting what was there and, as the days grew warmer, making preparations for spring. "Beware of heavy rains, and the ensuing moles and mess; make sure that the compost is well rotted."

A perfectionist in his art as in his garden, Monet left nothing to chance even when he was at home. His friend and neighbor, the American painter Lilla Cabot Perry, recalled the occasion when a new heater was installed in one of the greenhouses. Monet announced to his wife that he was going to stay up all night to make sure it was working properly. Alice insisted on joining his vigil – as did the daughters – and so it transpired that the whole Monet household sat up all night with the gloxinias.

A record of how Monet planned his garden and organized his gardeners does not exist. There are no planting plans or notes other than the names of plants scribbled in a sketchbook, scraps of letters, visitors' accounts – mostly those of art critics who knew nothing about gardens. Garden enthusiasts such as Octave Mirbeau, Georges Truffaut, and Jean-Pierre Hoschedé all wrote about the garden in spring, summer, and fall, but none of them mentions winter. However, in addition to Monet's letters, one valuable document pertaining to the winter garden survives. In February 1900 or 1901, on the eve of one of his increasingly rare trips abroad, Monet prepared a list of instructions for head gardener Félix Breuil:

> Sow approximately 300 pots of poppies, 60 pots of sweet peas, approximately 60 pots of white argemone and 30 yellow. Blue sage – blue water lily in a pot (greenhouse). Dahlias – *Iris kaempferi* [now *I. ensata*]. From the 15th to the 25th start the dahlias into growth. Take cuttings from the shoots before my return; think about the lily bulbs. If the peonies arrive, plant them immediately weather permitting, taking care initially to protect the young shoots from the cold and the sun. Do the pruning – don't leave the roses too long except for the older thorny varieties. In March, sow the grass, prick out the little nasturtiums,

and take good care of the gloxinias, orchids, etc., in the greenhouse as well as the plants in the cold frames. Plant the borders as agreed. Put wires up for the clematis and for the rambling roses. In case of bad weather, you can make reed mats – but make them lighter than the earlier ones. Plant the rose shoots from the water garden in the manure around the poultry yard . . . plant immediately the *Helianthus latiflorus* [*H.* × *laetiflorus*] in good-sized clumps and activate the chrysanthemums into growth . . . don't forget to put sulfur cloths on the frame of the glasshouse.

This dispels any notion that Monet might have gardened looking down from a window, for obviously no detail escaped him.

As well as the day-to-day concern over the welfare of his plants in cold and wet weather, winter sometimes brought more dramatic conditions, and occasional calamities. When floods followed by freezing temperatures turned the water garden into a skating rink, Monet would write to Alice asking that the children respect the borders as they slid joyfully about. On another occasion, during the winter of 1910, the Seine burst its banks, causing the worst floods France had known for a century. The water garden was completely submerged for over two months. The Japanese bridge as well as the little white wooden bridge under the rose arches had to be battened down with chains, and, although in shreds, were still there to be repaired when the floods finally melted away. Monet, believing everything that the incorrigibly pessimistic Breuil told him, walked around in a state of deep despair, thinking his whole garden was lost. His glumness cast a long shadow over Giverny that winter and was extremely trying for his wife and family. As the flood subsided, it left mud, straw, corks, and even dead cats in its wake. Monet described the devastated water garden as a real sorrow and it took two months of anxious waiting to see what plants had pulled through. Fortunately, the damage turned out to be overestimated. Alice reported that rot had destroyed the irises and many other plants had been lost. The trees, shrubs and rhododendrons, however, survived, although they bloomed poorly that year. Not in the least consoled, Monet moaned: "What calamity and only miseries!"

Another disaster struck a few years later when a cyclone hit the water garden, knocking over one of the weeping willows. It was subsequently righted and propped up with iron supports and ties.

The winter that fell on the garden with Monet's death lasted metaphorically until it was restored fifty years later. Monet left Giverny to his younger son Michel, but it was his stepdaughter Blanche (also widow of his elder son Jean) who lived there until the end of her life. She continued to care for the garden, maintaining it as best she could. For a while, the garden carried on of its own accord. Félix Breuil had retired at the end of World War I, but had been replaced by another devoted head gardener, Léon Lebret, who was there for thirty years until his death during the Occupation. With a far smaller budget, this disciple of Monet's was at least able to maintain the spirit of Monet. But, with no one at the helm, the garden gradually faded; colors and plants crept in that did not belong there, many that did disappeared. Without Monet, the garden remained static, a living museum. Plants that died were not replaced; it was neat but there were fewer and fewer flowers. Blanche was the last direct link with Monet, and when she died in 1947, Monet's presence slipped away for ever.

Throughout the 1940s and 1950s, Michel Monet sold his heritage of paintings in lots of ten through his girlfriend's gallery in Paris to finance the safaris which were his real passion. The house was empty, no money went into the garden, and only one gardener lived in the gardener's cottage. If ten gardeners working full time under Monet's keen eye were not enough, what could one gardener (who by all accounts was not as conscientious as he might have been) achieve? He scarcely had time to mow the grass and keep the weeds down. Claire Joyes, the art historian and wife of Jean-Marie Toulgouat, Monet's step-great-grandson, who still lives in the village, recalls that this gardener had laid out a fine collection of humorous garden statues on the veranda. His attempts at keeping the weeds down by rototilling the flowerbeds has given the present-day gardeners a never-ending problem. Parts of the garden now risk being overrun with *Helianthus rigidus,* which anarchically sends up a new plant from every fragment of cut root.

At the age of eighty-two Michel was killed in a car accident. Neither of Monet's sons had children, so Michel bequeathed Giverny to the nation through France's Académie des Beaux-Arts. As a bequest, Giverny was something of an embarrassment; the budget available for it was wholly inadequate, and both house and garden seemed almost beyond redemption.

The Académie turned to the indefatigable Gérald van der Kemp who, together with his equally energetic American wife Florence, had masterminded the restoration of Versailles by cultivating prominent American benefactors. There is no question that, without this formidable duo, Giverny would by now be history. As at Versailles, Van der Kemp set about finding Americans who would donate money to the restoration of Giverny. Charitable contributions are tax-deductible in the United States; moreover, Americans – always a generous race – felt a particular affinity with Monet, and many were only too eager to give. Attracted by Monet, prominent American painters such as Frederick Frieseke, John Leslie Breck, Louis Ritman, and Theodore Robinson, to name but a few, had established a thriving artists' colony in Giverny. One of them, Theodore Butler, had married Monet's stepdaughter and favorite model, the ill-fated Suzanne, and then upon her tragically early death, her sister Marthe.

Motivated primarily by indignation that in all of France not a single artist's house had been preserved intact, Van der Kemp obtained permission from the U.S. administration in Washington to place Giverny under the umbrella of the Versailles Foundation. This made it possible for United States citizens to make tax-deductible donations to Giverny. Arriving at the Metropolitan Museum in New York one day, he noticed the halls decked with fresh flowers. When he asked how they came to be there, he was told they were there in perpetuity, thanks to a donation from Lila Acheson Wallace, co-founder of Reader's Digest. Van der Kemp immediately organized a lunch with this patroness of flowers who, without being asked, produced a check for one million dollars by the time coffee was served. Many other checks followed, including donations from the French.

American funds restored Giverny just as a century earlier they had made it possible for Monet to transform it from a simple orchard, potager, and cottage garden to the sophisticated and inspiring masterpiece it became. In spite of his dealer Paul Durand-Ruel's efforts on his behalf in Europe, Monet would have died poor but for the recognition he received from the Americans in the decade after he moved to Giverny, when Durand-Ruel mounted exhibitions of Monet's work in Chicago and New York. The struggle, however bitter for Monet, was equally hard on Durand-Ruel, who stayed the course for thirty years before Monet's paintings began to sell. "Had I not been the son of a dealer and brought up in the business, I would never have been able to sustain the battle that I had undertaken against public taste," Durand-Ruel told Monet's biographer Geffroy many years later. "Had it not been for the Americans, I would have gone under. They didn't sneer, they bought

– modestly, perhaps, but they allowed Monet and Renoir to live."

They would do the same for Monet's garden a hundred years later. Having rescued Monet from the cold light of impecunity in the early 1890s – allowing him to buy his house and create his water garden and greenhouses – they stepped in once again and brought the derelict garden back to life. Their purpose was, of course, to restore the garden as faithfully as possible to the way Monet had it. But Giverny was also intended to serve as a place of pilgrimage and inspiration to painters, many of them American. Blanche told Stephen Gwynn in 1933 that, in Monet's lifetime, no one ever painted in the garden but Monet. Even Monet gave up portraying figures in the garden. Now, thanks to the restoration, Giverny is once again an artist's garden – though today's artists are the schoolchildren, students, and amateurs who come to pay homage to Monet.

A gardening enthusiast, Van der Kemp took classes at the École d'Horticulture at Versailles, where he became acquainted with a young gardener, Gilbert Vahé, who had completed his training and was working in the school's garden. In 1976 Vahé was hired to help Van der Kemp restore Giverny, and he has run the garden ever since.

As though being created from scratch, both the water garden and the flower garden had to be completely overhauled. With the exception of the trees and shrubs, the whole flower garden was razed and rototilled, the beds were retraced and the paths relaid. The company hired to lay the foundations for the paths and the new clematis arches over the paintbox beds made a grave mistake which Vahé, who arrived three months later, was powerless to change; for this, Van der Kemp has never forgiven them, nor was he in a financial position to rectify the error. Instead of using a mixture of silica, sand, and large stones as foundations for the paths which they dug 8 inches deep, they poured in a mixture of plaster and marl – which spelled disaster for a garden that was already very alkaline. Excessive alkalinity inhibits plants' absorption of iron and other trace elements, causing the leaves to lose their color and turn yellow. To remedy this deficiency, it is now necessary to add traces of iron regularly to the water supply to treat the whole garden systemically through the leaves, adding larger quantities to treat the roses growing around the foundations of the clematis arches.

Donations covered the cost of restoring the house and garden, but the budget was extremely tight. Gilbert Vahé remembers that they started from nothing. Friends gave him seeds, and they did the rounds of local fish merchants to beg for crates in which to sow and propagate. The team used ingenuity in other ways. Vahé devised a practical and economical solution to staking plants such as dahlias by using *fers à béton* – steel reinforcing rods made for the building industry – and painting them green. They are still in use today.

A well was dug deep underground to supply the flower garden with an independent water supply. All the borders had to be replanted. Except for the original crabapple tree (*Malus floribunda*) in front of Monet's house and the double row of lime trees under which the family was so often photographed, the only perennials left from Monet's time were an aster that no one can identify, but which refuses to die, and the invasive *Helianthus rigidus*.

In restoring the planting, Van der Kemp and Vahé could draw on innumerable black-and-white photographs and two sets of autochromes. One set was taken by Monet's amateur photographer friend Étienne Clémentel, supposedly around 1917, and the other for the magazine *L'Illustration* around 1924 and published in 1927, the year after Monet's death. For color, according to Vahé, they relied most on the recollections of André Devillers, who was Georges Truffaut's assistant after World War I and who later became director of the nursery. Devillers used to accompany Truffaut on his visits to Giverny and first met Monet in 1923. In 1976 the Truffaut nursery was about to send Van der Kemp all the records of the plants Monet ordered but, just two months before they were due to arrive, they were destroyed in a fire in which the whole nursery burned down. But at least Van der Kemp had something to fall back on. Georges Truffaut left a comprehensive account of the plants in an article he wrote for the magazine *Jardinage* in 1924. Invaluable help was also received from Jean-Marie Toulgouat and Claire Joyes, who had obtained from Jean-Marie's Uncle Jimmy (James Butler, Suzanne Butler's son) a list of irises and his own personal recollections of the garden. Claire Joyes, having married into the Monet family, and as guardian of the Monet archives, has done much else through her advice and writings to illuminate the enigmatic Monet. Other sources of information included reminiscences of local people, journalists' descriptions, and the chapter devoted to the garden in *Claude Monet, ce mal connu*, in which Monet's stepson Jean-Pierre Hoschedé recounted anecdotes and listed Monet's likes and dislikes. Princess Matsukata of Japan, by then in her eighties, who as a young woman had sent tree peonies and lilies to Monet and had visited in 1921, also helped reconstruct some of the planting. All in all, it was a painstaking task to try to piece together a picture of a garden which had taken forty-three years to construct and perfect, but which,

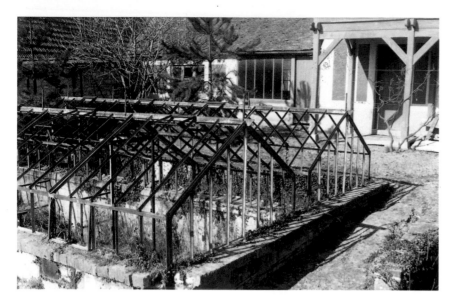
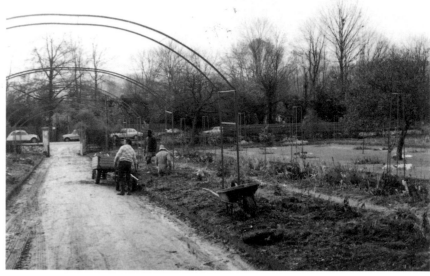

A series of snapshots taken during the three-year restoration of the garden. Virtually a whole new garden was created.

ABOVE *The flower garden, with one of the greenhouses as it was at the start of the restoration, and work in progress along the Grande Allée and among the flowerbeds.*

RIGHT *Work in the water garden to rebuild the Japanese bridge and line the pond with corrugated iron to reinforce the banks and protect against muskrats.*

AS IF IN MOURNING

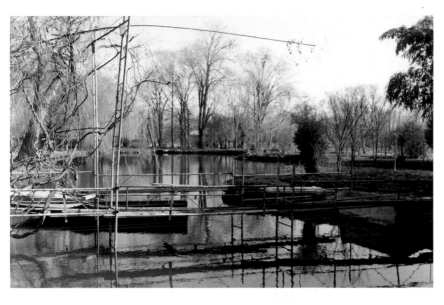
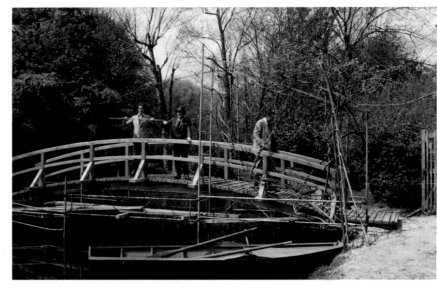
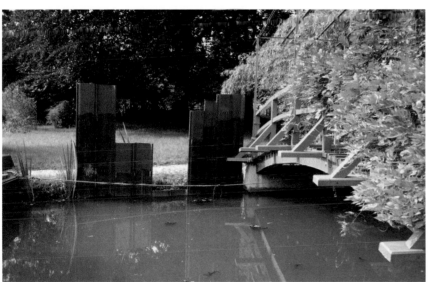

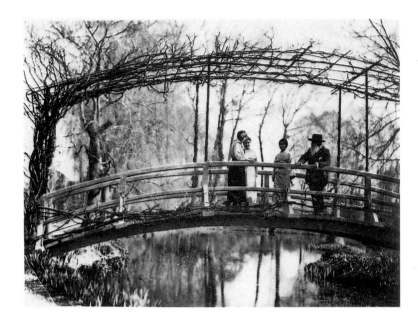

fine wire mesh. The gardeners are now too busy in spring to remove these wire mesh guards but if they are not removed before the lilies start growing, the new shoots are damaged. So the gardeners now have to rely on the metal pond lining and traps to curb the depredations of the still-plentiful muskrats.

When refilled from the river, polluted by effluent from the factories upstream, the refurbished pond was dank and rank. The solution to this problem was to find a new source. They sank a borehole deep into the limestone and installed a pump which now provides fresh, clear water – not one drop now comes from the Epte.

The restoration took three years to complete, and the garden was finally opened to the public in September 1980 amid much excitement. Wherever possible, the gardening team tries to obtain the original plant varieties and stays faithful to Monet's colors. In many instances, the old varieties are no longer listed for sale; where they have been superseded by newer forms that are similar, the gardeners use these instead. The same color schemes remain in each of the beds permanently, but if varieties become unavailable or a new selection appears, Gilbert Vahé will introduce slight changes. The new garden at Giverny brings a consciousness of having to dazzle the public continually. To keep the visitors coming and to finance the enormous cost of running the garden, strict authenticity has been sacrificed in favor of bigger flowers and longer blooming seasons. But no garden stands still, and who is to say whether Monet, always keen to obtain the latest novelty, would not have tried some of the newcomers himself? After all, he had his own trial area near one of the greenhouses, where he grew new plants to see how they fared and how they would fit into the scheme of the garden before planting them out.

after Monet's death, drifted without a captain for exactly half a century.

A great deal of work also went into restoring the water garden. The aspens and poplars that were there when Monet made the water garden and which he left had been removed in the early 1960s because they had grown so tall they shaded the water. Some twenty years later, poplars planted in a nearby field had to be felled for the same reason. The Japanese bridge had rotted and collapsed into the water, so an exact copy was made from the beechwood that forests much of eastern Normandy. The rose trellises were rusty and had to be replaced. A wisteria at the other end of the pond from the Japanese bridge had fallen in the water and over a period of months had to be gradually winched out and propped up on a long horizontal trellis, on which it remains to this day.

The pond itself had filled in with silt, and weeds obscured the banks which had, over the years, quietly slid into the water. The pond had to be completely redug and the banks reinforced. They were lined with corrugated iron five feet deep, for by far the greatest threat to the water-lily garden comes from muskrats, originally brought from the United States during World War II for cheap fur farming. The war ended: muskrat coats went out of fashion, but the muskrats stayed and multiplied. Their favorite food? Water lilies. The pond lining provides a barrier to protect the plants from these lily-loving pests. And until recently the pond was drained each fall so that the water lilies could be protected during the winter with

The garden in Monet's time had an altogether wilder look. Even when it was first restored, the planting was more natural-looking, but Giverny's very success as the most-visited garden of its kind in the world has necessitated several compromises. It is vital both to accommodate the enormous influx of visitors and to make sure that the show goes on. The paths have been widened, cemented, and edged with brick. The hordes of people have to be shepherded along selected paths, with restricted access to many parts of the garden in order to preserve it. A low-voltage wire fence was installed at one point around the bamboo thicket in the water garden to stop people from walking through it and crushing all the new shoots.

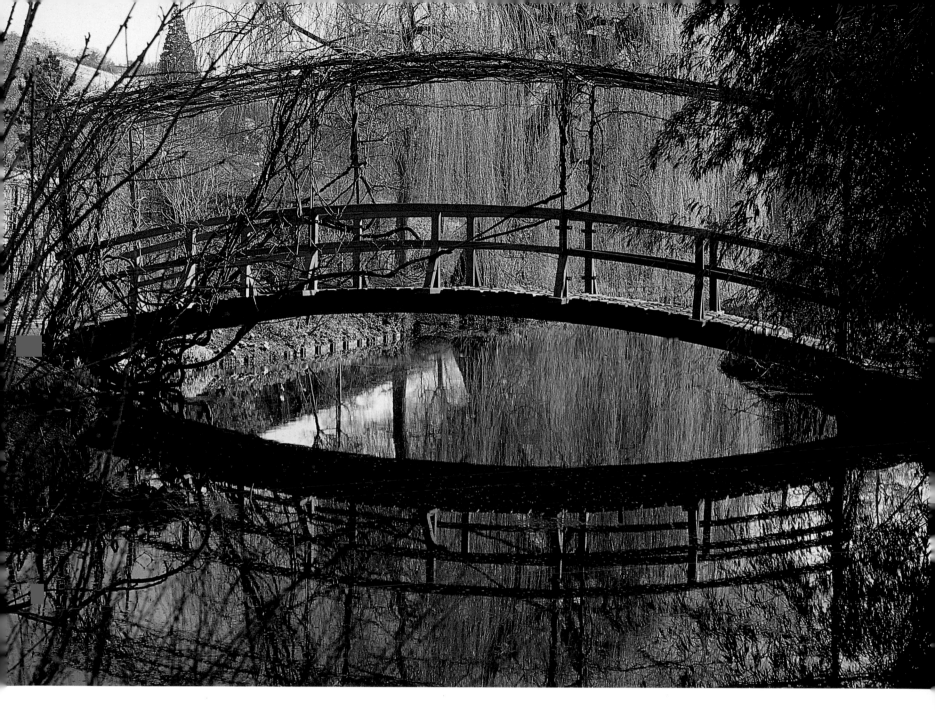

OPPOSITE *Madame Kuroki and Monet photographed with Blanche Hoschedé-Monet and Monet's stepgranddaughter Lily Butler on the wisteria-capped Japanese bridge in 1921.*
Hundreds of iris shoots can be seen sticking through the banks of the river. In 1906 the long-suffering Alice was hoping that she and Monet would go abroad that winter, but, as she wrote to her daughter Germaine, "he [Monet] is only waiting for the first green shoots to appear at the pond so as to start painting."

ABOVE *A reproduction of the bridge graces the pond. In the background is the weeping willow – survivor of the 1923 cyclone – planted by Monet. The corrugated-iron muskrat barriers that now line the banks of the pond are clearly visible.*

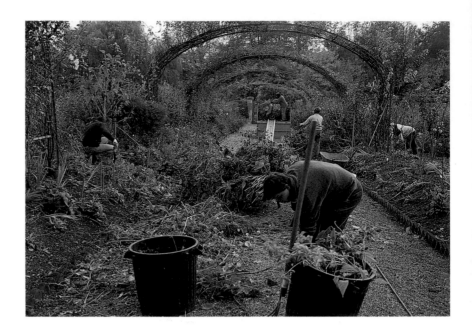

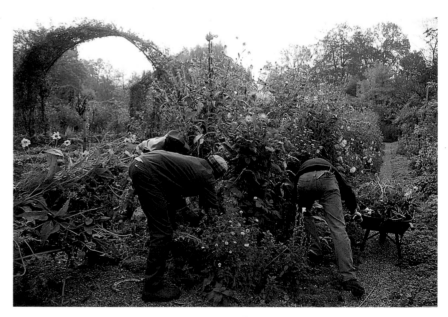

The gardeners, too, have to work inside chained-off areas where the public is not allowed. On some days the garden becomes so congested that it is impossible for a mouse, let alone a wheelbarrow, to squeeze by.

The garden shuts its doors to the general public every year on October 31 and remains closed for five months. No sooner has the key turned in the lock than preparations for spring begin. From then on the gardeners race around the clock to get the garden ready for its reopening on April 1. They switch from tasks of nurturing to those of demolition. The illusion that everyone has worked so hard to build up and maintain all summer is suddenly dismantled with the speed of light; in a race to beat the frosts, the garden vanishes faster than the Big Top when the circus is over.

On November 2, the transformation of the garden begins. The posts that seal off the paths are taken down, and a large pickup truck backs up the Grande Allée. A ramp goes up, and during the next month, the truck swallows up the whole of the flower garden.

The beds are stripped. On the first day, the tender plants are dug up and collected from the garden to overwinter in the large purpose-built greenhouse across the road. They include all the plants grown in pots such as plumbagos and daturas, and those planted out in

ABOVE LEFT *The garden's magnificent annual display has been ravaged by four nights of severe frost. The late-flowering helianthus and cosmos will be cut down when the garden closes on October 31.*

ABOVE *The decimation of the Grande Allée begins on November 2. Foliage is cut down, piled onto wheelbarrows or packed into bins, and loaded onto the pickup truck which takes it away every evening.*

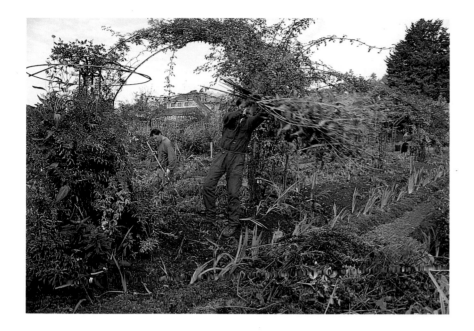

ABOVE *Whenever possible during the rush to clear the borders before frost hardens the soil and kills the tender plants, the most precious specimens are carted off to overwinter in the large greenhouse.*

ABOVE RIGHT *This wheelbarrow will make dozens of journeys during the clearance of the garden. Every Friday evening, all the gardening equipment is cleaned and put away for the weekend.*

the garden, such as agapanthus, felicias, and solanum, as well as a *Cornus florida* from the water garden, which is also dug up every fall and replanted again in spring.

On the second day, they start digging up the dahlias, including the 150 *Dahlia* 'Jet' that border both sides of the Grande Allée. All are dug up and brought to the garage, where they are laid out by variety and left to dry for eight to ten days before they are stored in the cellar beneath the garage, on a layer of peat.

On Day Three, work begins on the beds in front of the house and the Grande Allée. The pink and red geraniums and all the annuals and biennials are dug up and thrown away. The foliage of the larger perennials such as the asters, *Solidago canadensis*, helianthus, and peonies is cut down. The sweet rocket, oriental poppies, anchusa, and primroses are merely neatened and left in place, as they would not withstand the drastic trimming meted out to the other perennials. The stakes and removable plant supports are also taken out, cleaned, and stored away. If they have time, the gardeners dig up the shrubby tree mallows, which are not entirely hardy, and cart them off to overwinter in the greenhouse across the road. If there's too much of a rush, they leave them out, protected with layers of ivy; three out of four survive the winter.

When all the annuals and biennials have been removed, the perennials cut down or trimmed, and the roses tidied up, the gardeners can turn their attention to the gladioli. These are dug up and left to dry for a few weeks in the cool of the cellar, leaves and all, in numbered boxes according to their flowerbed number. When they are dry, the leaves are removed, and the new corm is cut away from the old.

The ruthless efficiency of the clearance operation leaves little room for conservation or sentiment. However, not quite everything is thrown away – any sunflowers, dahlias, and gladioli still in flower are gathered into bouquets by the gardeners as they clear the borders and taken home that evening. Everything else is piled on the wheelbarrows and wheeled onto the truck. At the end of each day, the truck heads for the tract of land near the Île des Orties where Monet's boathouse used to be. It is now the garden garbage dump, where everything is burned.

Giverny benefits from a sophisticated watering system which must be "put to bed" for the winter just like the rest of the garden. Low- and ground-level sprinklers are protected from freezing by a covering of straw and plastic. The overhead sprinklers mounted on poles have very delicate heads. The gardeners unscrew these in late October and keep them in a cellar to protect them. They will be brought back to the garden in spring as soon as they are needed for watering the biennials.

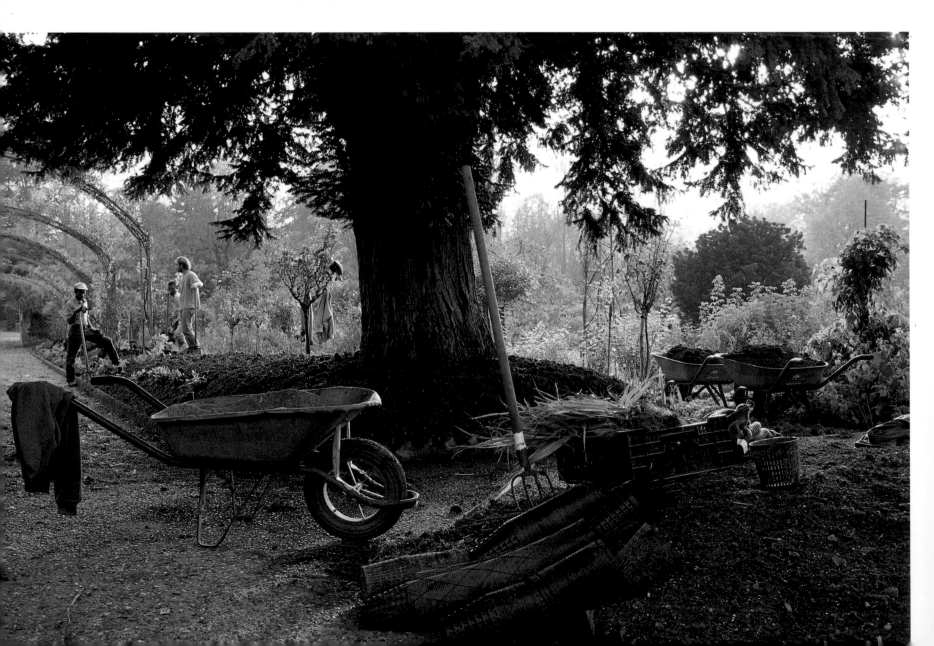

OPPOSITE *The large yew, now over a hundred years older and bigger than when Monet first saw it, has created an imbalance in the proportions of the Grande Allée. In the foreground, the black plastic pots will hold the fritillaries, planted in pure sand.*

BELOW *Digging the Grande Allée are, from the left, Rémi Lecoutre, in charge of the east side of the garden, Gilbert Vahé, Jean-Luc Lerenard (Rémi's assistant), Mamadou Niakhate (Yves' assistant) and Yves Hergoualc'h, in charge of the west side of the garden.*

Once the beds in front of the house and the Grande Allée have been cleared, the gardeners can begin to turn them over. The urgency here is to get these two areas planted with the spring-flowering bulbs and rhizomes before frost and heavy rains make the earth unworkable. Obviously, large shrubs, roses, the irises, and the carpeting perennials that edge the beds, such as aubrieta, arabis, and variegated elder, are left, but everything else is dug up, except the peonies. Starting at the top of the Grande Allée, they dig the soil over, remove all roots, and incorporate a handful of cow manure to every two square yards, adding a slow-acting, general-purpose fertilizer as they go. The perennials are never allowed to grow too large, but are kept the same desired size. Each plant is dug up,

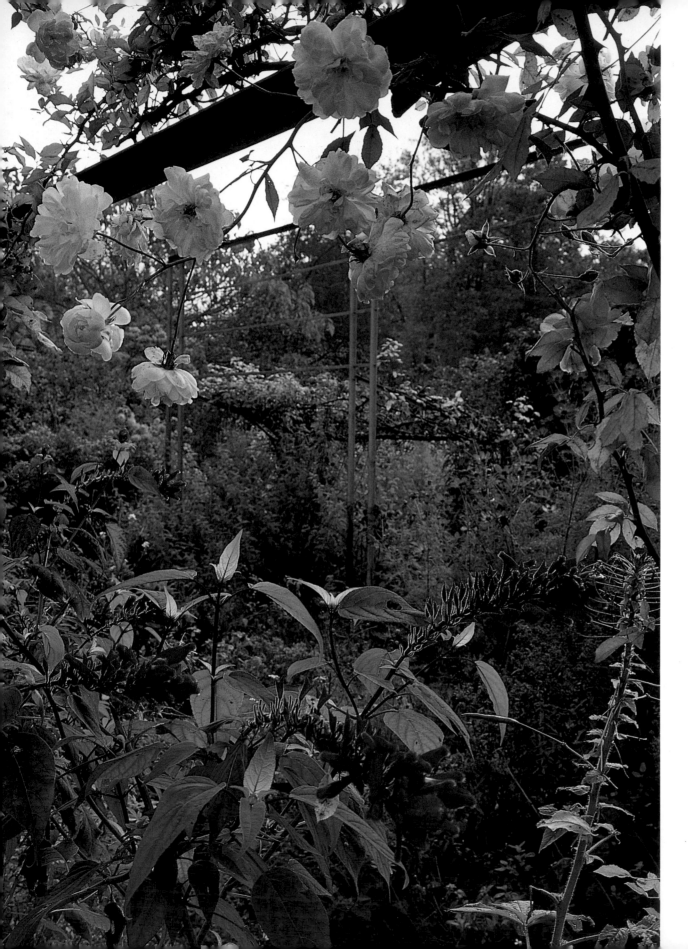

LEFT *Even in November the rose 'Phyllis Bide' and Salvia involucrata 'Bethellii' make a festive sight in one of the paintbox beds. The roses have to be carefully pruned and tied in so as to appear to be growing naturally, yet not dwarf or shade their neighbors.*

RIGHT *Using a tall ladder against one of the arches of the Grande Allée, Yves Hergoualc'h gives the first climbing rose, the 'Maréchal Niel', a thorough prune early in November.*

FAR RIGHT, ABOVE *This method of training roses by wrapping their main stems around the triangular support is characteristic of Giverny and its pillar roses. They will be pruned again in March and continually checked and tied in thereafter to make sure that there are no loose, thorny branches to scratch visitors.*

FAR RIGHT, BELOW *The beds have been cleared and planted, and large amounts of manure are brought in to feed the roses and improve the texture of the soil.*

AS IF IN MOURNING

inspected, its roots and top trimmed; then it is given a good shaking and replanted into the newly enriched soil.

The crown imperial fritillaries and eremurus are the first bulbs and rhizomes to be planted in the Grande Allée. When the gardeners have finished, they immediately start around the house and then return to the top of the Grande Allée, planting the tulips. These are all bought in as fresh stock each year. Deadheading them is not something the gardeners have time for any more, nor can they do the sorting, cleaning, and spraying that tulip bulbs need if they are to perform for a further season.

Before the bad weather sets in, the gardeners next go straight to the beds nearest the wall bordering the road. Because of the garden's natural slope from the house to this wall, these are the beds most likely to get waterlogged and frost-bound. If it does rain or the ground is too hard to work, they get on with clearing other parts of the garden. In tackling the rest of the beds, those that have the greatest quantity of tulips to go in are given priority. After all the tulips have been planted, the smaller bulbs are put in place – the anemones, alliums, tritelias, and Dutch irises (*I. xiphium* × *I. tingitana*). The last are planted *à la française* in a straight line using a string as a guide, between the bearded irises and the rest of the border. The whole bulb-planting operation, with the garden entirely dug over and all the tulips in place, is finished between mid-December and Christmas, weather permitting.

The watershed is the Christmas break. On their return the gardeners start planting out the biennials raised from seed in the greenhouse and later planted out in the nursery fields. This task will take them four to six weeks to complete – pansies, silenes, forget-me-nots, Canterbury bells, wallflowers and stocks. For some reason the stocks are roundly disliked by all the gardeners. For many years no one bothered to pinch the young plants out, and they grew 16 inches tall – leggy and ungainly with hardly any leaves and just a few flowers that stayed in the garden for weeks, like some neglected vegetable. "Not very inspired," says one of the gardeners. Now that they are pinched out and make bushy plants only 8 inches high that flower normally, they are really considered "not bad at all."

Over 180,000 annuals, biennials and perennials are raised from seed. About three-quarters of them are used; the remainder are insurance against unexpected losses. Vahé's greatest fear is that he might get caught out by weather or disease, which could leave yawning gaps in his borders. Apart from the bulbs, only the geraniums for the island beds just in front of the house are bought in. Mature geranium plants have a better chance than young home-

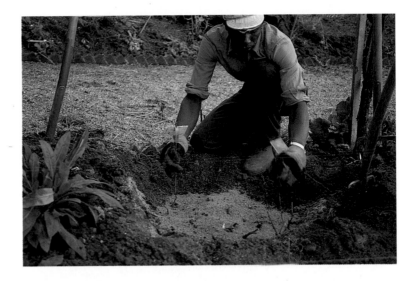

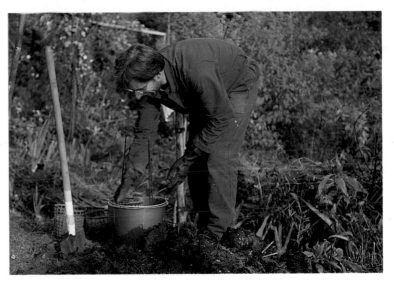

ABOVE *Mamadou Niakhate (top) plants eremurus in the Grande Allée in groups of three or four in a hole filled with horticultural sand. Normally refusing to flower for several years if disturbed, most of these will perform next summer thanks to this method of planting. Rémi Lecoutre (below) plants crown imperials in pots filled with the same sand. Twigs mark their positions so they are not damaged by the intensive plantings of bulbs, biennials, and annuals.*

OPPOSITE *The dahlia tubers have been laid out to dry for a few days before being stored in the cellar for the winter. Vahé's famous* fers à béton *separate the carefully labeled clumps.*

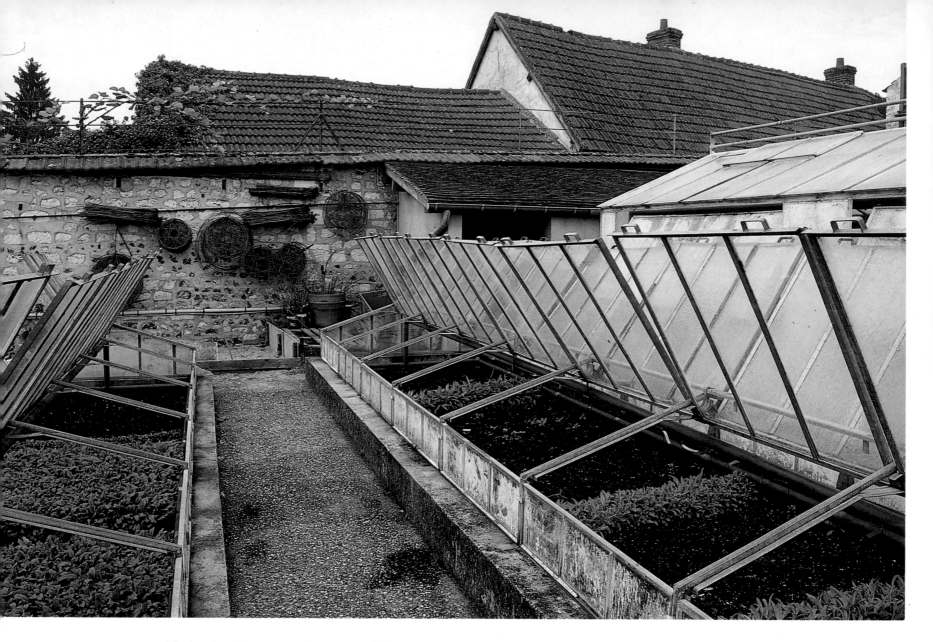

ABOVE *The heating pipes running the length of the cold frames provide warmth for the seedlings of marigolds, bellflowers, tithonia, and helianthus. Monet used cold frames – chassis – for many years before he could afford to build his greenhouses. In the background, hanging on the wall, are the* cercles de pivoines *used to support plants.*

RIGHT *The* Campanula medium *are ready for planting out in the nursery fields.*

RIGHT *A weeping crabapple hangs down like a curtain between the first beds of the flower garden and the nursery area. To the left are pots of many varieties of* Papaver orientale. *The field, Shirley, and opium poppies all seed themselves.*

AS IF IN MOURNING

grown ones of getting established here, in the difficult and shady conditions beneath the tall yews.

In the water garden, the water lilies are tended from a boat. After the garden closes, they are cut down with a large scythe which severs the stems as far below the water level as possible to stop the leaves from rotting; stems, leaves, and faded flowers are piled onto the boat along with any algae floating on the surface. The lilies are in groups of three, planted in a basket with handles for ease of movement. A post driven into the pond bed and just showing above the surface marks the position of each. Silt from the pond bed supplies sufficient nutrients, so the gardeners do not have to feed the water lilies.

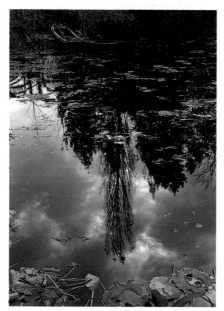

The garden looks skeletal but peaceful. Management, office staff, caretakers, and gardeners alike need this short period of relative quiet to recharge after the constant stream of children and visitors, bus tours, and ringing telephones, from which there is no relief for the seven months of the year when the garden is open.

Pared down to its bones, the garden is tranquil and austere. Its bare and graphic beauty depends entirely on the way light catches on water in its various incarnations – as soft mist enveloping the whole, as rain, and occasionally as frost. Stripped of all its deciduous ornament, the architectural outline of the Japanese bridge, the solid mossy trunk of the weeping willow with its filigree branches dipping into the pond, the structure of the metal arches and supports in the flower garden are all lit and backlit, by that same winter light whose magical quality so entranced Monet all his life that he sat outside painting it even as his beard froze solid and rheumatism set in.

LEFT *Three essential components of the winter water garden. Not a copy of Monet's boat (top) but one traditionally used in ponds, this boat spends most of its time in the water and has to have its bottom retarred every year. A pail stands at the ready to bale water out if necessary. The surface of the pond looks dark and menacing as it reflects a lone poplar and a stormy sky (center). One last solitary water lily is a reminder of the glories of the summer water garden (below).*

OPPOSITE *Jean-Marie Avisard, in sole charge of the water garden, cuts off the water-lily foliage with a scythe, then gathers it up in a net to prevent dying foliage from polluting the water.*

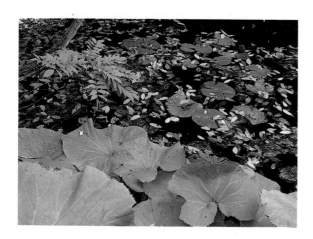

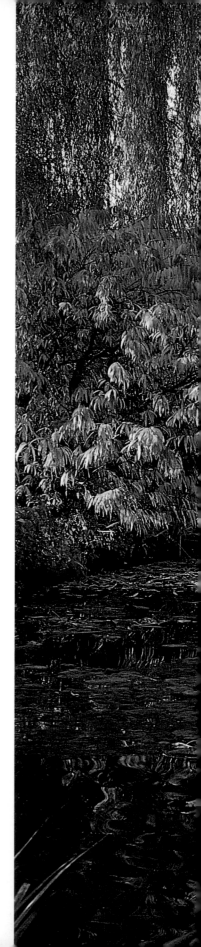

AS IF IN MOURNING

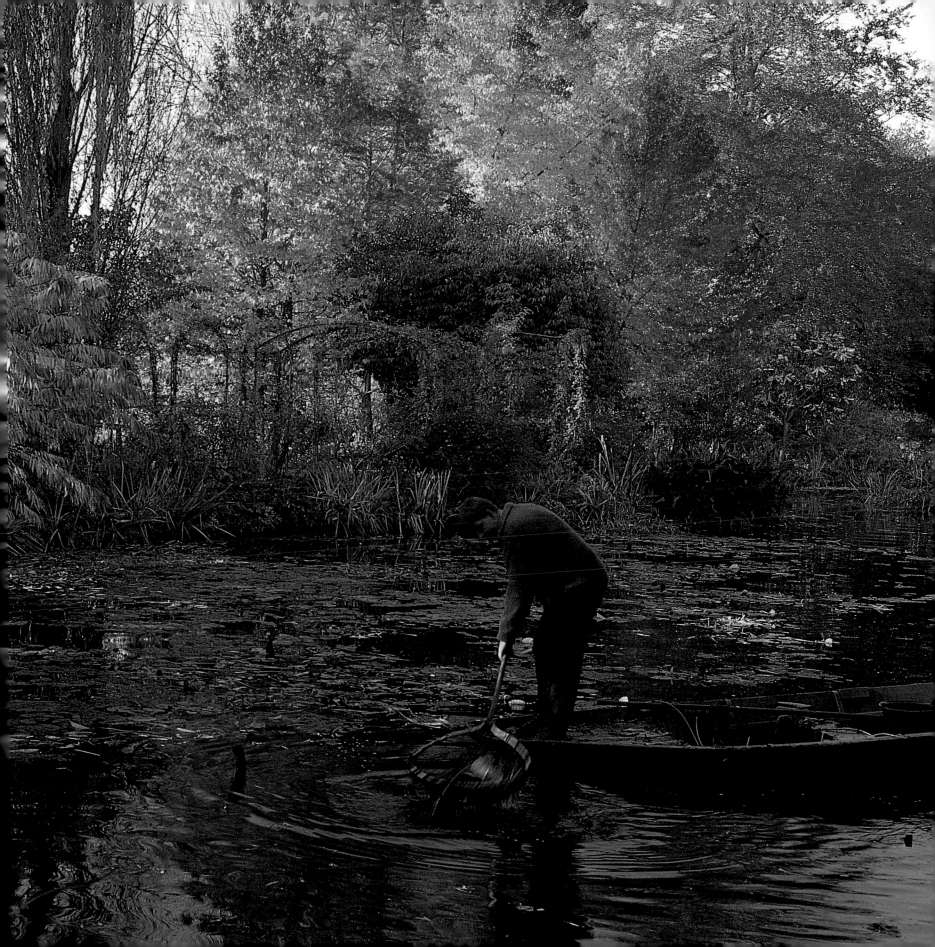

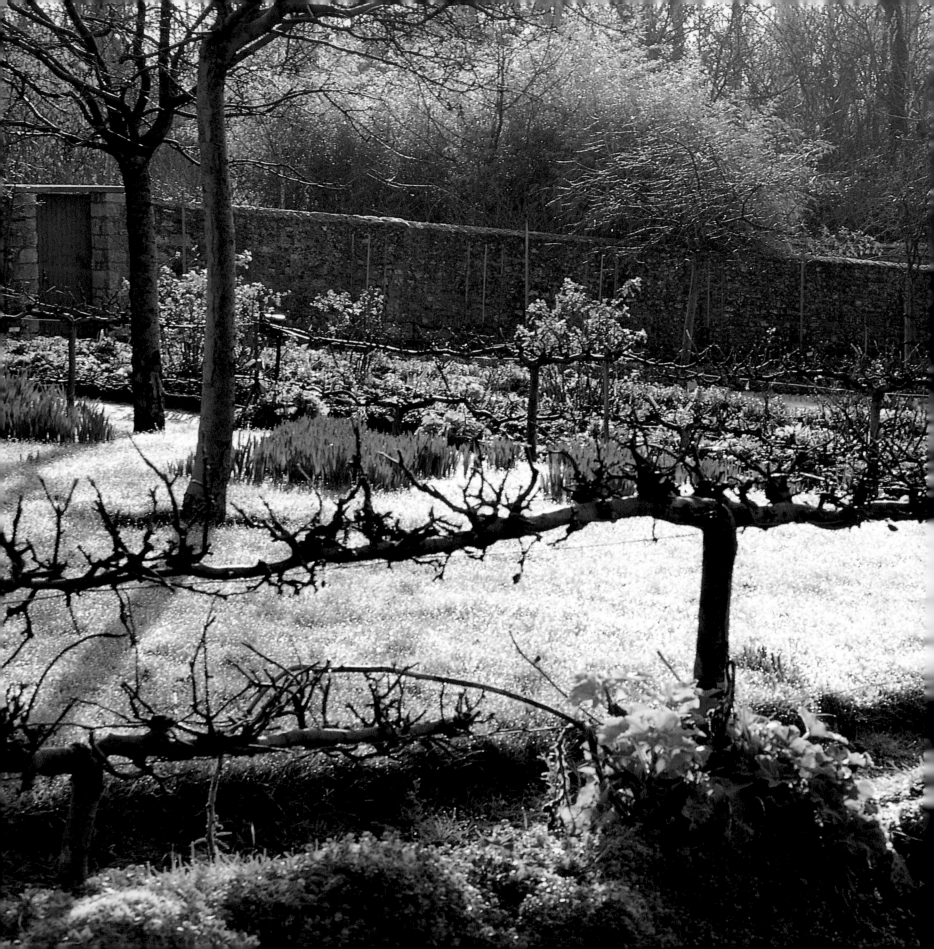

There is always a healthy glow about a garden that is well worked. It exudes promise even in the depths of winter. At Giverny, every square inch of soil is turned over, fed, planted, every rose pruned and tied in, the irises in straight neat rows, mats of aubrieta softening the repetitious and rigorously shaped long rectangular beds. Looking at the garden through the multifaceted lens of a kaleidoscope which picks up and distills colors where it is pointed, the winter garden glints in hues of brown and green. Bark, leaves, and earth; grass and small shoots; a canopy of evergreen ivy or moss; the early-morning dew against a row of espaliered pears; strong purple and green shoots. Then, from February on, flowers begin to break through; tiny snowdrops, colored crocuses, and as the green points of daffodils and narcissi push their way insistently through, the brown earth begins to disappear under a sea of green.

ABOVE *Winter is coming to an end and this crabapple, dating from Monet's time, is just breaking into leaf. These bedrooms on the second floor of the house were given over to the children, but are now occupied by the* gardiens *of Giverny.*

LEFT *One of only three oases of grass in the area open to the public, this lawn is encircled by apple trees grown* en double cordon. *In Monet's day, the head gardener lived in the house on the other side of the wall.*

75

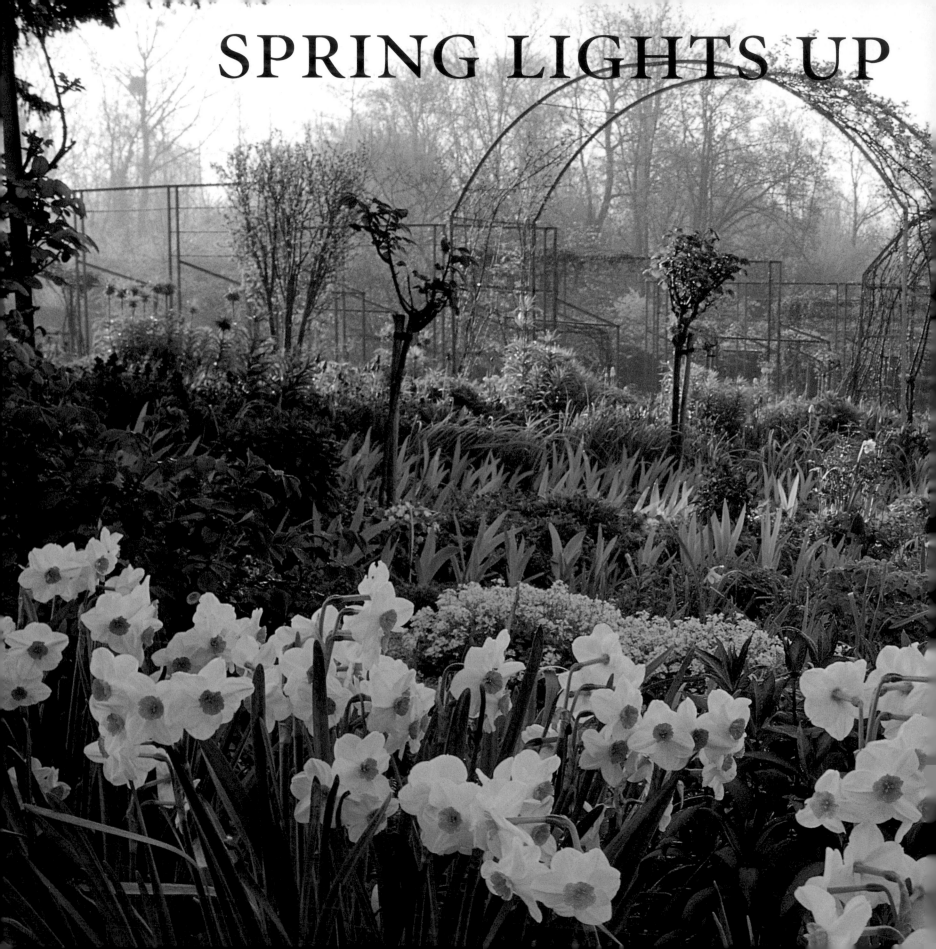

SPRING LIGHTS UP

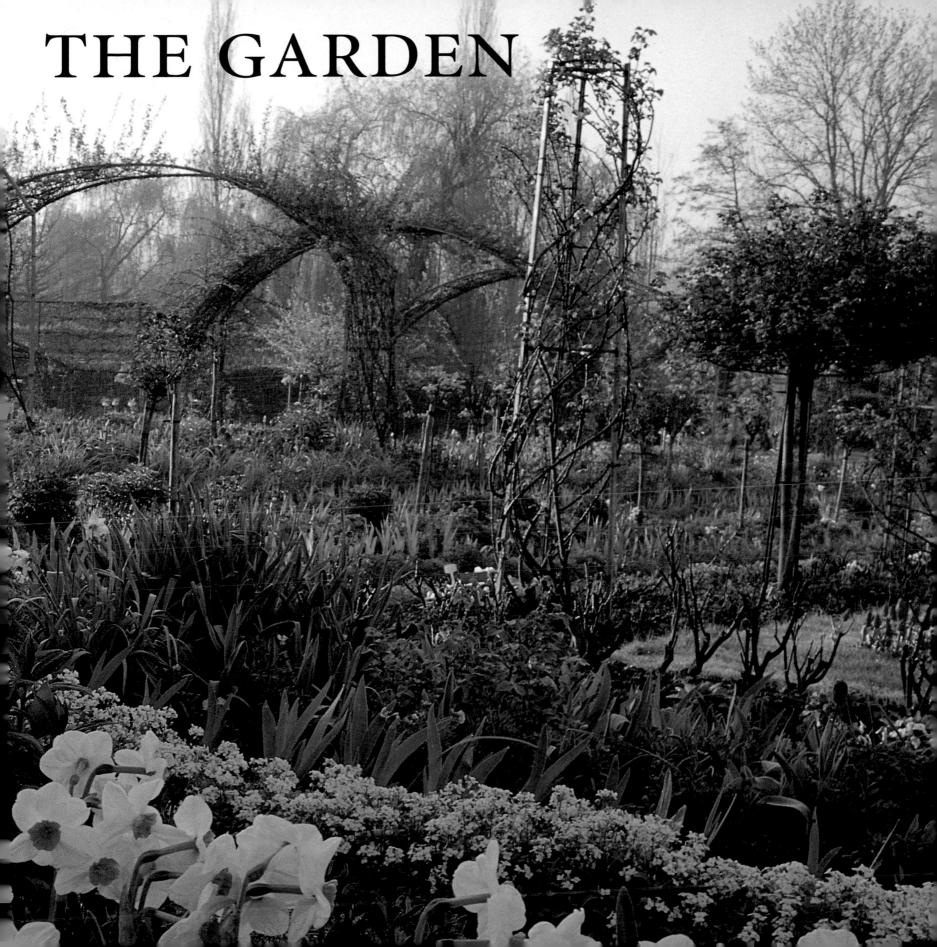

THE GARDEN

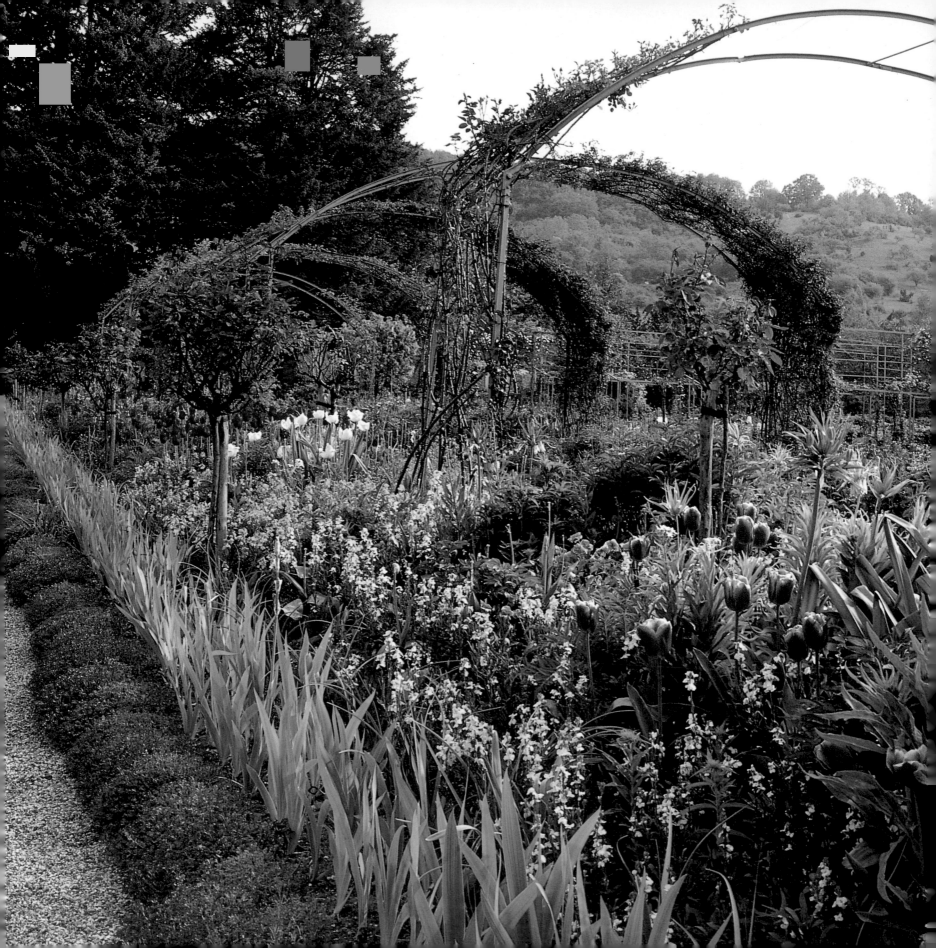

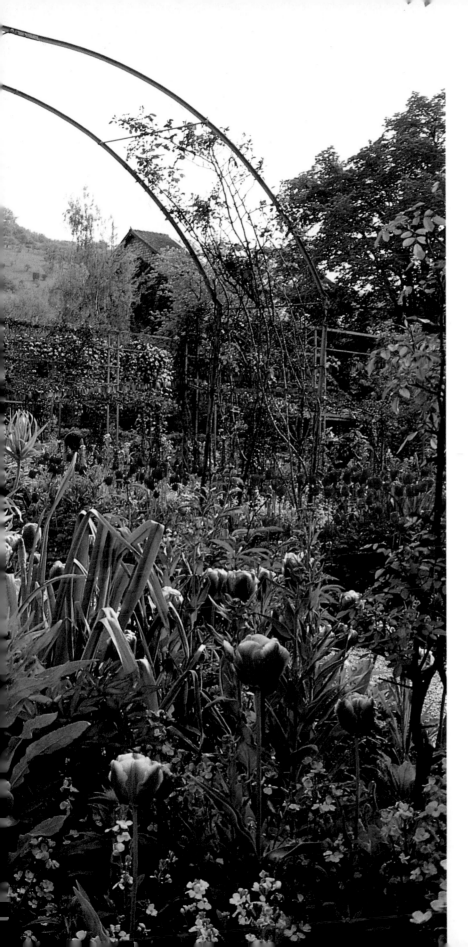

> *"Come February, spring will be here with its early flowers, and Monet will refuse to budge."*
>
> ALICE HOSCHEDÉ

In no other season is the transformation of Giverny more dramatic than through March, April, and May. The garden leaps from bare earth to the lushness of early summer in three months. By June, every color of the rainbow will have unfolded from the soil.

Giverny is above all else a colorist's garden. "What strikes the visitor most," wrote Georges Truffaut, "is the harmony that results from putting together the most opposite colors and the taste that has directed the framing of these floral marvels." Monet used color dramatically: bright colors melt away to more subtle tones only to reappear in a brighter, bigger form. Unabashedly bold in places, his garden invariably startles those accustomed to subdued pastel shades, but it can be subtle and cool. The boldness of April will fade away later when the garden switches gear. The red and yellow bulbs gradually finish, and the garden moves into its "blue period."

PREVIOUS PAGE *A fresh new tapestry of flowers unrolls with narcissi, arabis, the first of the purple aubrietas, and a few early pink tulips.*
LEFT *Spring gets under way in the Grande Allée. In Monet's time, the limestone hills in the background, now gone to rough grass and woodland, were covered with a mosaic of cultivated crops.*
ABOVE *The pale yellow centers of pink Iceland poppies echo the primrose color of* Erysimum cheiri.

79

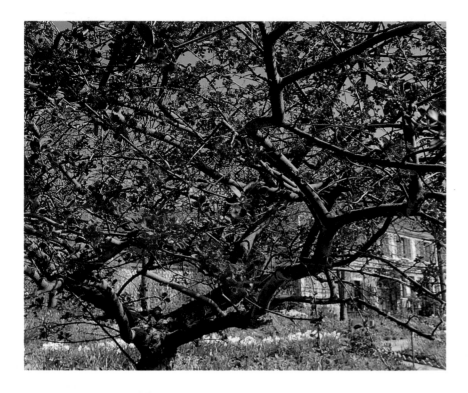

Spring steals gently into Giverny a whole month before the garden officially opens. First in flower in early March is the purple aubrieta, then comes the soft pink blossom of Monet's crabapple outside the kitchen window, underplanted with a primrose-colored *Erysimum cheiri*. Elsewhere, the flowering cherries, plums, and apple trees run the gamut of light and dark pink blossoms, their clouds of frothy pink carried high over the garden, echoing the warm-toned stucco of the house. Soon after coming to Giverny, Monet replaced some of the apples in the orchard with Japanese flowering cherries. Some of those now in the flower garden came as a gift to Giverny from the Japanese ambassador in 1990, but since the labels were in Japanese, none of the gardeners can tell you exactly what the varieties are.

Underneath the cherries, the lawns in early spring are decorated with drifts of white narcissi and daffodils. Georges Truffaut, writing about the spring garden in *Jardinage* in 1924, remarked on the profusion of narcissi – large yellow trumpet daffodils, the "Emperor" narcissi, and the poet's (or pheasant's-eye) narcissi. Other narcissi are planted in straight rows along a few of the borders and give off a wonderful scent when they are brushed against.

Cherry and crabapple blossom dominate the garden in April.
LEFT ABOVE *The pale pink façade of the house is a perfect foil for the electric pink blossom of one of the crabapples. The branches are pruned in the Japanese style to encourage a spreading, almost horizontal growth.*
LEFT BELOW *The pale yellow* Erysimum cheiri *beneath Monet's original crabapple tree have just passed their best. The gardener will weed thoroughly so that when the blossom falls from the tree in "une chute de pétales" it makes a very effective snow-like carpet over the dark soil.*

RIGHT *The lawns framed with cordon-trained apples and crown imperial fritillaries blaze with daffodils, narcissi, and tulips. These will fade to leave a simple grassy background to the summer-garden borders.*

SPRING LIGHTS UP THE GARDEN

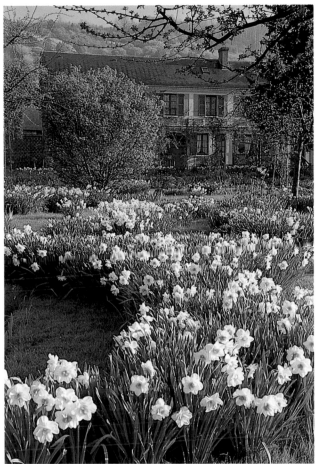

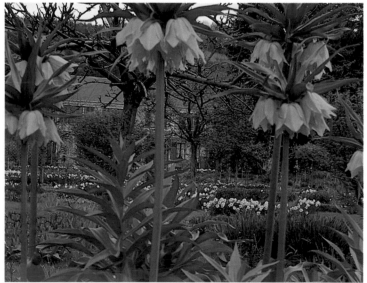

Early spring finds the gardeners preoccupied with the annual maintenance of the woody plants, particularly the roses and fruit trees. The remontant roses – those with more than one flowering season – are hard-pruned now; the summer-flowerers, which received their hard pruning in August, will have been cleaned up and shaped in February. Both kinds are *bien palissé* – tied in to their shaping supports. When the pruning is finished in early March, the garden is treated with a copper-sulfate fungicide.

Other members of the gardening team are working on the ceaseless task of keeping the beds planted for the coming season. By early March, they have finished the job of setting out the spring-flowering biennials – the pansies and wallflowers. These will be followed by waves of short-lived summer-flowering annuals and biennials as well as some perennials, all of which are sown in succession in the greenhouses depending on when they are meant to flower. They are planted out over a three-month period according to their hardiness, with the most fragile ones – for example, some varieties of bachelor's button – planted in June. There is always the danger that a prolonged cold spell or a sharp frost in May will damage those planted out early. Monet knew the caprices of the weather only too well. In February 1916, he wrote that there was "a warm winter and the first Japanese apricots, narcissus, were in flower and our weeping willow, completely green." By contrast, in May one year, he was talking of "*La floraison printanière absolument manquée* [spring flowering a complete failure]." Vicissitudes like these are anticipated in the way the plants that are set out early are

raised at Giverny today. To make them hale and hearty, they are sown, then potted in a light, poor soil mixed with perlite for good drainage. The poor quality of the soil encourages development of the roots as they scramble about looking for nutrients. The young plants are hardened off in a tunnel, but the large root system allows them to survive outside early in the season.

The earliest plants to emerge are *Leucanthemum × superbum* (*Chrysanthemum maximum*), *Campanula medium* (Canterbury bells), and foxgloves (*Digitalis purpurea*). Over the years, experience has taught the gardeners to judge accurately and appropriately when is the best time to plant them out, but a proportion of all plants is always kept in the greenhouses in case freak weather wreaks havoc. Next to be planted out are the honesty (*Lunaria rediviva*) and sweet rocket (*Hesperis matronalis*) which, together with the irises, will dominate the garden in May.

In the last week of March, in preparation for its opening to the public on April 1, Giverny is a hive of activity, and a *frisson* of anticipation runs through the garden. One of the tasks that most delights Gilbert Vahé, who is always happiest in his greenhouses, is providing potted plants for the house. Soon after Monet's death, both the big greenhouse and the smaller one he built later fell into disrepair, and during World War II they were almost destroyed, bombed by the English hard on the heels of the German retreat

SPRING LIGHTS UP THE GARDEN

after D-Day. The greenhouse built during the restoration to replace Monet's is much smaller than the original, but like the original it includes a temperate area, which accommodates a collection of four varieties of orchid. They are placed in the house for short periods only as they would not survive any longer.

Just before the house opens, Vahé coaxes his trolley laden with large houseplants along paths that are never wide enough and frequently gets stuck, tangled up in the shrubbery. For spring, he fills the house with cinerarias, azaleas, gloxinias, and orchids. In early summer, these will be replaced by schizanthus – a flower that elicits much admiration from the public who are always asking what it is – followed by coleus and begonias. In the fall, the house is full of decorative chrysanthemums. The pots of daturas, *Argyranthemum frutescens*, plumbago, and fuchsias that are placed outside in the garden will not leave the greenhouses until May.

Outdoors, some final manicuring touches are being applied before the garden opens. Along the paths, any aubrietas suffocated the previous summer by annuals spilling over them or damaged during a hard winter are replaced so that there are no gaps. Like the edges of the lawns, the ribbons of aubrieta that line the paths are trimmed with military precision: a long piece of string is stretched along the path and the plants are cut flush with it. Any other rockery or edging plants that need attention are trimmed. Leaves of *Stachys byzantina* that have become tattered during the winter are removed, for instance.

The veranda and the stairs from the house are given a fresh coat of the famous apple-green paint – *le vert Monet* – and the repainted benches are brought out and positioned as before.

Then the 3,000 feet of pathway can finally be cleaned up. They have borne the steady tread of many feet and the passage of countless wheelbarrows spilling over with plants, soil, and compost throughout the winter. Only days before the garden opens, the concrete is hosed down with a high-pressure jet and scrubbed. Literally the day before the garden reopens, 420 cubic feet of fine new gravel arrives to be emptied out in piles, starting at the top of the Grande Allée, distributed over the paths that the public does not walk on and finely raked. Posts are hammered back in at the ends of all the paths sealed off to the public. By the time the green and white chains are put in place and the garden is ready to open its gates, it all looks brand new.

Only days to go before opening, and the finishing touches are being put to house and garden. Jean-Luc Lerenard hoses down paths with a high-pressure water spray in preparation for the arrival of the gravel. This is spread along the Grande Allée, with corrugated iron forming a temporary "corridor" to stop the flowerbeds from being spoiled. M. Vahé's trolley stands ready with plants for the house. Pots similar to the blue ones Monet brought back from Holland, and which appear in his Vétheuil and Argenteuil paintings, have been brought out of storage and positioned in front of the freshly painted veranda. This year they will be planted up with Argyranthemum frutescens.

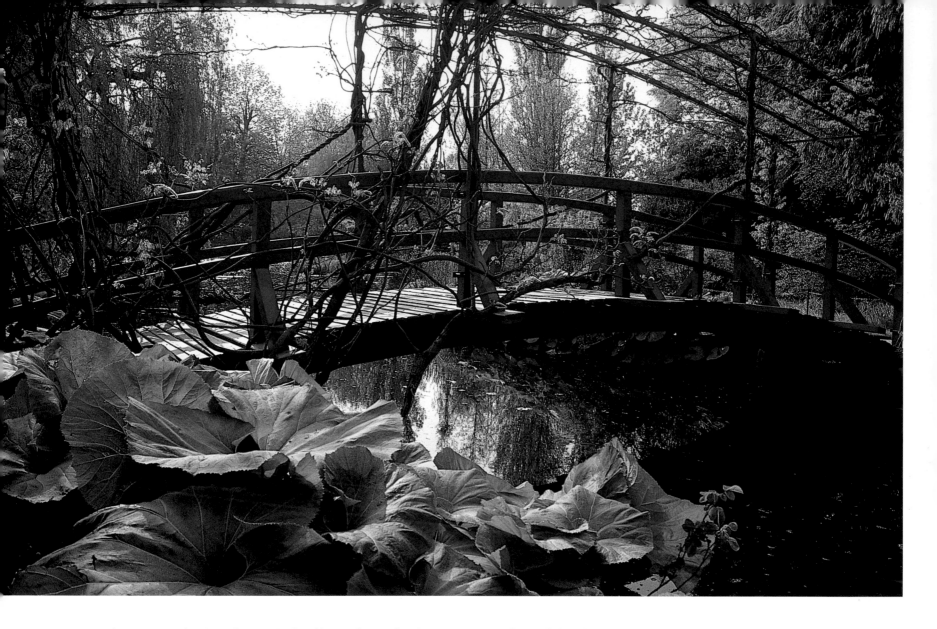

The water garden is perhaps at its loveliest and most luminous in early spring, when the buds are just breaking and the light shining through unclothed branches and reflecting off the water adds sparkle to its many hues of yellow and green underplanted here and there with clumps of the poet's narcissi and daffodils. Elsewhere, there are small treasures – the snake's-head fritillary, *Anemone blanda*, then tulips and a carpet of white-flowering sweetly scented woodruff (*Galium odoratum*) under the weeping willow that Monet planted himself.

The water garden brings its own spring tasks for the gardeners. In theory, the water should have been drained and the bottom of the pond dealt with by the end of March. In practice, however, the gardeners never get around to this job before the garden opens on April 1 and they have to use one of the three Friday or Tuesday public holidays in May that they can bridge with a Monday when the garden is closed anyway. They do the job at lightning speed. The whole team of gardeners swoops into the empty pond to weed and remove the algae – a laborious job, all done by hand. They divide the water lilies, clean them up, and replant them, replacing any that have been damaged by muskrats over the winter from a reserve kept in a cement pool near the greenhouse. The pond is then refilled overnight, ready to greet the next day's visitors.

The delicacy of early spring is replaced in late April by a sturdier and altogether heavier show – mature leaves, showy azaleas (*Rhododendron luteum* and R. 'Persil'), purple acers, and *Viburnum opulus* – all underplanted with pansies and wallflowers.

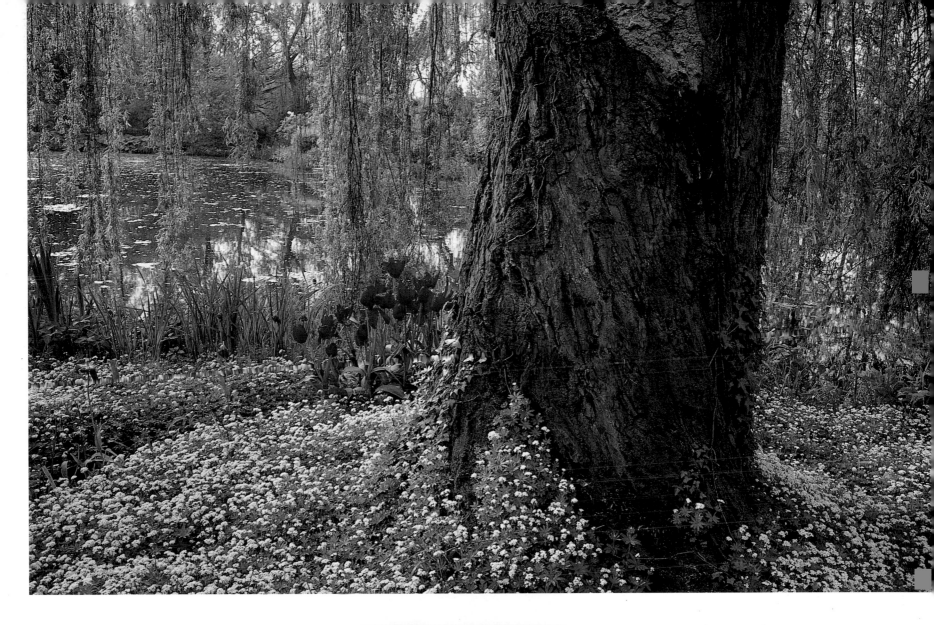

Spring creeps into the water garden.
OPPOSITE *Monet's famous Japanese bridge looks skeletal against the colorless sky of early spring. The bold leaves of the petasites add an air of solidity to the scene.*
ABOVE *The wispy branches of Monet's original weeping willow hang like a curtain around a carpet of sweet woodruff (*Galium odoratum*) and a clump of red tulips.*
RIGHT *This old sluice controlled the inflow of water to the pond. It is protected with a heavy padlock to stop idle fingers from turning the wheel.*

OVERLEAF LEFT *This* Acer palmatum *'Ornatum' and azalea 'Cecile' are rich and darkly dramatic, attracting attention long before the water lilies break through the surface of the water. In the background is Monet's second, smaller Japanese bridge.*

OVERLEAF RIGHT *The sword-like foliage of* Iris sibirica *with* Cotinus coggygria *and red and yellow* Aquilegia *'Koralle' make a spare, slightly oriental combination in the water garden – a sharp contrast with the blowzy planting in the flower garden across the road.*

85

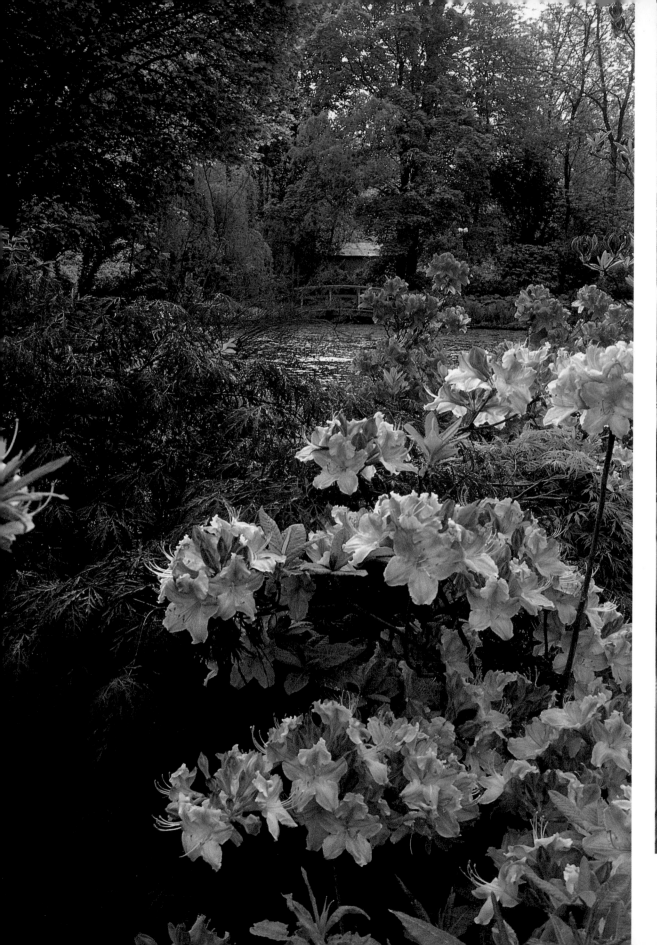

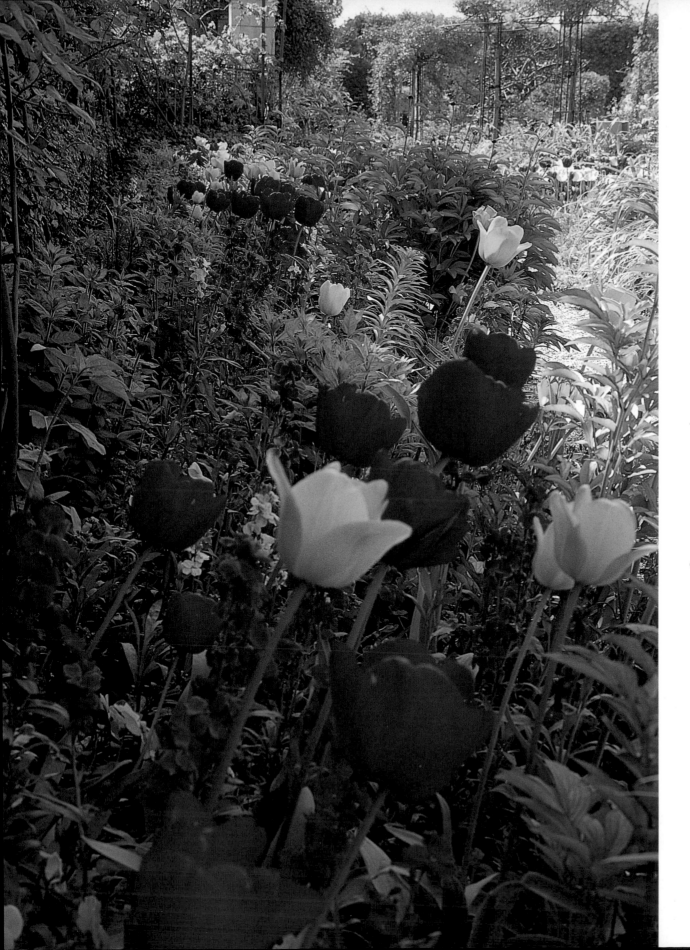

LEFT *The ultra-bold colors of the Darwin tulips 'Marmasa' and the Triumph tulips 'Paul Richter' floating above yellow and orange wallflowers in a border along the south wall of the flower garden come straight from the bulb fields of Holland, where no apologies are made for striking, strident color combinations. Red and yellow was one of Monet's favorite color schemes and one which he explored in his paintings long before he started gardening.*

RIGHT *The tulips 'Angélique,' 'Preludium,' 'Esther,' and 'Aristocrat,' together with pink and yellow wallflowers and red and mauve pansies are the basic ingredients of the pink and red border running next to the east lawn. The ever-present aubrieta edges the paths. Monet's third studio, the Grand Atelier, is visible on the far right.*

In the flower garden, the soft harmonies of early spring – the mauves, pinks, primroses, and creams – are dispelled in April once the tulips begin to blaze – long lines of early-flowering tulips from Holland in every hue, soon followed by the Rembrandt tulips with their mottled and marbled petals making brilliant patches of color. Truffaut noted yellow lines of the Lily-flowered *Tulipa retroflexa* springing up amid the violet aubrieta borders, "and above them, like a shower of golden rain, the dainty flowers of the Caucasian doronicum." Truffaut's *doronicum du Caucase* was in fact leopard's bane, *Doronicum caucasicum*, now *D. orientale* – a vigorous plant with bright yellow daisy-like flowers that grows in any soil (excellent for rough places, according to the nineteenth-century author and gardener William Robinson in *The English Flower Garden*). Yellow and orange crown imperials (*Fritillaria imperialis*) lend a stately air to the Grande Allée and mix dramatically with tall dark tulips. Finally the Darwin tulips on tall stems add their striking note toward the middle of May.

Spring is when the bulbous and rhizomatous plants reign supreme. Narcissi, daffodils, tulips, fritillaries, eremurus, and irises are the bright stars of spring's continuous performance, each in turn taking center stage. Even as they take their bow, the next one steps out of the wings to steal the show; all eyes on the new star, the faded one is hastily removed and replaced. But these stars could not shine so brightly in the spring garden were it not for their supporting cast. The bright flower-heads of the larger bulbs float above a cloud of blue forget-me-nots or jostle with massed pansies or wallflowers in many colors. The wallflowers are an old-fashioned favorite that delight the elderly ladies who visit.

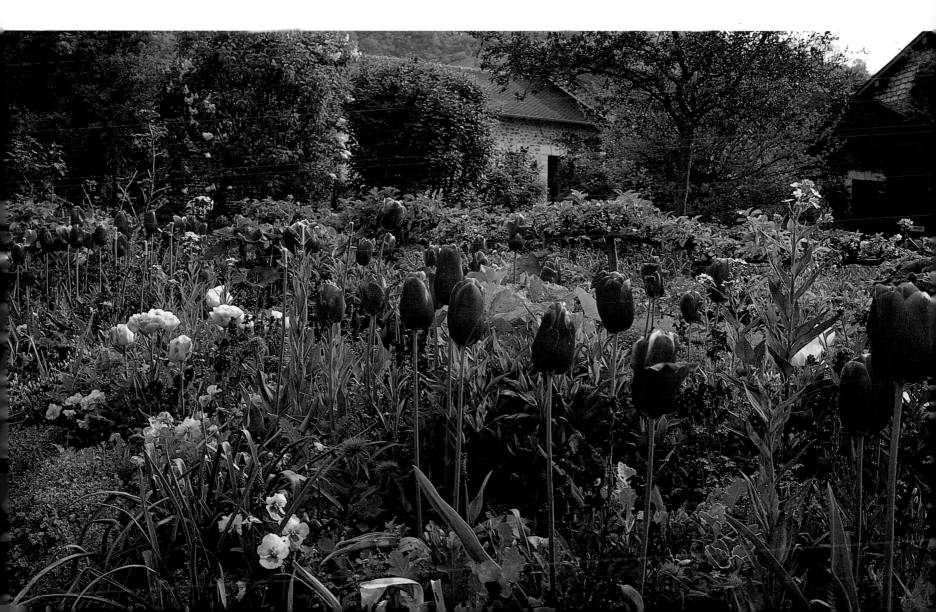

Some of the tulips at Giverny.
LEFT ABOVE *The Lily-flowered* Tulipa *'West Point' growing in the back of the garden with* Erysimum cheiri *'Mascott.'*
LEFT CENTER *In "un coin orange" the wallflower 'Fire King' ('super belle' according to the gardeners) and the tulip 'Prinses Irene,' beautifully nuanced from light to dark orange.*
LEFT BELOW *The Lily-flowered* Tulipa *'Ballerina.'*
RIGHT *Anomalies sometimes occur. Here a lone 'Blue Parrot' tulip arrives unexpectedly among the other tulips. They are surrounded by* Erysimum cheiri *'Ruby Gem' and the pansy 'Erfurt.'*

OVERLEAF *Spring-flowering bulbs mingle with biennials and bedding plants to make a cottagey jumble.*
LEFT *In the bed by the main stairs to the house, purple* Fritillaria persica *'Adiyaman' jostle with mauve pansies, red wallflowers, and the tulip 'Groenland.'*
CENTER *The white daisy-like* Leucanthemum maximum *flowers with the striped tulip 'Sorbet' against a background of white and mauve forget-me-nots.*
FAR RIGHT, ABOVE *The purple tulip 'Negrita' rises up from a bed of white violas.*
FAR RIGHT, BELOW *A vision of green and white in front of the house with white forget-me-nots and Lily-flowered tulips. In the foreground, to the right, alliums are in bud.*

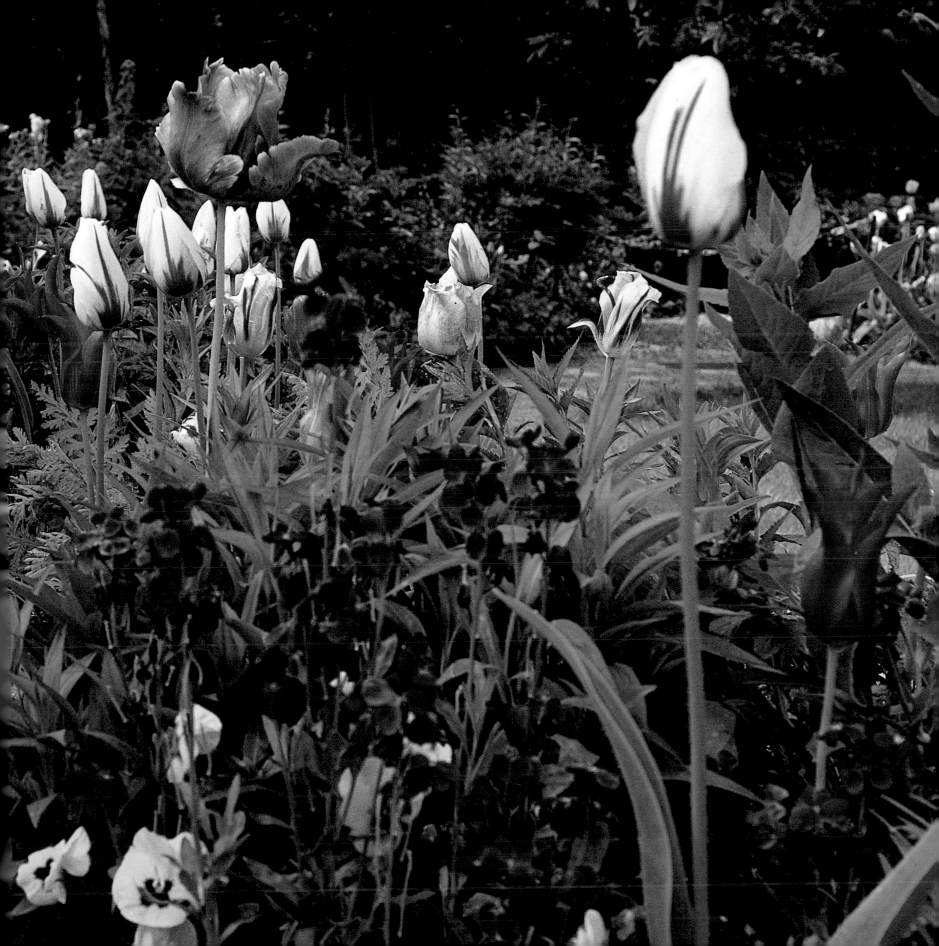

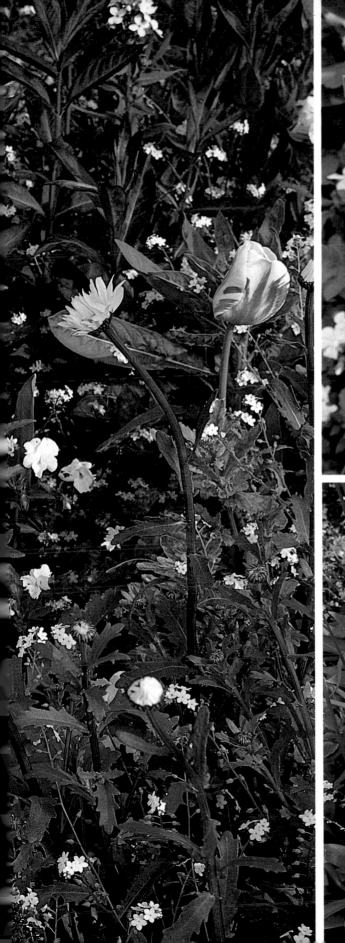
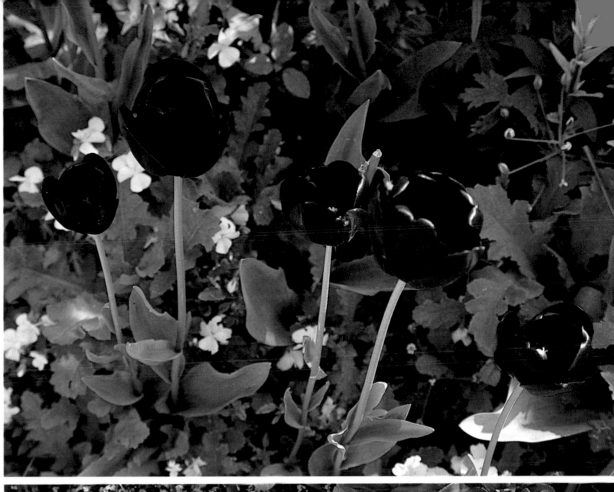
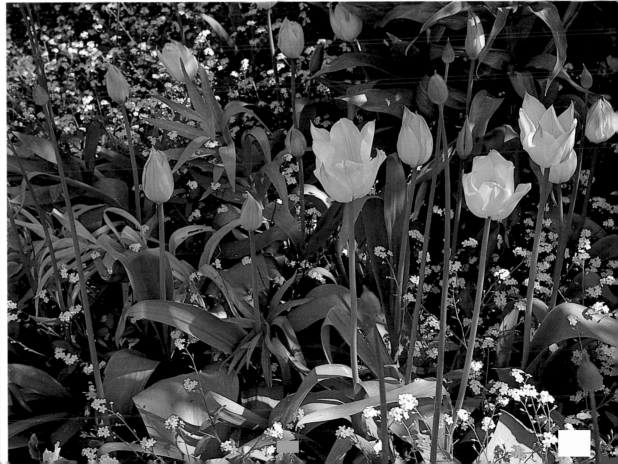

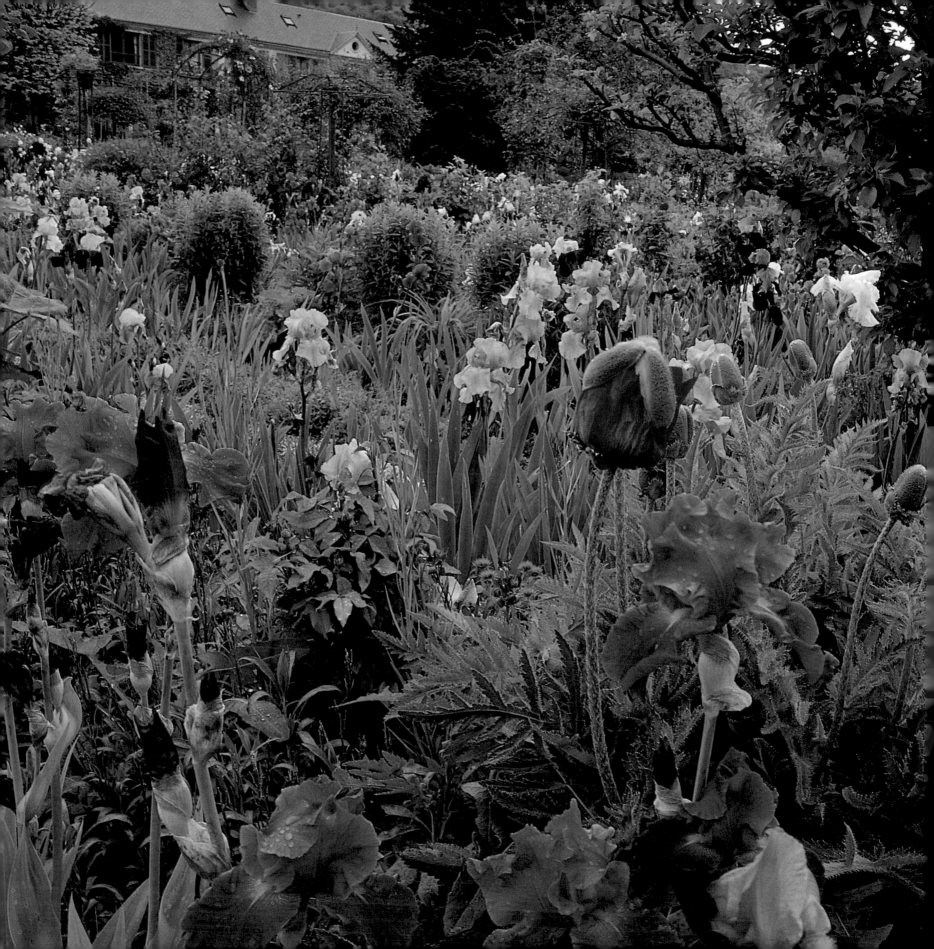

Now comes the grouping together of many shades of just one color, like a world within worlds. Giverny is sublime during May and early June – a vision of blues and mauves. Monet was certainly satisfied with his garden in May: "In spite of *le sacré temps* [the confounded weather], the garden was magnificent the whole month of May," he wrote to Caillebotte in 1892. The stars of his blue borders and of the water garden in spring were the irises, grown in every imaginable variant and described by Alice Kuhn in the women's magazine *La Femme d'Aujourd'hui* in 1912 as "violet-blue, violet-gray, violet-old rose, a few darker, violet-brown with gold flecks; violet-purple." Marc Elder described his visit to Giverny in *À Giverny chez Claude Monet,* published in 1924: "We walked down the Grande Allée underneath the shadows of the spruces. To the right and left, the irises spread out in large airborne sheets, like a haze of lilac in the sun."

The aubrieta-edged beds of tall irises in blues, violets, purples and white were the pride of the garden in May, for Monet, as they are today. Known simply as *"les iris des jardins,"* the irises were second in his affection only to the water lilies. Again and again, we come across letters urging friends to hurry before the irises finished flowering or the garden would be *défleuri* – devoid of flowers – as though Monet considered them the only flower worth looking at in May. Truffaut reported that, in the flower garden, Monet massed them by variety, in very long rows often more than a yard wide, and wrote of the remarkable effect produced by thousands of these flowers in one single monochromatic line.

The irises were such a feature of Giverny that the head gardener Félix Breuil was asked to write an article for the October 1913 issue of *Jardinage* on the many varieties of iris, both in the water garden and the flower garden. According to Breuil, Monet planted his famous blue bearded irises in the orchard, beneath the apple trees, where "a light shadow protected large clumps of irises whose violet spots followed the short-lived *éclat* [burst] of the trees in blossom."

A 'Granny Smith' apple tree spreads its branches over borders alive with fading 'Sterling Silver' irises and nascent 'Ali Baba' oriental poppies. Flashes of 'Fire King' wallflowers glow among the greens of the foliage.

LEFT *Irises are grown under the trees in the orchard just as in Monet's day. Here a trio comprising the violet 'Lilac Haze,' the white 'Ice Sculpture,' and the pink 'Elisa Renée' glows in the dappled light.*

RIGHT *This border running parallel to the Grande Allée is the only large, predominantly white border in the garden. The planting consists of alternating white daisies and sweet rocket (*Leucanthemum × superbum *and* Hesperis matronalis*), interspersed randomly with dashes of red provided by* Papaver orientale. *It makes a good transition border, drawing the eye away from the adjacent border where the biennials are just fading.*

Monet thought the colors of the blue bearded irises were at their best when they were planted in half-shadow. They were planted in September, 12–16 inches apart. Elsewhere they framed borders of perennials and were set out in groups in the lawns. Breuil maintained that, if planted in free-draining sandy soil – *terre franche siliceuse* – the rhizomes could remain undisturbed for seven to eight years without being divided. According to Breuil, there was no need to feed irises grown in a mixed border; the fertilizer applied to the neighboring perennials would suffice.

Another favorite flower-garden iris of Monet's recorded by Breuil was *Iris pumila*. Some 3–5 inches tall with dark violet flowers in April, it made a pretty edging plant for beds of gladioli. It was cultivated in the same way as the tall bearded irises, but was planted much more closely. Breuil wrote that *Iris stylosa* (now *I. unguicularis*), the Algerian iris, would flower from the fall through winter and into spring if it was planted in healthy, well-drained soil in a sheltered, sunny position. He added that it was best grown against a warm wall. Its gracious white, blue, and violet flowers were deliciously fragrant. Breuil also included on his list *Iris* 'Mme. Claude Monet,' which had large, dark violet-blue flowers; but, unfortunately, he did not include details of where it was planted or how it was cultivated at Giverny.

Like the blue and purple forms of aubrieta and the mauve honesty and sweet rocket that flower with them, these irises are well suited to the alkaline soil of Giverny, flowering happily for weeks mixed with early and late cultivars to prolong the show. In addition to sweet rocket (*Hesperis matronalis*), masses of white *Leucanthemum × superbum* provide a contrast to the blues and mauves, while the fast-growing annual *Phacelia tanacetifolia* gives an effective blue transition as the biennials go over and the annuals begin.

LEFT AND RIGHT *A detail and plan of arguably the loveliest blue borders in the garden, to the east of the Grande Allée. In the plan, the border on the left is edged with purple aubrieta, while irises are repeated the length of the bed. White 'Henry Shaw' irises break up the otherwise relentless parade of purples. The deep purple irises are 'Dark Triumph;' 'Wild River' are the next deepest, 'Rococo' is purple and white, while the mauve iris is 'Lilac Haze.' In the photograph, a few red* Papaver orientale *are starting to appear. By June they will have helped to change the overall character of the garden from blue to red. In the plan, the bed on the right is filled with mauve sweet rocket and a mass of* Myosotis 'Blue Indigo' *and* 'Ultramarine'.

FAR RIGHT *Close-ups of three irises. The* Iris *'Lilac Haze' (above),* Iris *'Dark Triumph' (center) and* Iris *'Blue Reflection' (below).*

Meanwhile in the water garden in Monet's day, the banks of the pond were garnished with irises of many kinds, described by Breuil in his precise and methodical way. The water-garden irises constituted a very different group from the famous irises that Monet grew in the dry soil of the *Clos Normand*. The first species Breuil singled out was, appropriately enough, the Japanese iris (*Iris ensata*) "in marvelous single and double varieties." He noted that these liked *terre bruyère* – sandy, acid soil – and needed frequent watering from when they started into growth until they flowered.

Breuil went on to list the native yellow flag, *Iris pseudacorus* (also known as *flambe d'eau* or marsh iris, and the fleur-de-lis of heraldry); he also described as yellow an iris native to the Mississippi area – *Iris fulva*, which is perhaps more copper-toned than yellow. Blue *Iris virginica* was another American iris that flourished at the waterside. White-flowered irises included the butterfly iris (*Iris ochroleuca*, now *I. orientalis*) from central Asia, and *Iris gigantea*, with stems 4 feet tall. There was *Iris aurea* (now *I. crocea*) with yellow flowers on 40 inch stems, and *Iris* 'Ochraurea', a handsome dark yellow hybrid between *I. ochroleuca* and *I. aurea*. *Iris monnieri* he described as "one of the most beautiful for water," with its lemon-yellow flowers and lanceolate leaves; the related *Iris* 'Monspur' (now *I.* Monspur Group) was a mauve-blue. Another hybrid *Iris* 'A.W. Tait' was a "porcelain blue." One of the earliest of the water-loving irises to flower was *Iris sibirica*: named varieties grown at Giverny included 'Blue King,' 'China Blue' and 'Snow Queen.' Breuil also mentioned *Iris gueldenstadtiana* (*I. spuria* subsp. *halophila*) "whose small flowers are of little interest" and *Iris delavayi*, with flowers in white and purple.

RIGHT *Lavender-blue Dutch irises mingle with yellow* Iris pseudacorus *at the edge of the pond.*

FAR RIGHT *Jean-Marie Avisard has pruned the berberis and is now weeding and pulling out spent wallflowers in preparation for the planting of the annuals. In the foreground are Dutch irises and the yellow* Iris pseudacorus.

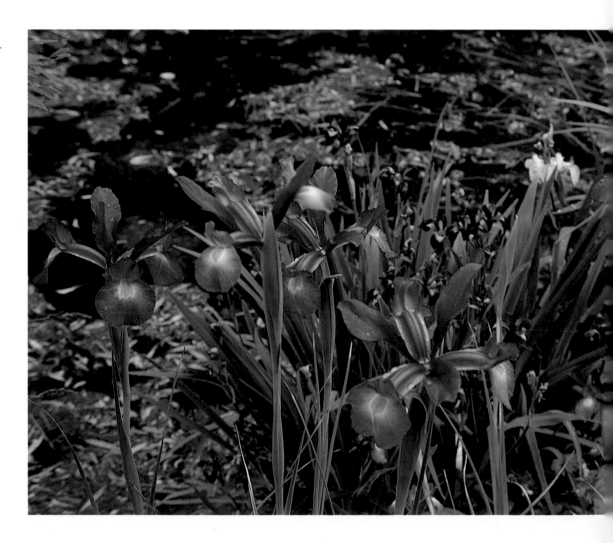

SPRING LIGHTS UP THE GARDEN

Breuil, as well as being Monet's head gardener, was also charged with the care of the water garden. Although Alice Kuhn reported that "the pond was edged with irises all the way round, shaded by weeping willows that let the sun filter through gently," according to Breuil the pond's margins were not densely planted. "In places we leave the edges simply grassy," he wrote, "so that we can open up the bank and create spots where we can approach and admire the decorative aspect of the planting on the edges." He explained the naturalistic, informal style of the pondside planting: "To have an elegant effect with these plantings, there must be no symmetry. Regularity in the planting would be a serious error." The clumps of irises were set some 20–28 inches apart and were separated from one another by other moisture-loving perennials such as calthas, large yellow water ranunculus, trollius, or violet lythrums.

The principle was to allow the irises to naturalize as far as possible, though they could be increased by division. Breuil noted that most varieties seeded with great ease, but this was not always encouraged, at least while new plants were being established: "So that you don't weaken them too much, you must cut the flower stems before the seeds have formed." Should you want to grow irises from seed, you had to sow them in an acid soil, but they often took more than a year to germinate. The moist soil at the waterside suited them well, and they rarely needed watering. Breuil detailed the soil preparation, which involved digging in some sandy, acid soil and adding a measure of an all-purpose fertilizer before planting the irises. This was best done in October. The irises would be fed again in March. The only other maintenance involved periodically removing old leaves and dead flowers.

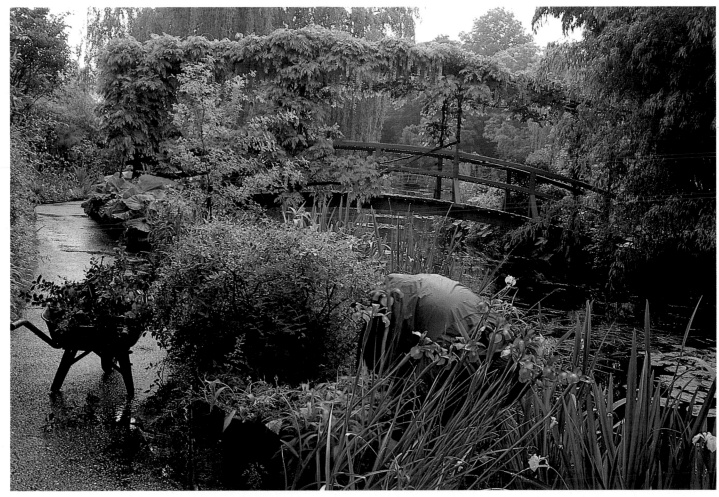

Today, restricting the public's access to large parts of the garden makes it possible for the gardeners to continue working, which the sheer numbers of visitors would otherwise make impossible. Although it is easier for an entire team of gardeners to concentrate only on one border at a time, this is not feasible once the garden opens. While the visitors are in the garden, the gardeners can do jobs such as weeding, removing spent plants and bulbs, and planting out the next season's bedding, but spraying, major pruning, and all work along the paths used by the public must either be done on Mondays, when the garden is closed, or from eight to ten in the morning on other days. The gardeners work within the roped-off areas, bringing with them all they will need for the day's work early that morning. For the purpose of logistics, the garden is divided in two – the east and west sides of the Grande Allée – each with a team and its *chef*.

In early April there are few weeds, but by the middle of the month an army of intruders is soaring up, and it is vital to keep them at bay. With six gardeners and seventy beds, weeding is described as *un gros boulot* – a huge chore. The roots of *Helianthus rigidus* are particularly hard to get out, and removing as many of these as possible is one of the most arduous of the spring weeding tasks.

Then it is important to get plant supports in place. Young plants are pinched out to encourage bushiness and sturdy growth, but some are naturally lax growers and need either staking or the support of a stronger neighbor. By May, the *cercles de pivoines* or peony supports are installed. Timing is essential: the adjustable frames have to be set to support the leaves when the peonies' distinctive red shoots have achieved their full height and just before they burst into leaf. The tricky thing about peonies is that once the shoots have stopped growing, the leaves open immediately. If positioned too soon, they will be too low; too late, and the leaves will be in the way. Supports like these are also used with *Sedum spectabile, Clematis recta, Lysimachia punctata, Centaurea montana,* and *Echinops ritro.* The supports are raised as the plants grow, but *Lysimachia punctata* can suddenly put on a spurt which can take the gardeners by surprise if they are busy elsewhere for a few days.

As the weeds and plants shoot up, so do the various climbers – the clematis, roses, honeysuckle– all of which need *tuteurage* (training and tying in). The pears grown as double cordons – *en palmette verrier* (in the shape of inturned "U"s) – are pruned for *formation* rather than fruit. Every plant is attached to its support and then *suivi*, or "followed" – by which the gardeners mean keeping a close eye to check for signs of pests, diseases and wayward growth.

By early May, the spring-flowering ornamental shrubs such as forsythia, *Ribes sanguineum, Prunus cerasifera* 'Pissardii' and the tamarisk have finished flowering and are pruned. Tamarisks flower on the previous year's wood and can become straggly if not pruned; at Giverny the tamarisk is pruned very hard – almost within hours of the flowers fading. This gives it its distinctive and beautiful shape, and encourages rapid growth of the new leaves that unfurl after the flowers. The forty-foot length of santolina that serves as an edging on the north side of the east lawn is trimmed twice a year, in May and again in summer, to prevent it from flowering; it is the effect of the foliage alone that is wanted. May is also the time of year for the lilacs, once they have flowered, to be lightly pruned and for an outside contractor to be called in to prune the limes – *en carré*, or pleached – between the house and second studio, and the chestnuts near the chicken yard.

The floral relay race that is so tightly and skilfully run at Giverny requires meticulous planning and perfect synchronization for the annuals, biennials, perennials, and bulbs to succeed and overlap each other over several months. The gardeners rely on a policy of "safety in numbers" and on staggered sowings to cover themselves. Spring-flowering trees, the roses in June, and fall foliage can be relied upon as a back-up, but gaps in the borders are Gilbert Vahé's recurring nightmare. Raising plants specifically to fill gaps left by fading perennials is not new to French gardening. J.C.N. Forestier urged his readers to adopt this technique, telling them that Le Nôtre made abundant use of the method, growing plants in large pots and popping them in the borders for instant flowers. Even Monet never quite got the hang of such coordinated horticulture; after eight years in Giverny, we find him telling Caillebotte that he was sorry Caillebotte had missed the irises, adding "now that the first blooms have passed we must wait for the summer flowers . . ." That is a luxury not afforded to Giverny today.

Once the spring-flowering bulbs have finished, they are lifted. The only exception is made for the narcissi. Despite the requirement that the garden look beautiful at all times, Vahé insists the narcissi are left for two months until the foliage is completely rotted. This means that they have multiplied prodigiously, and there has been no need to buy new bulbs for several years.

Hardy and half-hardy annuals raised in the greenhouse, such as snapdragons and the many varieties of tobacco, take the place of

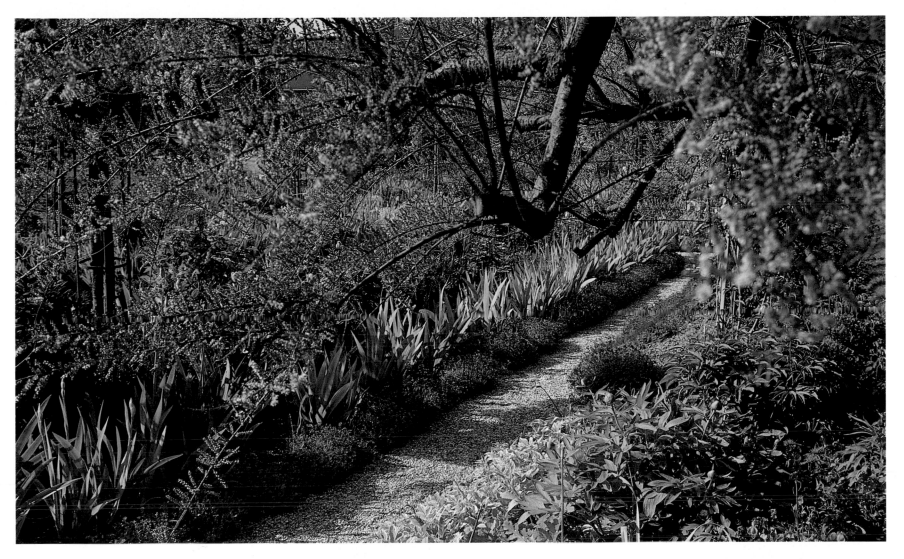

ABOVE *The striking* Tamarix tetranda, *which flowers in May before it comes into leaf, is pruned hard as soon as the blossom has faded to encourage its arching stems. This means the tree has to make new leaf buds which, the gardeners say, are a lighter, fresher green.*

RIGHT *Early May, and the first of the dahlias are being planted out by Yves Hergoualc'h. The long, color-themed beds are clearly visible here with red tulips and yellow wallflowers in the foreground, while close to the house and echoing its pink walls are light and dark pink tulips.*

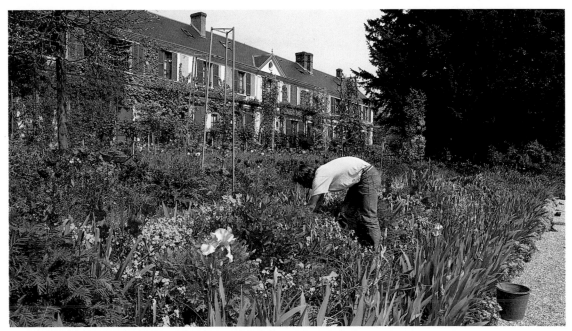

the spring-flowering bulbs, and are planted at the same time as the bulbs are dug up. Two weeks later, other hardy annuals such as poppies that do not tolerate being transplanted are broadcast-sown in gaps in the borders. This procedure is known as *semis pleine terre*. Theoretically, the borders should have been weeded, the summer bulbs put in, and a day chosen just before rain is forecast. In practice, the sowings are made before the summer bulbs go in, slotted in whenever there is time on the schedule. The famous nasturtiums are also sown in the Grande Allée at about the same time as the poppies, but unlike the poppies, they are backed up by a quantity grown in the greenhouse in case they should for any reason fail to germinate. So far, they never have. A Grande Allée without its nasturtiums, and the garden might as well close. Some of the broadcast seeds never germinate; others, such as the marigolds and special poppy varieties from the Thompson & Morgan catalog like Danebrog Laced, come up faithfully.

Summer-flowering bulbs and tubers that arrive from the nurseries during the winter and early spring are kept in a refrigerator to stop them from starting into growth until the weather is suitable for them to be planted. The lilies are the first of the summer bulbs to go in, followed by the gladioli, montbretia, and acidanthera. Last are the dahlias which have been brought out of hibernation in the dark recesses of the cellar at the beginning of April. They spend a month laid out under the chestnut trees on a bed of peat protected by a cover of heavy white felt. Hardly watered, warmed by the sun, they start into growth while protected from any late frosts. They will be planted out only when the danger of frost is judged to have passed, usually in early May, and always accompanied by a handful of *corne broyée* – the equivalent of hoof and horn. There are so many varieties that they are labeled twice – one label is attached to the roots and remains underground, the other is attached to a stake. Slug pellets, which are generally used very sparingly at Giverny, are spread around the newly planted dahlia, to stop the slugs from attacking as soon as the leaves are out.

As the summer-flowering bulbs and tubers go into the ground, so the spring-flowering biennials are removed. Wallflowers, which have a short flowering season, go first, and the pansies, which give the longest display, are among the last to be taken out. At the same time, the gardeners are busy dealing with what they call *les spontanés* – the self-seeders or volunteers – mainly *Impatiens glandulifera* and opium poppies (*Papaver somniferum*). All the opium poppies come up of their own accord in such quantities that much time is spent thinning them and removing them from places where they should

not be. Any growing among the aubrietas, irises, or within a foot of the path are pulled out, but those growing in the thick of the borders are allowed to stay; if they become invasive they are merely subjected to thinning out – *trier* in French.

At the same time as they are planting out the summer-flowering bulbs and dahlias, the gardeners are busy spraying the roses and mowing the grass. Every other year, in April, the lawns will have been treated with a sulfate of iron to control the moss. They do not

need any fertilizer as they benefit throughout the growing season from the fertilizer that is sometimes added to the water in the sprinkler system. Weeding and pulling out bulbs, annuals, or biennials that have finished flowering are jobs that the gardeners do every day, but the time-consuming task of watering is done automatically during the night. The overhead sprinklers that were stored away for the winter are brought back and mounted on their poles, and the low-level sprinklers have their straw and plastic protection removed by mid-May in time for watering the annuals. The borders are so densely planted that strategically positioned overhead sprinklers are the only solution to the watering problem. The garden is watered in spring and fall if there is a dry spell, though they water as little as possible when the irises are in flower, since water marks would spoil the blooms. During the summer, the garden is watered every night for about 15–20 minutes, and for 40 minutes in times of great heat.

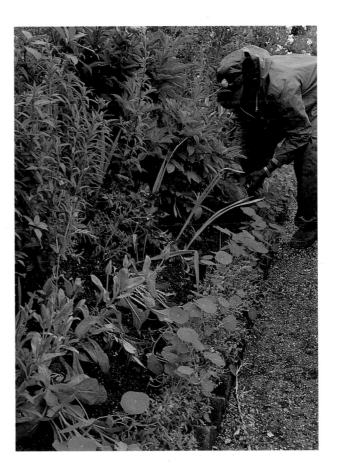

ABOVE *Makan Niakate plants a* Nicotiana sylvestris *with N. 'Domino Pink' along the Grande Allée.*

LEFT *A wet Monday morning in May when the garden is closed. The first of the roses are blooming on the arches, and one or two foxtail lilies are in flower. In the foreground, boxes of young* Nicotiana sylvestris *wait to be planted, while the gardeners are busy with the snapdragons.*

As spring looks forward to summer, the garden begins to move from purple, blue and white in May to a vision of pink, white, and purple. In his article in *Jardinage* in November 1924, Truffaut described the water garden in May: "On the grassy banks by the pond, thalictrums stand out, their leaves as serrated as those of some ferns, with light pink and white cotton-like flowers; there are several standard wisterias, yellow daisy-like inulas, and many varieties of geum, some of which form borders of a charming slate-pink."

He also spoke of the white flowers of *Spiraea × vanhouttei* mixed with tamarisk whose delicate pink flowers were as dainty in May "as plumes of ostrich feathers." The stunning pink foxtail lily, eremurus, with enormous spikes of pink and of cream, gives height to the Grande Allée in the way the orange and yellow crown imperials did in April. Starry pink and white garlands of *Clematis montana* clambering over the frames Monet built specially for them above the paintbox beds are another glory of the May garden, flourishing just as they did in Monet's time. The frames were replaced during the restoration of the garden in the late 1970s, and some new hybrid clematis plants were put in, but the gardeners have found that, for some reason, these climbers are unhappy; indeed, many of them die.

At this time of year, visitors stroll among the flowers blissfully unaware of the dizzying round of horticultural activity that surrounds them. Roused from its winter sleep, the garden is fresh and new and full of promise. The spectacle is a sumptuous one. Monet, with his fastidious nature and ever-critical eye, would only rarely have permitted himself such indulgence.

RIGHT *White* Clematis montana *'Spoonerii' flowers on the special clematis frames over the paintbox beds. White flowers such as these and white sweet rocket are used abundantly in the monochromatic color schemes. Here the planting is predominantly pink, with purple alliums, red peonies, and mauve hesperis surrounding the distinctive foliage of the long-flowering Himalayan balsam* Impatiens glandulifera.

FAR RIGHT *The banks of the water garden in May. The trunk on the right is that of the original wisteria that had fallen into the pond and was hoisted back up during the restoration. It is still too early for the water lilies, though their stems have grown to the surface. Along the bank, the large-flowered, primrose-colored shrub rose 'Nevada' and a clump of* Delphinium *Guinevere Group are in flower.*

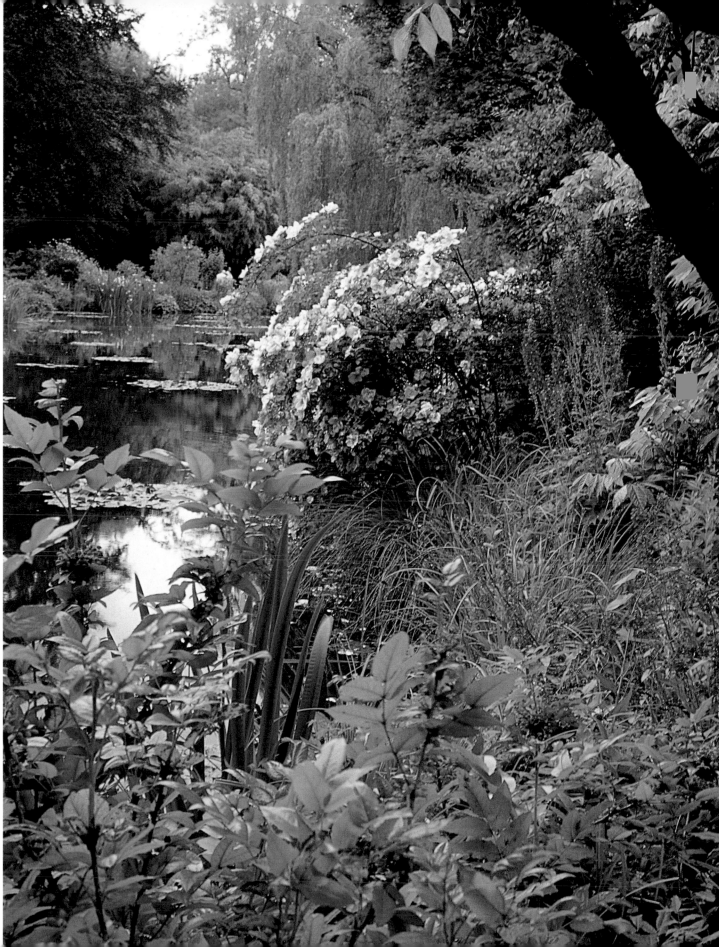

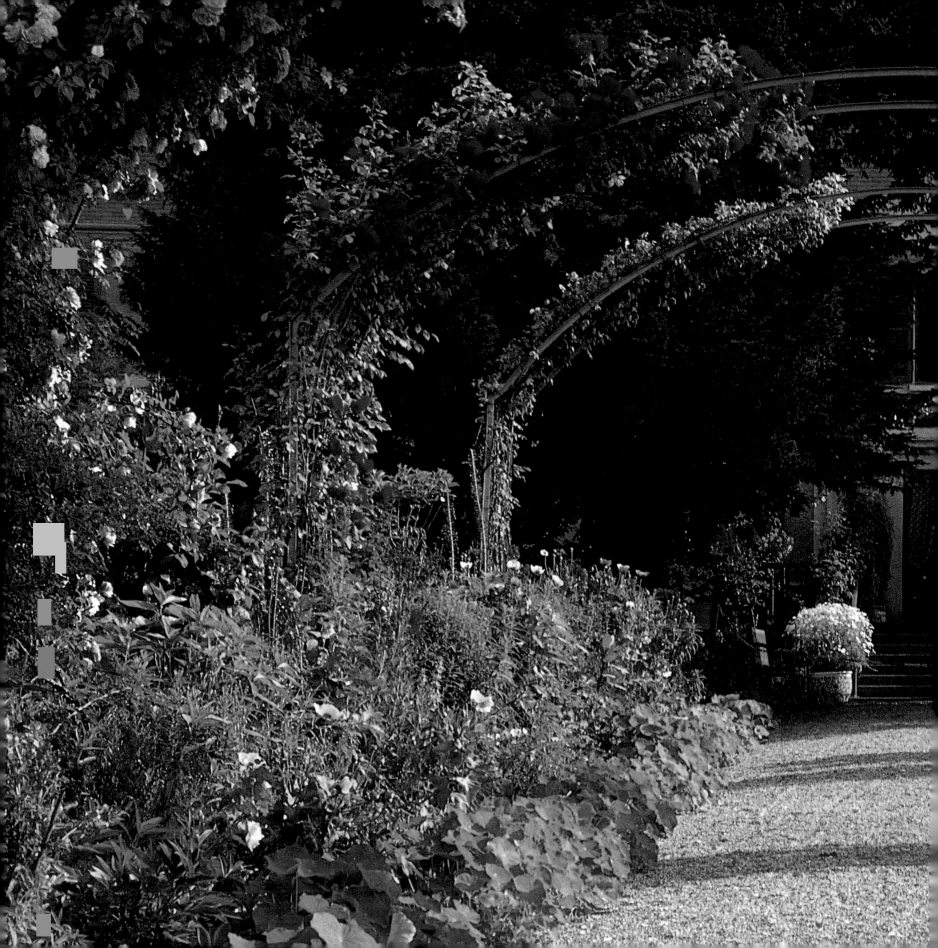

SUMMER SPLENDORS

> *"It was in summer that one should have seen him, in this famous garden that was his luxury and his glory, and on which he lavished extravagances like a king on his mistress ..."*
>
> LOUIS GILLET

As the blues and mauves of the irises fade at the end of May, the kaleidoscope turns once again, and June marches in with a flamboyance of reds and rosy pinks unmatched in any other season. The lush peonies, poppies, and roses that are set against a backcloth of rich greens decorate the garden like baubles on a Christmas tree.

Usually Monet preferred simple, single-flowered garden plants to the gaudier and artificial-looking doubles. The herbaceous peonies (*Paeonia lactiflora*) of Giverny were an exception to this rule. These beautiful cottage-garden plants were allowed to establish themselves in the Clos Normand where they relished the sunny site and limy soil. In his 1924 *À Giverny chez Claude Monet*, Marc Elder remembered a summer visit to Giverny, when the garden was brimming with "scarlet peonies, and at the end of the avenue stood the pink house, with green shutters, welcoming and gay."

PREVIOUS PAGE *The vault-like arches of the Grande Allée and ribbons of nasturtiums at ground level lead the eye to the house.*
ABOVE *Sweet rocket and* Paeonia lactiflora *'Monsieur Jules Elie.'*
RIGHT *A profusion of pink, red, and purple roses and poppies smothers the outlines of the Grande Allée.*

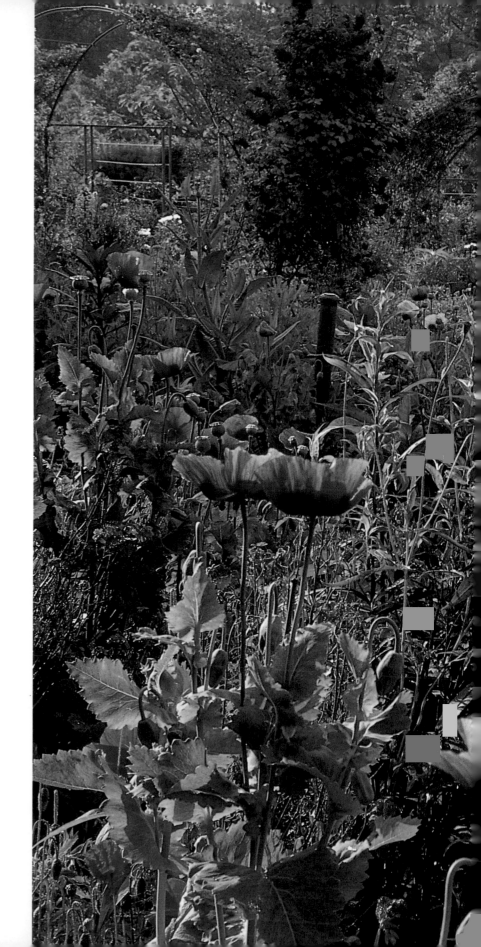

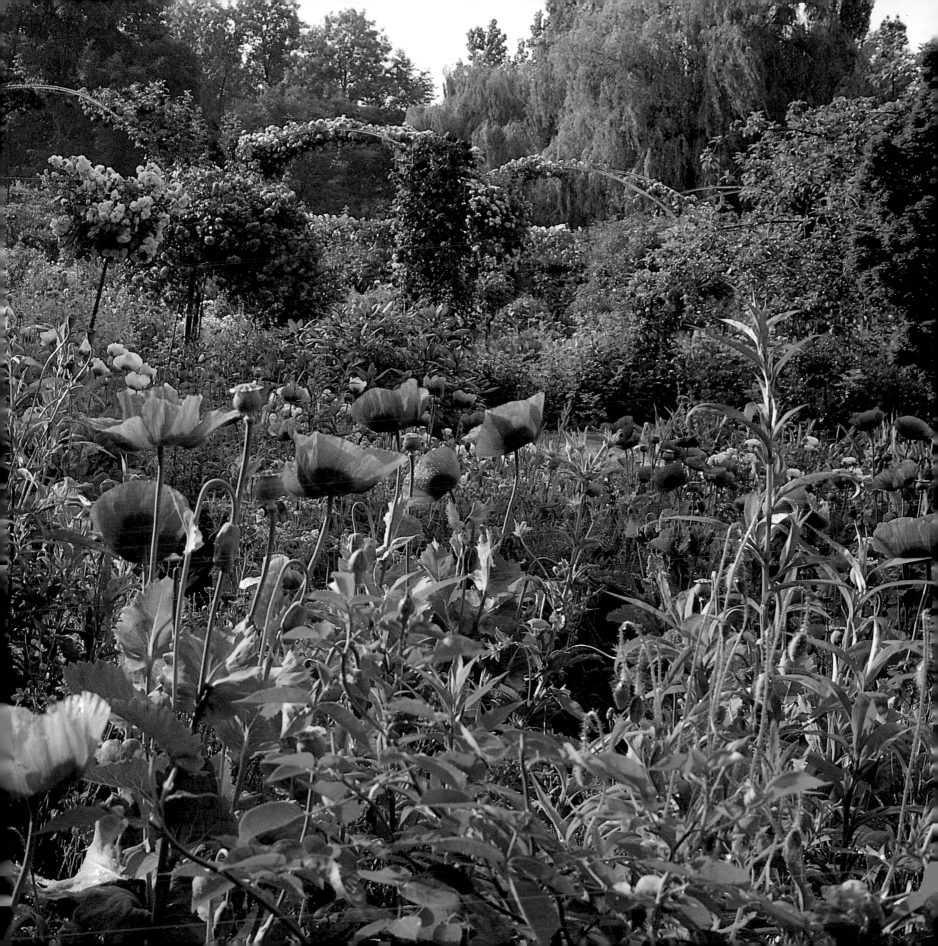

The roses were the hallmark of the June garden, blowzy and exuberant. Everyone who came to Giverny remarked on them. Georges Truffaut wrote, "In June above all else it is roses – rose bushes in all their forms, varieties of polyanthas grown as standards, dwarf roses, large-flowered roses …" Roses added their charm to the water garden as well: "The water garden was strewn with shrub roses and roses on tall stems, garlands of roses making a setting for the whole scene." The stunning effect of the roses was also noted by Alice Kuhn writing in 1912 for *La Femme d'Aujourd'hui*. She extolled the irises and the splendor of the peonies but, "Roses," she emphasized, "are one of the other riches of this enchanting garden." In the records we have, Monet himself mentions specific roses only once or twice, but a picture of the roses grown at Giverny can be built up from the accounts of family, friends, and the many journalists who visited Giverny over the years.

Consistent with his preference for single, simple, wild flowers, Monet favored traditional species roses like the sweet briar (*Rosa eglanteria* syn. *R. rubiginosa*) or the thicket-forming Scotch or burnet roses (*R. pimpinellifolia* syn. *R. spinosissima*). He had a beautiful collection of these, obtained from a grower in Edinburgh. Although native to the wild regions of Europe, many of the early hybrids were raised in Scotland – hence the name Scotch roses, which, incidentally, Jean-Pierre Hoschedé rendered in *Monet, ce mal connu* as "les Irish," confusing Ireland with Scotland.

Hoschedé also mentions *"toutes les 'Scarlets'"* among the roses growing at Giverny. These are most likely to be 'Paul's Scarlet Climber,' a rose raised in 1916 by the English rosarian Arthur William Paul. His father William was author of the classic book on roses *The Rose Garden* (1848), and founder in 1860 of Paul's Royal Nurseries at Waltham Cross, Hertfordshire. Roses bred at the nursery won countless medals including a Gold Medal at one of the Paris Bagatelle Trials of New Roses. Monet, an avid show visitor, would have seen them there. Other roses raised by the nursery and planted at Giverny included 'Paul's Single White' (1883) and 'Ophelia' (1912). Confusingly, 'Paul's Lemon Pillar' (1915) was raised by H.N. Paul & Son of Cheshunt, Buckinghamshire. This, too, was grown at Giverny, and its parent, 'Maréchal Niel,' now grows in the Grande Allée. This remontant rose astonishes the gardeners at Giverny today by flowering well into November even in temperatures of almost six degrees below freezing. One of the roses bred by Arthur William Paul was 'Mermaid' (1918), which became Monet's favorite. He planted it directly beneath his bedroom window so that he could look down on its dark, glossy foliage and its large, delicately scented

sweet-briar-like yellow flowers. It flowered steadily – if somewhat sporadically – from May to October, and flowers there still.

The climbers raised in Mr. Paul's nursery were only one example of Monet's taste for roses overhead and in the vertical plane. Long before the arches to support his roses were erected over the Grande Allée, he grew roses as standards, in swags, and trained them up the living but gradually denuded spruces of the Grande Allée. The effect was just as Monet wished it: along the Grande Allée, reported Alice Kuhn, "the dark pines are profiled against the light façade of the house, and the trunks of these dark pines are entirely covered by white roses – a white pure and warm – 'Madame Alfred Carrière' – they scramble amongst the sombre branches that they try to brighten up; above the entrance, they join in a glorious triumphal arch." In 1924 Marc Elder also remembered these roses curiously trained up the trunks of the trees: "Everywhere the soil disappeared under the weight of pinks, of azaleas, of campanulas, of delphiniums, and the air was embraced by the roses assailing the trunks of the trees."

With his penchant for climbing roses, the timely evolution of the fashionable "pillar" roses at the turn of the century must have suited Monet perfectly. These tall-growing cultivars were meant to be grown on supports in upright, columnar shapes. They were the offspring of and owed their vigorous habit to *Rosa wichuraiana*, which arrived in the West from Japan in the last quarter of the nineteenth century. Breeders in both Europe and America quickly took advantage of the new wichuraiana genes to cross it with existing cultivars and produce new strains of Ramblers, the English-bred 'Paul's Scarlet Climber' being one of them. Breeders made sure that the propensity to be grown as a "pillar" could not be overlooked by giving their new roses names such as 'American Pillar' (1902), 'Paul's Carmine Pillar' (1895), and 'Paul's Lemon Pillar' (1915).

Many other roses are known to have been grown by Monet. There was the extraordinarily vigorous 'La Belle Vichysoise' raised in 1897 by Lévêque, a breeder and nurseryman in Ivry-sur-Seine who supplied Monet direct. Remarked on by Truffaut, it had pinkish-white, sweetly scented medium-sized flowers in clusters and was exceptionally vigorous; Monet grew it over trellises and arches and in his water garden, where it was allowed to scramble into trees. 'Crimson Rambler' (1893), the multiflora Rambler from Japan, was also a favorite, with its bright crimson double flowers in pyramidal trusses. It was a vigorous, late-flowering climber grown by Monet in swags in the water garden as well as in front of his house on the two-tiered railing running the length of the façade. In 1908 Forestier visited Giverny and reported passing "vaults" of 'Félicité Perpétue,'

ABOVE AND RIGHT *The view from Monet's bedroom window across to the Grande Allée. From this vantage point he could see his flower garden in all seasons and all weathers. Climbing up the wall outside the window is the lovely large single rose 'Mermaid,' reputed to be Monet's favorite.*

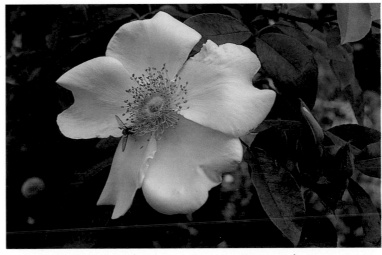

Monet never painted close-ups of flowers, but Clemenceau described him working on his water-lily panels with his nose only inches from the canvas. In close-up here are Paeonia lactiflora cultivars (above) and the roses, 'Golden Showers' (right above), 'Papa Meilland' (right below), 'Paul's Scarlet Climber' (far right, above), and 'Centenaire de Lourdes' (far right, below.)

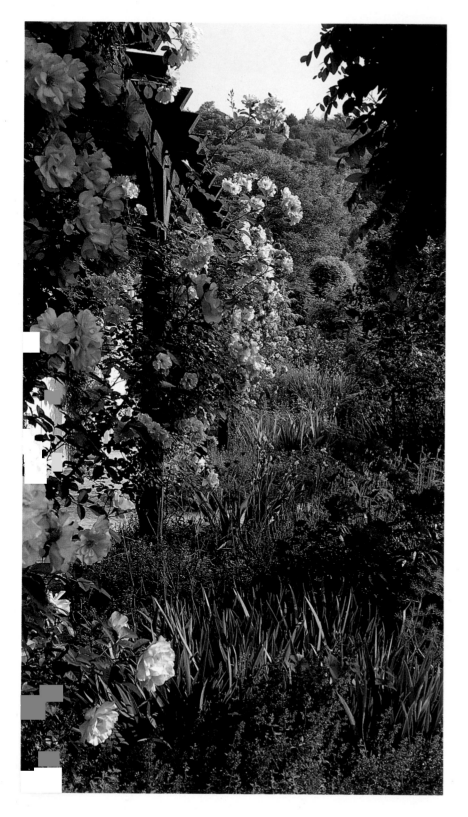

'Dorothy Perkins,' and 'Crimson Rambler' as he walked from the house to the greenhouse. 'Crimson Rambler' is prone to disease, so it is no longer cultivated at Giverny, but 'Félicité Perpétue,' and 'Dorothy Perkins' are still grown. 'Dorothy Perkins' may also be the identity of the pink rose shown growing as a pillar in the water garden in one of the Clémentel autochromes.

Alice Kuhn described 'La Gloire de Caire' – a rose I have been unable to trace – growing as standards 12 foot high, in balls resembling huge wedding bouquets. She also cited the very vigorous climbing Hybrid Tea rose 'Reine Marie Henriette', cochineal-carmine in color, which "very decoratively spread out like a fan." 'Virago,' a shorter rose, is a *R. setigera* hybrid, blush-white with large double blooms. Monet reported it as growing *"sur tige"* – as a standard. This is one of only two specific references – along with a reference to the 'Crimson Rambler' in front of the house – that Monet ever made himself to a rose. Although 'Virago' is listed by the old German rosarium at Sangerhausen, it has disappeared from contemporary rose lists, but 'Reine Marie Henriette' is available from both Peter Beales in England and André Eve in France.

Planted elsewhere in the garden are roses either grown by Monet, or in the spirit of Monet. The Edwardian rose 'Gruss an Aachen' (1909) is popular, as are the Moss rose 'Blanche Moreau' (1880) and the Hybrid Perpetual 'Baronne Adolph de Rothschild' (1867). When these have finished flowering, 'The Queen Elizabeth' and modern Hybrid Teas take over and provide roses well into August.

A rose named 'Claude Monet' was raised by Delbard several years ago as part of a series of roses named after painters. The selection was not initiated by Giverny, nor has it any bearing on Monet's preferences. Plans were made to launch it at Giverny but so far the 'Claude Monet' rose has not materialized. However, another rose of Delbard's, 'Centenaire de Lourdes' – a Floribunda rose produced in 1958 and flowering all summer long – is grown as a standard in the island beds in front of the house, replacing Monet's pink and white roses identified by Peter Beales as 'Elsa Poulsen' and 'Niphetos'.

LEFT *In the cafeteria area, the pink* Rosa *'Clair Matin' flowers profusely on a pergola with* R. *'Crimson Shower,' and* R. *'Cramoisi Supérieur' alongside.*

RIGHT *Like Alice Kuhn's "wedding bouquets," this 'Centenaire de Lourdes' rose has been trained into a "cloche" (bell) or "champignon" (mushroom) shape, following a framework or "armature."*

It was often the simplest flowers – like the scarlet field poppy (*Papaver rhoeas*) – that gave Monet the greatest pleasure. These appeared regularly in many of his paintings and were among the flowers that seeded themselves so abundantly in his garden. He also grew oriental poppies. Besides the well-known perennial oriental poppy, there was *Papaver orientale* var. *bracteatum*, a finer variety, according to William Robinson, of *P. orientale*, with its mass of luxuriant foliage and huge blood-red flowers 6 to 9 inches across. But Monet's poppies were not invariably red. In addition, there were annual poppies – Californian poppies or saffron-colored eschscholzias – as well as many varieties of opium poppy (*Papaver somniferum*), with flowers in every nuance from slate-gray to vermilion red. He also grew the *pavot cornu*, the seed of which was much solicited by Mirbeau. This horned poppy is one of the glauciums. Mirbeau says nothing of its color, so it could have

been the yellow *Glaucium flavum* or maybe another red one, *G. corniculatum*.

The common field poppies were not the only commonplace plants in Monet's garden. The nurseryman Georges Truffaut and other commentators noted the abundance of others. There were forms of *bouillon blanc* – the common mullein, *Verbascum thapsus*. This biennial has rosettes of white felted leaves and graceful spikes of pale yellow flowers from early summer; and there are related garden forms with flower spikes in soft violet-pink. Mulleins are great self-seeders, but Monet encouraged them particularly in the paintbox beds under his clematis frames, where they grew beside the gray, sword-like foliage of the faded irises in a satisfying textural contrast. Truffaut also noticed the mulleins in another pleasing combination that is still effective today, their light and graceful spikes contrasting strikingly with the heavy oriental poppies planted

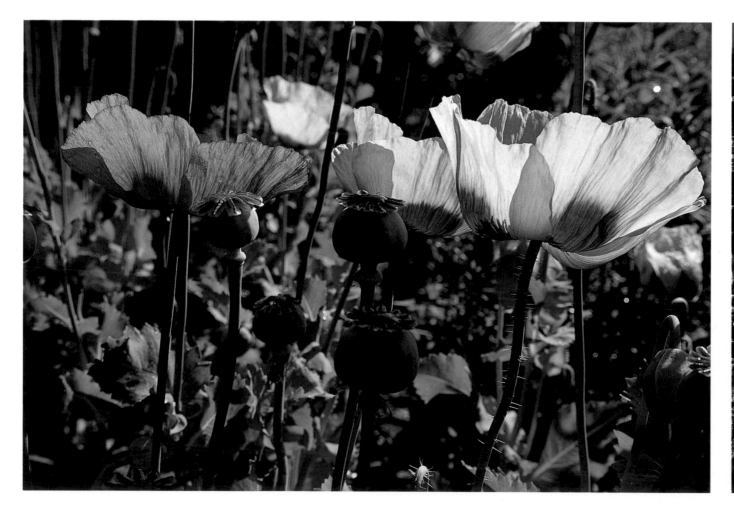

prolifically in the lawns and orchards of Giverny.

Such striking contrasts of form and habit are less pronounced now that the plants at Giverny are intermingled rather than grown in distinct blocks of separate varieties as Monet grew them. Forestier described Monet's approach, saying how Monet "massed his flowers together to the right and left in radiant clumps – of the same variety and color. It was," he said, "like crossing a meadow of dazzling color." Monet's plantings in masses of one variety are effective dramatically, but only for a short period of time. Today a more impressionistic style is favored. This compromise has been evolved to make sure that the display hums a steady flowery tune for the six months that the garden is open to the public. Today's visitors still find the plants Monet grew, but they are mingled everywhere in mixed border style, together with some interlopers to the garden that Monet may not have grown.

BELOW *Three of the many poppies growing at Giverny. From left to right,* Papaver somniferum, *the red field poppy* (Papaver rhoeas) *that almost became Monet's trademark, and pale* Papaver orientale *'Karine.'*

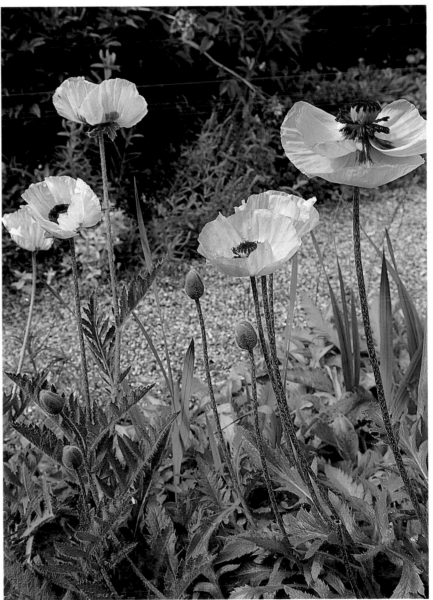

In a yellow paintbox bed, five large yellow Solidago canadensis
are surrounded by a random, pointilliste-style planting in oranges
and yellows. It includes Tagetes erecta F1 hybrids, 'Diamond Jubilee,'
'Golden Jubilee,' 'Sovereign,' and 'Doubloon;' the daisy-flowered
Rudbeckia fulgida 'Goldsturm;' hollyhocks; Coreopsis tinctoria
'Elegant'; Cosmos sulphureus; Zinnia mexicana 'Old Mexico;'
Asclepias curassavica; and a small group of Primulinus
gladiolus 'Merry.' The bed is edged with Chrysanthemum segetum,
Oenothera fruticosa 'Youngii,' and Sanvitalia procumbens, and,
where it borders a path, with English lavender.

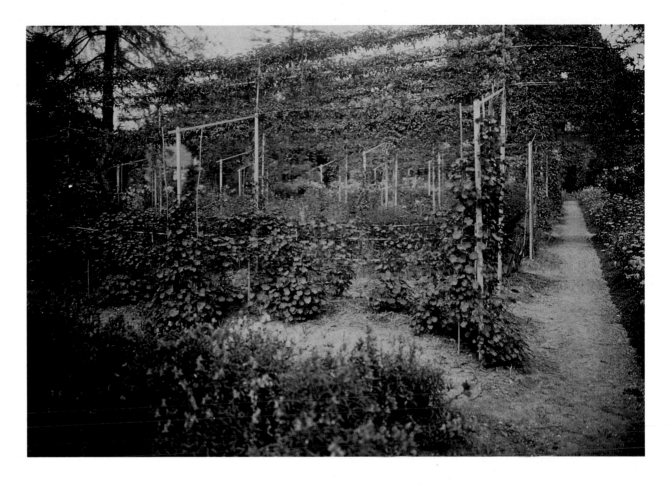

Published in the magazine L'Illustration in 1927, an autochrome shows the starkness of some of the paintbox beds as they were in Monet's time. Far from overflowing with color, the beds look bare and almost neglected.

Summer is when the paintbox beds came into their own. Situated between the garden itself and the compost area, they made an attractive transition between the two. Devised to enable Monet to observe the effect of blocks of color, they also provided cut flowers for the house. Each bed played host to a different flower – gladioli, larkspur, phlox, asters, large marguerites, penstemons, Japanese anemones, snapdragons – sometimes two different colors planted together. The autochromes taken by the magazine *L'Illustration* around 1924, but not published until the year after Monet's death reinforce this "laboratory of color" idea. They show empty beds with nothing more than separate clumps of dark red nasturtiums growing, like some forgotten experiment, on supporting *tuteurs.*

Elsewhere in the garden, larger and longer beds were reserved for more sophisticated effects – runs of beds planted with blues, with deeper blue in the beds in the foreground and softer blue or pale yellow tones farther away. Or, on the west side of the garden, beds planted in hues of yellow and gold, whose colors would catch and radiantly glow in the rays of the setting sun.

The summer garden was eloquently summed up by Alice Kuhn, who called it "a harmonious orgy of colors, of perfumes, of drunkenness of the senses." It typified Monet's appetite for life. He liked the voluptuous, the sensual, the larger-than-life, in the same way that he had a sensual enjoyment of food or of driving in fast cars. Pointing out a new garden acquisition – *Helianthus atrorubens* (syn. *H. sparsifolius*) – he commented that he loved the "*ardeur*, the sumptuousness of their big yellow flowers." Yet at the same time, he admired Japanese restraint and relished the delicacy of simple plants like his field poppies. Everything hung in a delicate balance. Monet's discriminating judgment in both his garden and his art created a vision that has perfect integrity. And this is why his work endures.

By July, the hollyhocks, delphiniums, and cleomes or spider flowers all rose tall, foreshadowing the height of the many varieties of helianthus and dahlias that were to follow in the fall. Everyone who visited the garden was struck by the height and the density of

the plants. René Gimpel reported that there was no flower less than three feet high. Today there are still plenty of tall plants adding their glory to the summer garden, among them *Salvia guaranitica*, *Nicotiana sylvestris*, and *Lythrum salicaria*. Monet emphasized the height of his plants even more by banking the soil up in all his borders. Not only did this have the effect of making the plants appear taller, and more dramatic, profuse and exuberant, but more plants could be fitted in. Today, only the Grande Allée is markedly banked up, the rest of the beds only gently.

The delphiniums were one of the plants given this banked-up treatment, their blues enumerated by Alice Kuhn – porcelain blue, azure blue, royal blue, clear dark blue. As with many of Monet's other flowers, the delphiniums are no longer grown *en masse* as they once were. Their presence is still felt, but now they are dotted around, adding their blue splashes here and there.

The tall hollyhocks – *roses trémières* – were also special to Monet. Soon after arriving at Giverny, he expressed concern that a worker digging in a border by the chicken run might damage some hollyhocks planted there. A very early pre-Giverny sketch pad reveals that he sowed his hollyhocks not in one or two rows, but in seven. Hollyhocks have always grown well in Giverny. Truffaut said that they grew well in the poor soil, and today's gardeners report that some of those now in the garden have been there for ten years. Hollyhocks are notoriously susceptible to rust, though, and a careful watch is mounted to prevent it. Unlike the roses that are sprayed with fungicide every two weeks after their buds break and the first new shoots appear, the hollyhocks are sprayed once a week in spring as soon as their leaves are out. But by June, the gardeners are so busy planting out annuals that they have no time to carry on treating the hollyhocks. They have to trust that the early preventive spraying has done the trick. All they can do now is keep an eye on them, and if either rust or red spider mite is spotted, the affected leaves are removed and destroyed.

Even as summer arrives, the gardeners still have some planting out to do. Many varieties of bachelor's buttons, more fragile than the Canterbury bells, are planted out very late, only when all risk of frost is well past. Last of all come the China asters or "*reines-marguerites*" (*Callistephus chinensis*), which are planted out bare-rooted early in July, with a sprinkling of slug pellets to protect their susceptible young growth.

Once the annuals are in, the gardeners have a sudden change of gear. All the months of planting and the encouragement of rapid growth are replaced by the constant vigilance needed to contain it.

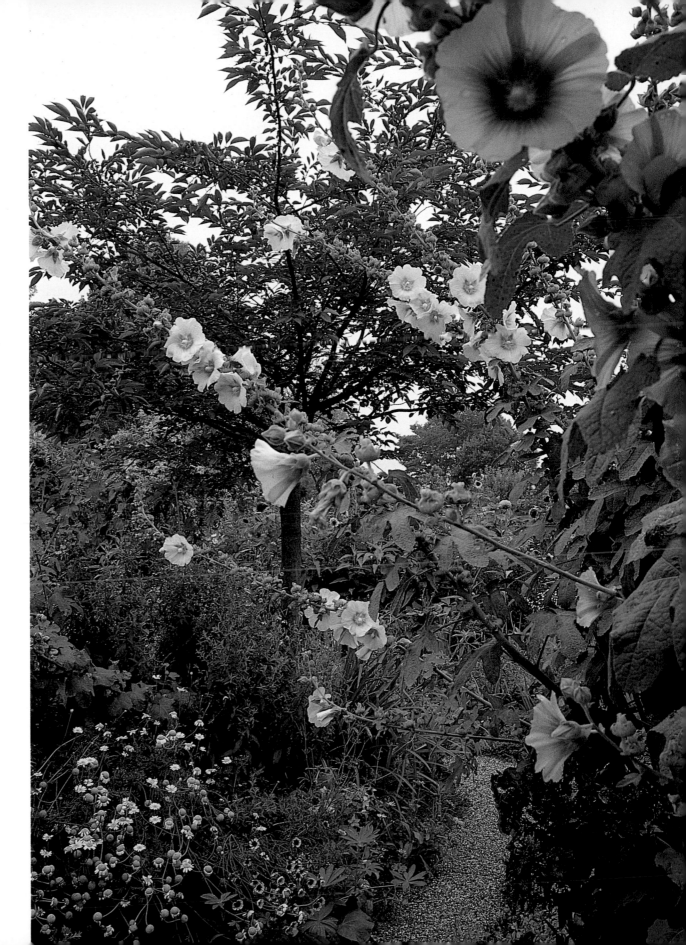

LEFT *Color in the borders at the height of summer.*
ABOVE *Delphinium hybrids, the long-flowering* Solanum rantonnetii, *and* Salvia farinacea *'Victoria.'*
CENTER Cosmos bipinnatus *'White Sensation,'* and C. b. *'Gloria Sensation,'* veronica, Cleome hassleriana, *and* Ageratum mexicanum *'Top Blue.'*
BELOW Nicotiana *'Nicki Red,'* the pink Rosa *'Hermosa,'* Nanus gladiolus *'Elvira' about to open, and a touch of the silver* Tanacetum ptarmiciflorum *'Dentelle d'Argent.'*

RIGHT *One of the many self-seeding hollyhocks at Giverny. Whether they are left or pulled out depends on the goodwill of the gardeners. Beneath the hollyhock is a* Phlox paniculata, *and on the other side of the path is* Anthemis tinctoria *'Kelwayi.'*

MIDSUMMER ALONG THE GRANDE ALLÉE

The floral tunnel along the Grande Allée consists of tall, medium, and short plants, the tallest appearing even taller because the soil is banked up to a height of 3 feet.

The standard roses in the borders and those growing over the six metal arches form a permanent framework to the ever-changing planting beneath:

ROSES

1 Noisette 'Maréchal Niel'
2 'Paul's Scarlet Climber'
3 Rambler 'Dorothy Perkins' and climber 'New Dawn'
4 Ramblers 'Dorothy Perkins' and 'Albertine'
5 Climber 'Sympathie'
6 Rambler 'Albertine'
7 Standard 'The Queen Elizabeth'
8 Standard 'Robin Hood'
9 Standard 'Palissade Rose' syn. 'Pheasant'
10 Standard 'Prima Ballerina'

SHORT PLANTS

Zinnia 'Lavender Dream'
Antirrhinum 'Sonnet', *A.* 'Tapis rouge'
Climbing nasturtiums
Nicotiana Nicki Series
Nicotiana Domino Series
Tagetes signata pumila
Red busy lizzies and white busy lizzies

MEDIUM PLANTS

Antirrhinum 'Rocket'
Lychnis coronaria Atrosanguinea Group
Verbena rigida
Dahlia 'Jet'
Rudbeckia fulgida
Rudbeckia hirta Mon Plaisir Group
Salvia farinacea 'Victoria', *S.f.* 'Annapurna'
Salvia farinacea 'Féerie Bleue'
Primulinus gladiolus 'Merry', *P.g.* 'Perseus'

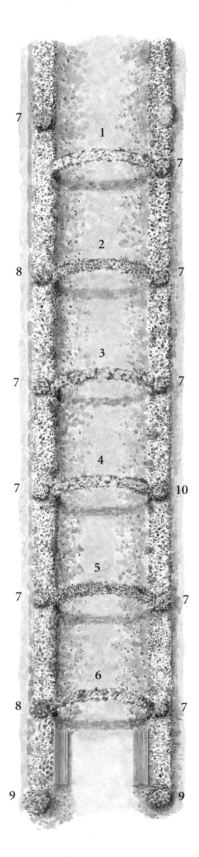

Primulinus gladiolus 'Lady Godiva', *P.g.* 'White City'
Chrysanthemum coronarium, C. segetum
Scabiosa atropurpurea 'Double Oxford Blue'
Cleome hassleriana Color Fountain Mixed
Amaranthus tricolor
Lysimachia punctata
Cosmos sulphureus 'Diablo'
Nicotiana 'Nicki'

TALL PLANTS

Helianthus rigidus
Lythrum salicaria
Nicotiana sylvestris
Helianthus annuus Beauté d'Automne Group
Helianthus annuus 'Géant de Californie'
Helianthus annuus 'Holiday'
Cosmos bipinnatus 'Sensation'
Tithonia rotundifolia 'Torch'

OPPOSITE ABOVE *Along the outer, west-facing border, the bold chocolate-purple foliage of* Amaranthus tricolor *and the white tobacco plant* Nicotiana sylvestris *are surrounded by a cottagey jumble of yellow and orange. The planting is dominated by mahogany-centered* Rudbeckia hirta, Helianthus rigidus *'Mon Plaisir,'* R. hirta *'Marmalade' – brilliant yellow with black centers.* Chrysanthemum segetum, Cosmos sulphureus *'Diablo,' and* Lysimachia punctata *add smaller splashes of yellow and orange, while* Salvia farinacea *'Victoria' provides a blue accent.*

OPPOSITE BELOW *Creeping nasturtiums are backed by an array of pink bulbs and annuals. Cream-throated pink* Primulinus gladiolus *'Merry' jostle with the dahlia 'Jet' and with the airy spikes of* Lythrum salicaria. *The only bed in the garden to be banked up, the extra height spotlights the fritillaries, eremurus, Giant Cactus dahlias, and Mexican sunflowers that play their part in the drama at different times of the year.*

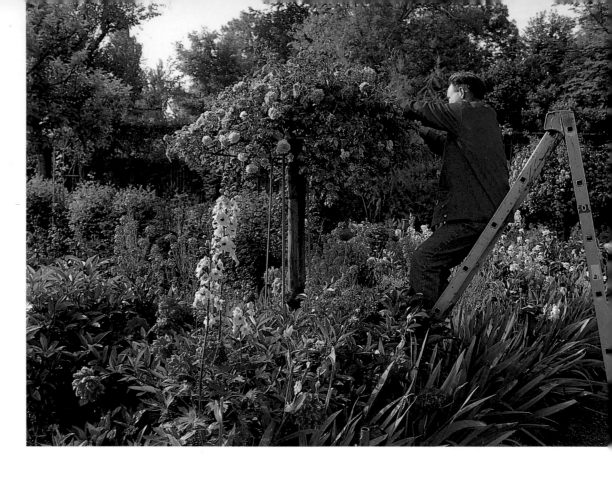

RIGHT *Didier Van Euw methodically deadheads a weeping standard* Rosa 'François Juranville' *on a day when the garden is closed to the public. The rose rises from a sea of green – rolling waves of hesperis, poppies, and peonies.*

By July, the gardeners are concerned with shaping and controlling growth, supporting plants, and even cutting some back.

Generally, the plants that are grown from seed such as *Nicandra physalodes*, *Salvia guaranitica,* and *S. verticillata* are pinched out while they are still in the greenhouse to encourage them to make sturdy, bushy plants. After they are planted out, the gardeners continue to pinch them out or else they acquire a spindly, floppy habit which is difficult to mask. In addition, the two tall impatiens, *Impatiens glandulifera* and *I. balfourii,* are pinched out to stop them from choking medium-sized plants.

Spent plants are systematically either deadheaded or removed, depending on the merits of their foliage. The sweet rocket that served as a foil for the irises in spring is deadheaded, and its discreet foliage acts as a host for later annuals to grow through. Other plants with good foliage such as *Clematis recta*, *Delphinium* × *belladonna* hybrids, and *Lysimachia punctata* are also left in place and deadheaded. The perennial honesty (*Lunaria rediviva*), by contrast, has coarser leaves which turn an unsightly red and green, so this is treated as a bedding plant and is pulled from any borders that face the public.

An interesting technique that I have not seen practiced elsewhere is the cutting right back of some perennials after flowering. At Giverny, in the case of perennials that flower only once, the gardeners prune them very hard if they know that the foliage is not particularly attractive and will only deteriorate. Cranesbill geraniums such as *G.* 'Johnson's Blue,' which has good foliage, but tends to become leggy and sprawling, are cut hard 4 inches from the base; at the same time as this is done, annuals are planted around them. *Geranium pratense* f. *albiflorum* is so rampant that it is cut back twice, and the day lilies are cut back three times a year – in winter, in spring to keep them in check, and then again after flowering, to allow room to plant large numbers of cleomes and cosmos among and around them. The new crop of foliage, the Giverny gardeners believe, is often much more beautiful than the first. As the annuals grow up and among the fresh green herbage of the shorn perennials, some unusual effects are created. The juxtaposition of perennial foliage with annual flowers causes no small puzzlement to visitors who try to identify the unfamiliar plants. Inevitably, some annuals and some perennials are sacrificed in this ruthless procedure, but overall the Giverny team finds the results worthwhile in terms of keeping the beds well furnished with flowers and interesting foliage.

In addition to orchestrating these low-level effects, the gardeners

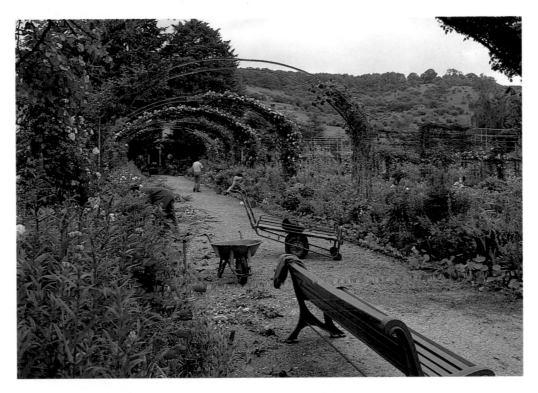

A great deal of behind-the-scenes work goes
into keeping the summer garden at its best.
The gardeners have just planted out the
crimson Lychnis coronaria *in the Grande
Allée (left), taking advantage of a day
when the garden is closed.*
*A pause for lunch (below left). After their
break the gardeners will use this four-
pronged fork – traditionally used to spread
manure – to pick up prunings and load
them into the wheelbarrow.*
*When the watering heads (below center)
are replaced in spring, their labels indicate
where they are to go.*
*Tiles shade clematis roots (below right)
from strong light in the paintbox beds.
A native of forests, clematis scrambled
through trees to reach the light, but their
roots were always protected on the dark
forest floor.*

are kept busy looking after the taller-growing plants, particularly the latecomers whose performance does not get under way until toward the end of summer. By the end of June, when they reach the height of 12 inches, the asters and dahlias need staking with Vahé's famous green-painted *fers à béton*. The giants like hollyhocks, sunflowers, and anchusa also need the strong support of the *fers à béton*. Once these plants become top-heavy, their stems are impossible to straighten, and they fall over and crack in the middle. Very slender bamboos with supple wire or thin string are used to support finer plants such as solidago and *Coreopsis tinctoria*. Every third stem is staked and supports the two neighboring plants as well. The much-used bachelor's button is a weak plant, but too spindly to stake unobtrusively, so the gardeners find hosts for it such as hollyhocks and phlox.

One special routine peculiar to Giverny involves the training of the nasturtiums, which by June are beginning to grow vigorously in the borders alongside the Grande Allée. When their trailing stems reach some 15 to 20 inches long, the gardeners start guiding them toward the middle of the path. Once they reach 36 inches long, the leaves and growing tips are cut back to reveal the flowers and put a brake on their growth.

One or two major gardening jobs dominate at Giverny in July and August. Ideally, every two years, the bearded irises are divided and replanted, but this sometimes has to be extended to four years. This is true especially on the west side of the garden, partly because there are so many irises there and the work involved is enormous, and partly because the beds would look empty and this would not please the visitors. When the irises are dug up, any weak or diseased plants are thrown out and the best ones selected for replanting. The healthy portions of rhizome are cut, keeping this year's and last year's growth and discarding the older, congested material. The roots are trimmed to 2 to 4 inches and the leaves neatened. The tallest (and oldest) leaves are cut halfway down in a point, leaving the newest leaves intact in the middle. This trimming minimizes water loss, prevents the newly planted rhizomes from being rocked by the wind, and looks more "*esthétique*." The rhizomes are replanted in two neat rows following wires (later removed) running the length of the beds. Irises like Giverny's poor, limy soil and dry conditions, so they are not fed. It is important, however, to keep them weeded, and this is done fastidiously, especially to eradicate the roots of the invasive *Helianthus rigidus*. When the gardeners redo a whole border of irises, they put granules of selective weed-killer on the surface of the soil to suppress the germination of weed seedlings. Many new varieties of iris are being planted every year, and particularly good and interesting ones – especially pink irises, notorious for their fragility – are noted and labeled with future propagation in mind.

Another major chore for the gardeners in August is to sterilize the soil in the nursery fields in the middle of the village, where the biennials are grown on after sowing in the greenhouse. A tried and trusted method is used. The prepared bed is rototilled by tractor. The soil is then steamed by machine and two iron lids each two and a half yards square are immediately placed on top. They work like the lid of a casserole – the tremendous heat rising from the soil is contained within the lids and kills off all the bacteria, insect eggs, bugs, and fungal spores. Then the beds are marked out with string into sections wide enough for a gardener in each section to weed and plant four lines of plants. A layer of peat is raked over the surface and, by late August, the ground is ready for the biennials to be planted out.

This method of sterilizing the soil has also recently been used on the two island beds in front of the house where, from August on, the bedding geraniums were rotting. Their shady position and the irrigation sprays were exacerbating the situation and lowering the plants' resistance to fungal infection. Sterilizing the beds by this steam treatment has helped to solve the problem, but since it can only be done on a completely empty bed, it is a drastic measure as far as these very prominent beds are concerned, to be resorted to only in an emergency. Meanwhile, any recurrence of the problem is kept in check by treatment with a fungicide for both the soil and the plants.

Perhaps a similar strategy would occasionally have helped Monet. "Thank you for the border plants," wrote Monet to Caillebotte in July 1893, "but I fear they won't take, it's so hot and dry here. It's a disastrous year for my poor garden because on top of the dryness I've got white worms that are devouring everything. Every day it's ten to twenty plants and I destroy these foul beasts in their thousands – in short, it's a real disaster and I don't know if they will leave a single plant."

Pests and the weather – complaints familiar to every gardener. If there was not drought, there would be torrential rain. Then as now, by August, as the garden neared its climax, the blowzy flower heads on towering stems were particularly vulnerable to adverse weather. A heatwave would parch all the foliage; storms would batter the flowers to pieces. "I have fled Giverny," wrote Monet from La Manche in August 1908, "disgusted by the bad weather, my poor garden devoid of flowers."

The dividing and replanting of the border irises is a labor-intensive process. After they have finished flowering, Makan Niakate digs the plants up (left); Sandra Bertin follows to "top and tail" the rhizomes (below); the irises are ready for replanting, but only the best will be used (bottom left); Makan replants them in two straight rows using the black wires as guidelines (bottom right).

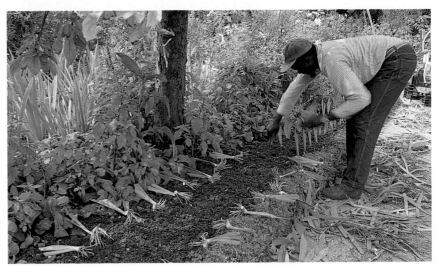

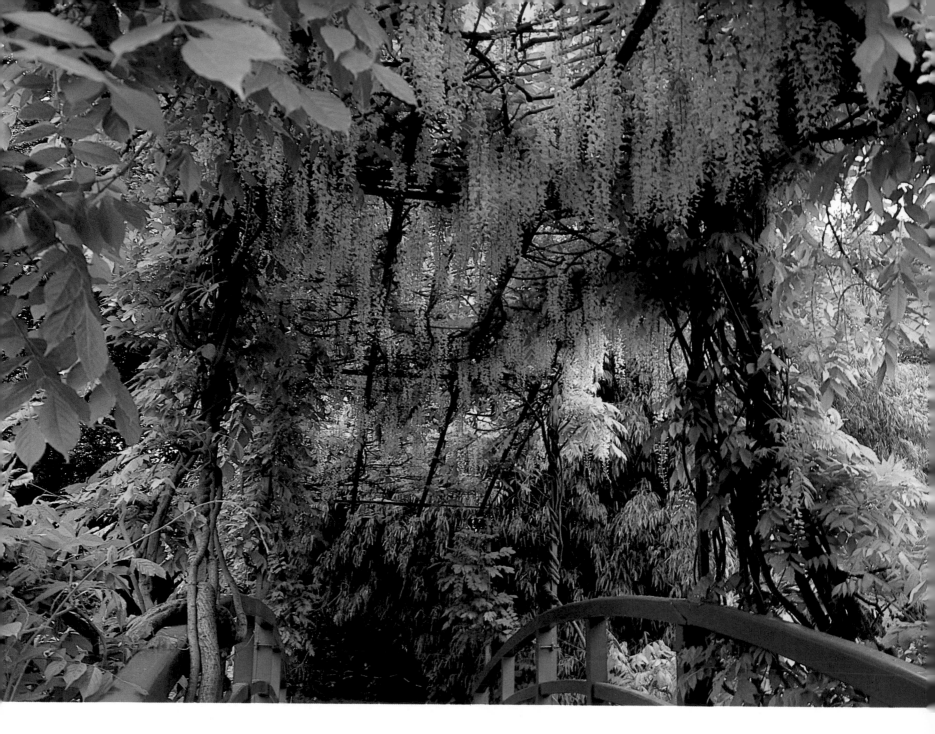

From the month of June, the water garden, shaded by poplars and willows and framed by tall aspens, was covered with flowers of many colors and was, in Georges Truffaut's opinion, *"le véritable enchantement"* of Giverny. Truffaut described the Japanese bridge so familiar from Monet's paintings, with its marvellous decoration of mauve-flowered wisteria high overhead and long pendent white flower clusters at a lower level. Nowadays, there are both colors on top, the white – *Wisteria floribunda* 'Alba' and *W. sinensis* 'Alba' – following the mauve – *W. floribunda* 'Multijuga' and *W. sinensis*. In August, once they have all flowered, the wisterias are pruned to remove the bean-like seed pods and any untidy trailing shoots, as well as to encourage ripening of the flowering spurs.

SUMMER SPLENDORS

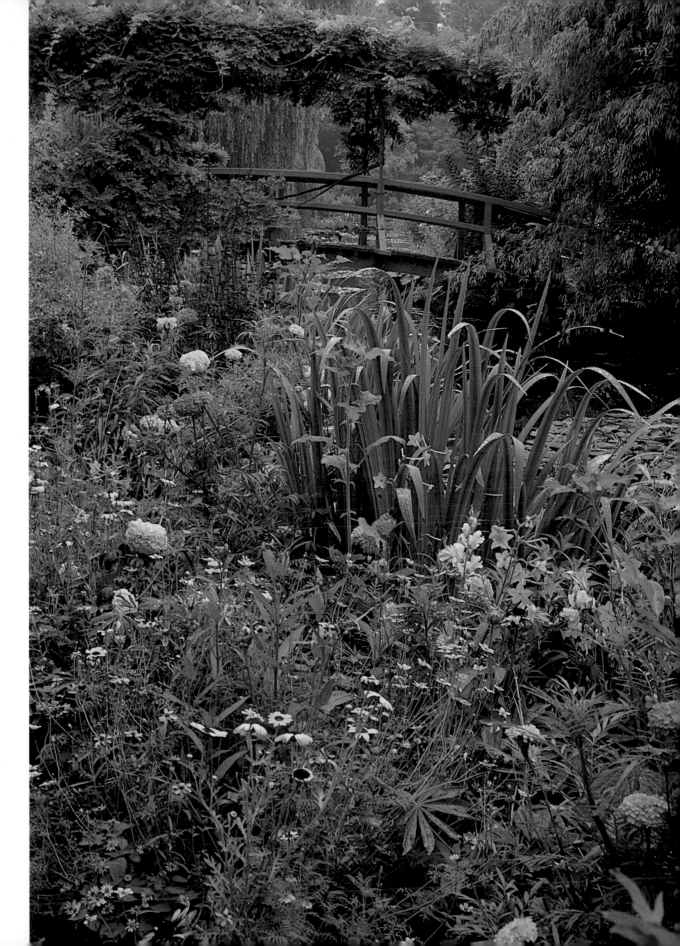

LEFT *A symphony in white and green, the Japanese bridge is clothed in the long white racemes of* Wisteria sinensis *'Alba.' This was Monet's original wisteria, cut down when the bridge was rebuilt during the restoration, but coming up again today of its own accord.*

RIGHT *The jumble of yellow annuals that has been planted by the water's edge acts as an attractive deterrent to keep determined amateur photographers from trampling over the banks.*

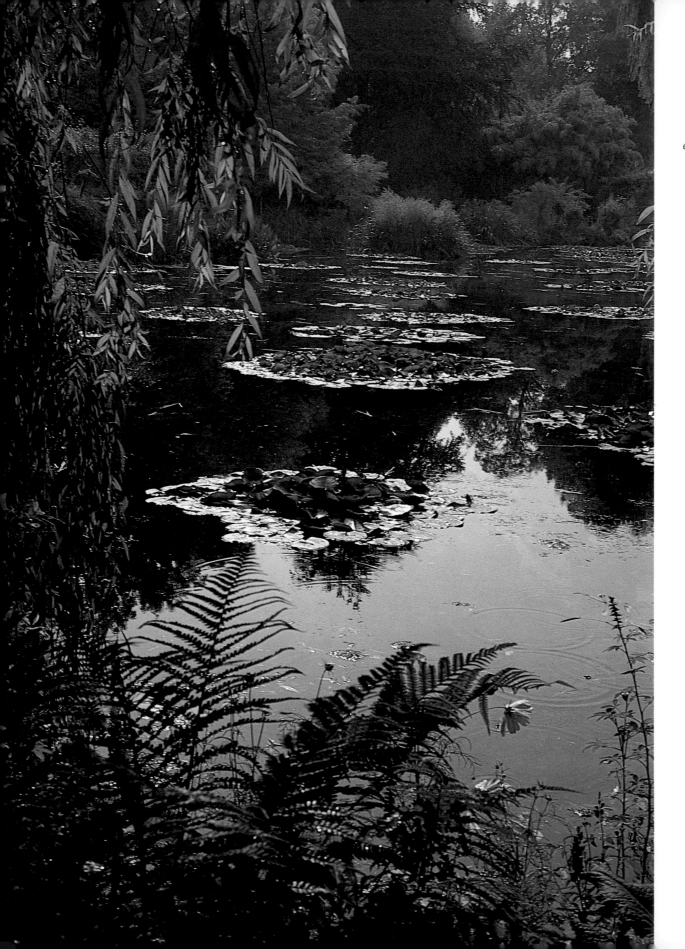

FAR RIGHT *In a photograph that appeared in 1924 in* Jardinage, *Monet shows its editor Georges Truffaut around his collection of Japanese tree peonies in the water garden.*

LEFT *On a wet summer afternoon, rafts of water-lily pads float on the calm, unfathomable surface of the pond.*

RIGHT *The rich yellow of a tree peony (*Paeonia × lemoinei*) glows among the dark foliage of a mahonia.*

In addition to wisteria, other exotic plants such as peonies and bamboos carried on the Japanese theme. According to Truffaut, the oriental effect was a complete success: "the herbaceous peonies, in colors varying from white with yellow flecks to a vivid violet-toned red, beneath gold groups of laburnums, give one the impression of being transported to the suburbs of Yokohama." Monet particularly wanted his tree peonies – probably varieties of *Paeonia suffruticosa* which he obtained direct from Japan around 1904 from his friends the Kurokis – to stand out as oriental "accents." For these he had large circles cut out of the grass, which picked up and repeated the motif of the circular rafts of water lilies in the pond. The oriental theme was continued with Monet's bamboos. "Monet is starting plantations of the large bamboos around the pond," reported Alice to her daughter Germaine in February 1906, "and he does not leave it." But a month later, severe night frosts threatened his plans: "Monet is disconsolate, his dearly cherished bamboo plantations are in jeopardy." Eighteen years later, the bamboos were thriving. Truffaut observed: "A sizeable plantation of bamboos emphasizes this [oriental] effect. These bamboos have become as big as trees, seven to eight yards high, and form a dense wood where the artist has cleverly selected his beautiful views."

Monet planned his water garden to create an atmosphere quite different from that of the flower garden. Against the backdrop of tall trees, the ornamental shrubs and trees with which the area was predominantly planted were grown not so much for their individual

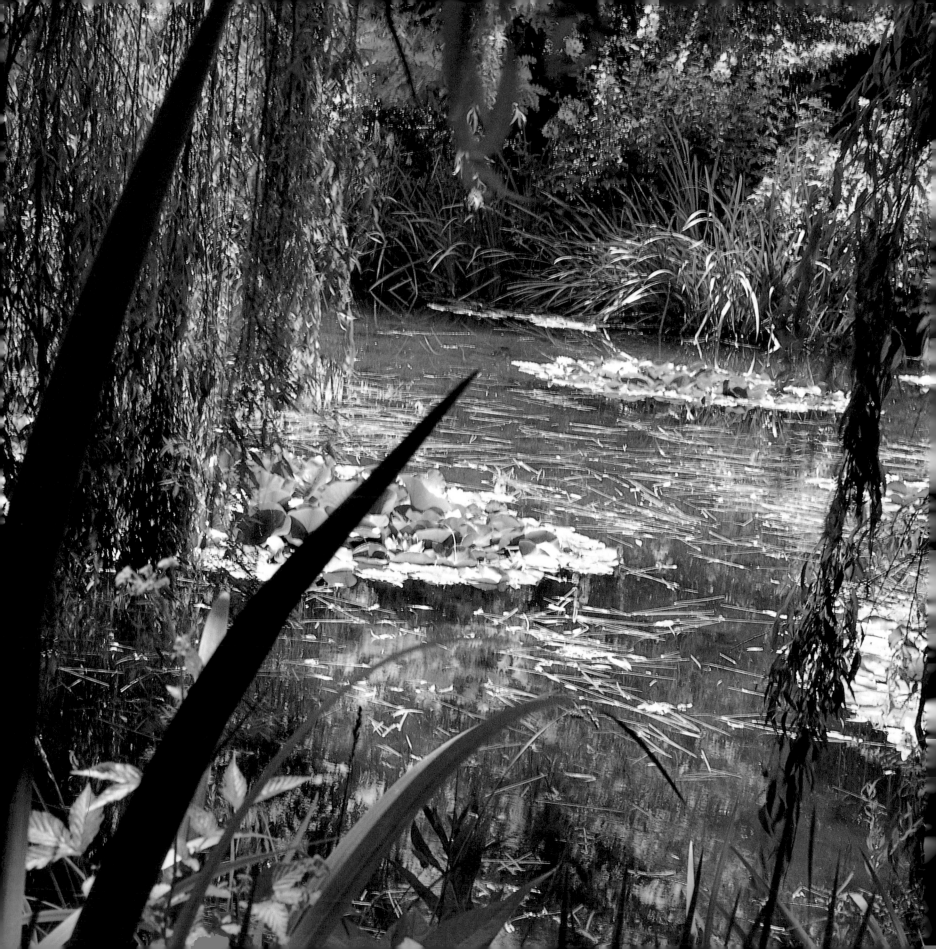

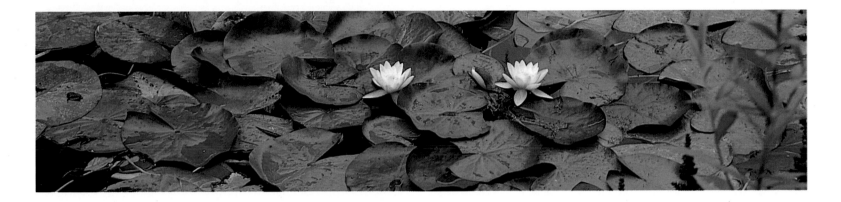

qualities – with perhaps the only exception being made for the Japanese tree peonies – but to make a setting for the mirror-like expanse of water. Even the roses that garlanded the water garden were diffused masses of color rather than special features singled out for attention.

As he grew older, the rainbow-colored horticultural excitements of Monet's early years at Giverny changed to subtler pleasures, the ephemeral, intangible images of a single flower – his last love, his water lilies. Leaving behind the hundreds of flowers he had enjoyed, he moved from the garden of dimension that had preoccupied him for many years to a garden of reflection, focusing almost obsessively on this one flower for the rest of his life. The novelist Marcel Proust compared the rafts of lilies on the pond to floating flowerbeds and the petals of the water lilies to the wings of butterflies. Monet was well into his fifties when he first began to paint this reflected garden. Feeling his age, perhaps, he murmured in his letters about his first rheumatic pains, the result of many winter mornings spent painting in freezing fog waiting for dawn, followed by evening vigils waiting for dusk. At least the water lilies kept civilized hours, opening at ten thirty each morning and closing at five. As Marc Elder put it, "Like all beautiful people, the water lilies rise late and even then the sun has to come and beg them to."

In the water garden in Monet's time, the gardeners were preoccupied with curbing the rampant growth of the water lilies. Head gardener Félix Breuil, in an interview exactly thirty years after he retired, recalled the task as "a fight against rampant growth and crowding, preventing certain varieties from dominating exclusively while allowing them to look natural." Now, thanks to the muskrats, the gardeners are happy to find the water lilies even alive at the end of the winter. Partly as a consequence of the depredations of the muskrats, the water-lily varieties have become mixed up over the

years, and no one is sure of the names of those that are still there. There is no complete list of those Monet himself planted, although the records of the celebrated Latour-Marliac firm offer tantalizing glimpses. In May 1904, for example, they dispatched to Monet one each of *Nymphaea* 'Arethusa,' 'Atropurpurea,' 'James Brydon,' and 'William Falconer' – all of which still appear in catalogs today. In 1897 Latour-Marliac also quoted prices for *N. stellata* and *N. capensis* var. *zanzibariensis*, tropical species either intended for an indoor pool or for planting out in summer. Breuil remembered, "We had white, yellow, red – the red more or less marked – some blues too, exotic varieties prepared in the greenhouse." He found that the varieties *de haut fond* [the shallow-growing ones] did best, and took only two to three years to make a sizeable pad. "The cultivation of the water lilies is simple enough but requires a special touch. The plant is robust, normally fecundity is assured by the bees, and crossings are frequent." Monet experimented with installing a special cement basin in the pond to accommodate the more tender species, but they all died and the basin was removed. He continued, however, to grow his blue water lily (*N. capensis* var. *zanzibariensis*) in his greenhouses.

Elsewhere in the water garden, the acid-loving rhododendrons, kalmias, hollies, and ferns do not grow too vigorously, but increase steadily and slowly, helped by ample additions of acidic soil and peat. The gardeners use a special water-permeable wrapping for the roots of new calcifuge plants. This allows moisture in but keeps the calcareous elements out.

LEFT AND ABOVE *Turning from the floral fireworks of the Clos Normand, Monet planned a garden of reflection and mystery. His last love – the water lilies – float like delicate butterflies on the mirror-like surface of the pond.*

At the height of summer, Giverny rarely provides the intimate and personal experience such a garden should. You can try to time your visit to avoid the crowds, but if you do find yourself among the busloads of adults and school children all talking at once and all in different languages, with a thousand cameras clicking away, Monet's spirit will have fled and cannot be prevailed upon to return. This is the moment to seat yourself on one of the many accommodating benches and just enjoy the pageant. As used to be said of 42nd Street, if you stand there long enough, the whole world will eventually pass by – and there are times at Giverny when you think it has. But do not forget that in Monet's day, eight children were brought up here, children who scampered up and down the paths, ate the sunflower seeds Monet wanted to save, threw their balls into the summer flowerbeds, then skated over those same beds when they froze over in winter. Together with these children and Monet's many visitors, the garden also had to accommodate the six gardeners always needing instruction and keeping in line. Monet must at times have felt just as crowded in his garden as today's visitors.

ABOVE *A tangle of pinks in an end-of-summer jumble in front of the veranda.*

RIGHT *In late July, the annual sunflowers are already rising tall, but the rudbeckias, perennial helianthus, and other yellow annuals and perennials that will soon camouflage the house completely are just beginning their ascent.*

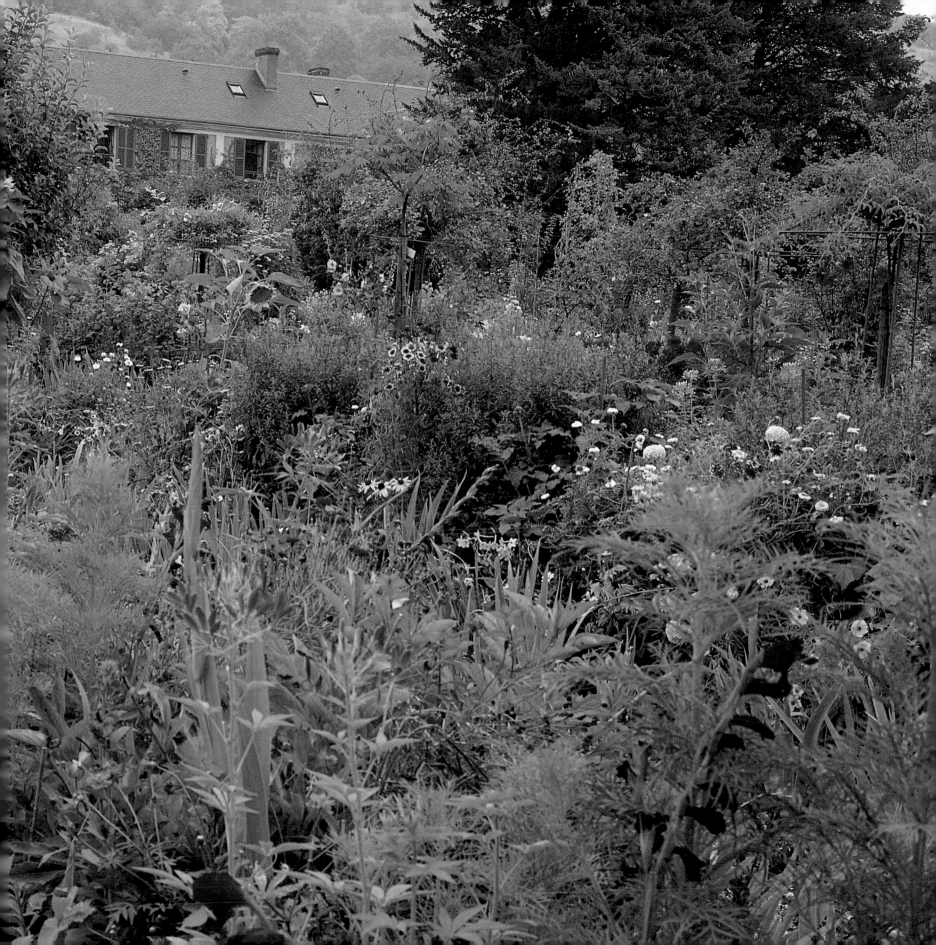

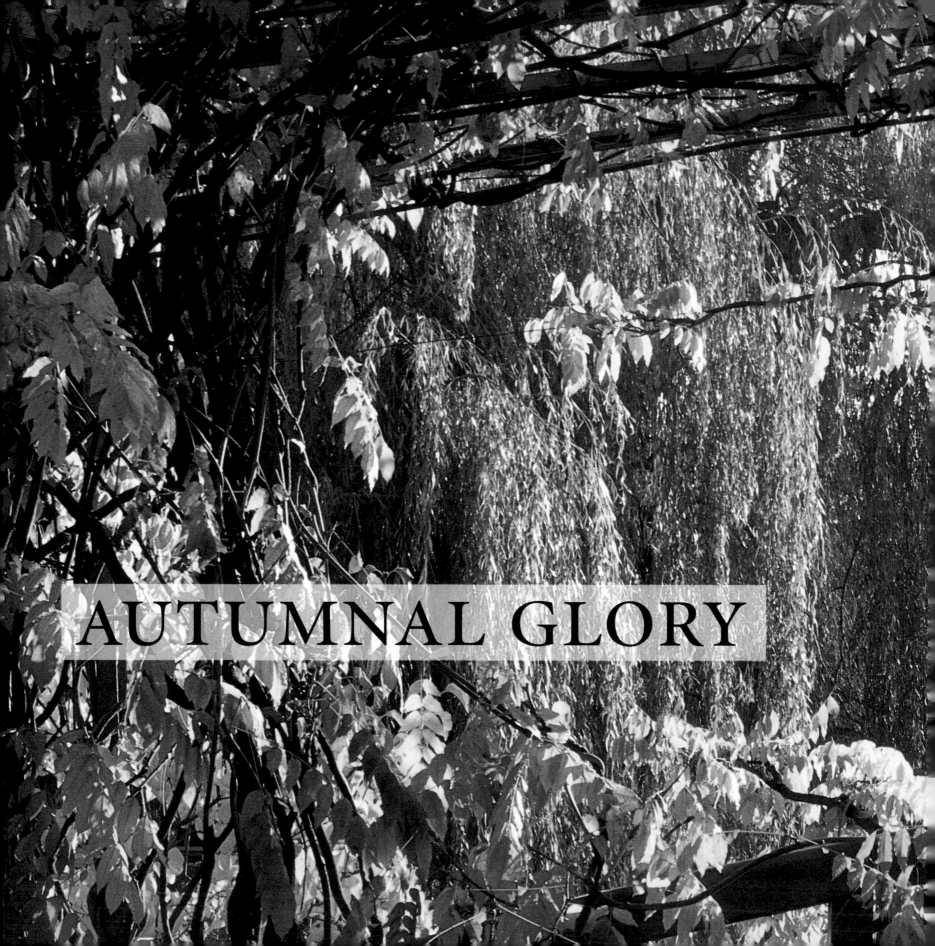

AUTUMNAL GLORY

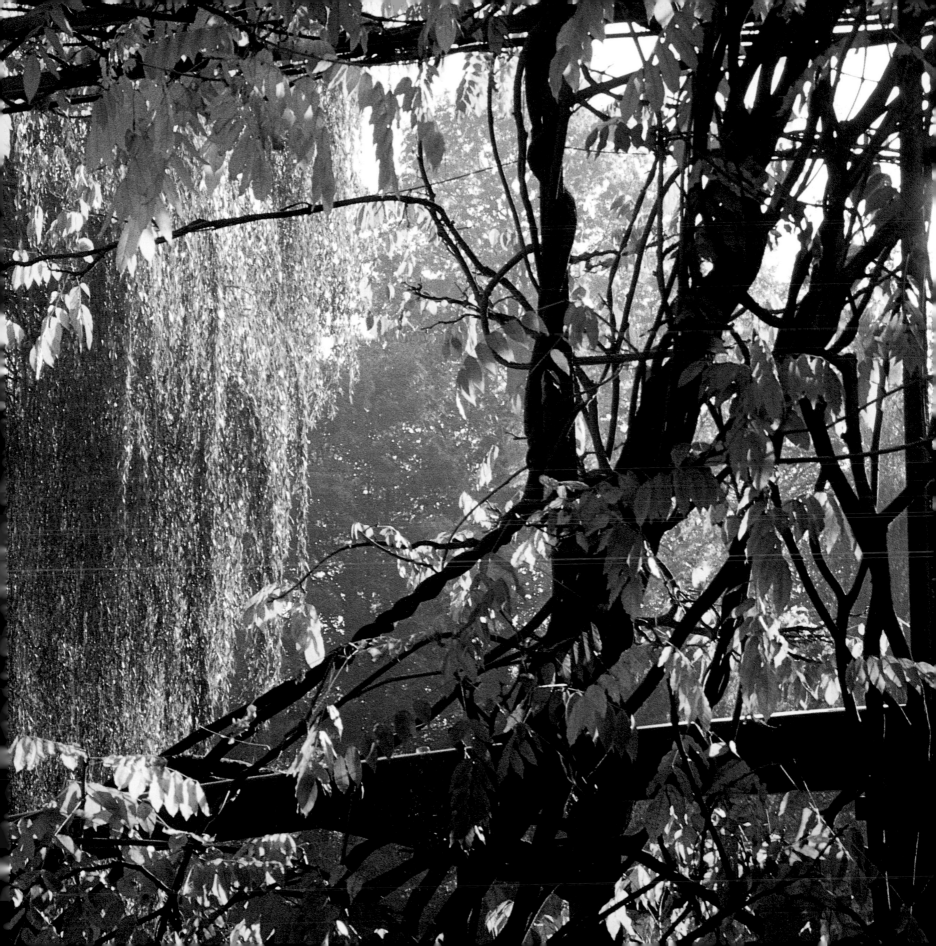

> *"Everywhere you turn, at your feet, over your head, at chest height, are pools, festoons, hedges of flowers, their harmonies at once spontaneous and designed, and renewed at every season . . ."*
>
> ARSÈNE ALEXANDRE

Early-morning mist rising from the Epte often envelops the fall garden and dissipates only slowly in the warmth of the sun. This is Giverny's most atmospheric and magical of seasons. Like so many smiling faces, a few enormous sunflowers and the many yellow blooms of the lanky *Helianthus × multiflorus* are the first to peep through. Next come the Cactus dahlias which reign over the borders. When the mist has evaporated, clouds of asters offset the heaviness of the dahlias and sunflowers. The garden glows in a mantle of red, pink, purple, and gold, enhanced by reddening, yellowing foliage everywhere. Marigolds, heleniums, heliopsis, rudbeckias, and many varieties of helianthus carry the autumnal torch for the golds and yellows. The cleomes gradually turn into decorative spiky seed heads, their pink and white theme picked up now by the prolific flowers of pink and white cosmos.

PREVIOUS PAGE *Early fall and the water garden is resplendent in shades of gold.*
ABOVE *The dark red Dahlia 'Arabian Night.'*
RIGHT *The pale pink façade of the house rises from a sea of deep pink cosmos, and velvety red dahlias.*

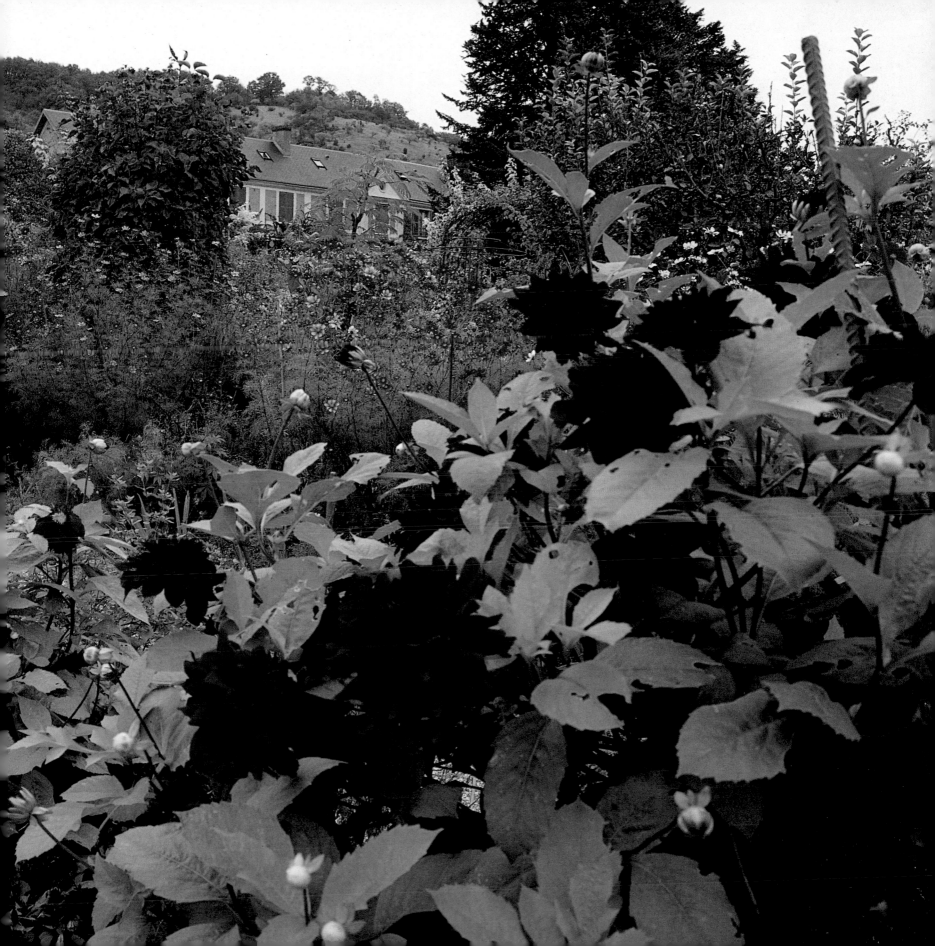

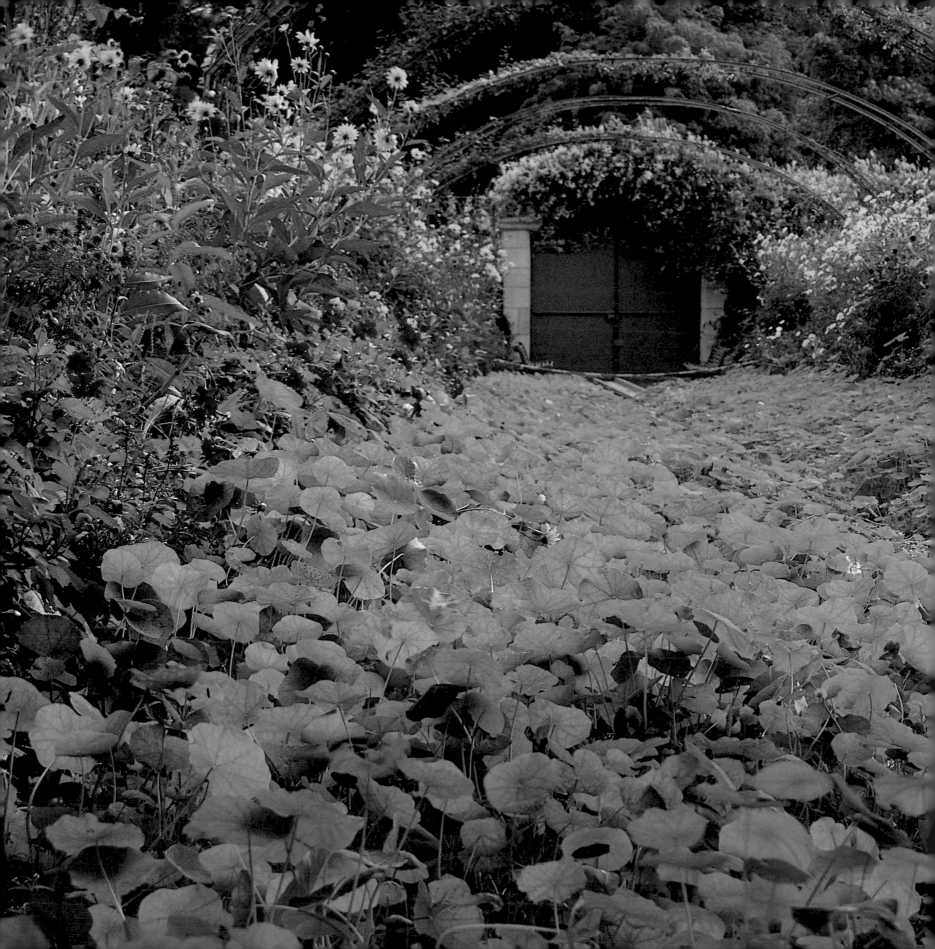

Giverny has often been compared to a carefully orchestrated display of fireworks, and as we all know, in a firework display, the most spectacular effects are always saved for last. But the tension in the air as the striking reds, golds, and yellows of the dahlias, sunflowers, and the famous Grande Allée nasturtiums all blaze out is increased by the knowledge that the firework display could disappear overnight with a single sharp frost.

At no other time of year does the weather play upon the garden as forcefully as now. Capricious swings in mood deliver blessings and blows with careless unpredictability – a cocktail of rolling clouds, thunderous skies, blazing sun. The flowers bask one moment in the warmth of hazy Indian summer sunshine and then are suddenly pummeled by fierce rain and gusting winds. The painstaking and time-consuming attention the gardeners have paid to the *tuteurage* – the neat tying up and staking – now fulfills its purpose and keeps the garden on its feet until the closing date of October 31. Storms and winds can do their worst, but the dahlias and sunflowers safely anchored to their metal stakes stay upright and unassailable until vanquished by frost.

The Grande Allée is at its peak now, a vision of purple and yellow. Flanked on each side by the dark red *Dahlia* 'Jet' and mauve asters, the Grande Allée today looks much as it does in Monet's well-known 1902 painting, with its young nasturtiums and purple asters in bloom. Shimmering above them, the pink and white flowers of the painting are too formless to identify, but the Grande Allée at this time was always said by Monet's visitors to be full of dahlias. Perhaps what we can see in the painting are pink and white dahlias; or they may be cosmos or Japanese anemones. Who knows? Perhaps Monet has rendered only an impression of the scene.

The *pièce de résistance* – unique to Giverny – is, of course, the carpet of trailing nasturtiums leading the way along the Grande Allée toward the front door. This effect was already in place in 1892, according to a photograph from that date, and was possibly used even earlier. How was it conceived? One can only guess. On fine, warm days the family lunched on the wooden green veranda that

There may be another source of inspiration for the nasturtium-lined Grande Allée. The first Impressionist salon was held in 1874 on the Boulevard des Capucines. Perhaps Monet was inspired by the idea of a boulevard of nasturtiums, capucines *being French for nasturtiums.*

ran the length of the house, under a canopy of Virginia creeper, roses, wisteria, and aristolochia. Monet always sat with his back to the house, facing the garden and gazing down the Grande Allée. Alice's refusal to let him cut down the spruces prevented him from planting this pathway as he would have wanted it, and one can imagine the many hours he must have sat there contemplating the long, wide, monotonous stretch of gravel. The central axis of the Grande Allée was a crucial element in the garden's layout, leading to the gate, beyond which lay the road and a railroad track. Later, of course, Monet would continue the line of the path across the road and over the little Japanese bridge in his water garden; meanwhile, he must have longed to fill this drab expanse of bare canvas with color. He would have noticed in other situations the creeping, trailing habit of climbing nasturtiums and their capacity for covering the ground far beyond where their roots are anchored, and, being a canny and resourceful character, he may have thought that this would solve the problem of the Grande Allée. The sturdy, reliable nasturtiums were planted on either side and allowed to creep toward one another and toward the light in the middle of the path. By September, only a narrow sinuous path was visible between the sea of undulating leaves, brilliantly translucent in the sun and making waves of frothy acid-green on which floated orange flowers. The whole concept was not that far removed from the water lilies that would later float on his pond. Even the disk-like leaves of the nasturtiums echo the shape of the water-lily pads that were to come.

At Giverny today, great care is taken to make sure the nasturtiums perform on cue. The seeds are planted in spring directly in the soil along the Grande Allée after being soaked for twenty-four hours in warm water. The seeds, two planted every 2 inches, are supplied wholesale by weight, and identified as nothing grander than "medium high," "high climbing," and so on. Although extra sowings are made in the greenhouses simultaneously in case the seeds fail in the main garden, they have always proven dependable and so far have carpeted the whole of the Grande Allée by mid-September every year.

Nasturtiums figured prominently in Monet's late summer and fall garden, and as with all the favorites of his early years, he remained faithful to them, growing annual and perennial varieties over many years. He grew some – probably annuals rather than perennials – up the *tuteurs* in the island beds in front of his house and in his paintbox beds. They are depicted both in the autochromes and in a *Country Life* article dated 1933, but we do not know what variety he chose for these plots. He had also discovered "two curious little nasturtiums" in Rouen and had them dispatched to Giverny by train. He apparently planted them along the railing at the end of the flower garden. Later, in a letter to Blanche, who was by then herself living in Rouen and married to Monet's son, Monet reported that "*cet étourdi de Florimond* [that scatterbrained Florimond]" had let them die – "*ou à peu près* [or nearly]." He asked Blanche to go to the gardener in Rouen on rue Green and buy some more of "that famous little perennial nasturtium that we grew every year all along the railing. It's from him that I had a pot of them in the past." A variety with bright red flowers long lost to the garden was mentioned by Jean-Pierre Hoschedé in his memoirs *Claude Monet, ce mal connu*. And in 1920 Forestier talks of nasturtiums with their flickering green leaves and their flowers the color of fire planted "at intervals" along the railings. Were these the replacements that Blanche sent to her stepfather? If so, perhaps they were *Tropaeolum speciosum* whose flowers fit the description of the color of fire.

Today, the railing that was once ablaze with nasturtiums in late summer and fall is festooned with the orange and yellow berries of pyracantha. From the point of view of the garden today, pyracantha offers the more practical advantage of providing a permanent evergreen screen. In Monet's time, passersby along the road separating the two parts of the garden were welcome to look through the railing. All without exception stopped to admire the colorful effects within and longed to explore the garden, though, according to Truffaut, if visitors were admitted, "*ce serait la cohue* [there would be a mob]" and *le maître*'s age and desire for peace needed to be respected. Things are different today. With the garden having to be commercially viable, a free peep through the railing is no longer affordable and the "mob" that Truffaut feared often makes its presence felt.

Monet's radiantly sunny Vétheuil garden painting with only towering annual sunflowers against blue skies of an almost Mediterranean intensity is a far cry from Giverny today. From the simplest annual sunflowers that he grew and whose seeds he collected every year (if the children hadn't first picked them off to nibble), he went on to collect the perennial varieties. Unable to get what he wanted in Paris, in April 1891 he wrote to Caillebotte to ask his friend the nurseryman Godefroy for a journal, some lilies, and some sunflowers which might be obtainable from England. Monet listed "*Helianthus latiflorus* [correctly *H.* × *laetiflorus*], *Helianthus* × *multiflorus*, *Helianthus orgyalis* [now *H. salicifolius*] and *Helianthus rigidus harpalium* [*H. rigidus*]," urging haste because there was still time to plant them. A week later, thanking Caillebotte for the lilies

A plan and detail of the border on the southwest corner of the Grande Allée shows a bed filled with the typical golds, yellows, and purples of the fall garden. The border is edged with nasturtiums. Behind, there is the ubiquitous Dahlia *'Jet,' asters that the gardeners cannot name,* Helianthus annuus *'Holiday,' the self-seeding* Impatiens balfourii, Cosmos bipinnatus *'Versailles' alternating with* C. *'White Sensation,' the Cactus dahlia 'Czarda,'* Chrysanthemum segetum, C. coronarium, *and the very invasive* Helianthus rigidus. *In the background stands a standard rose, 'Palissade Rose' syn. 'Pheasant.'*

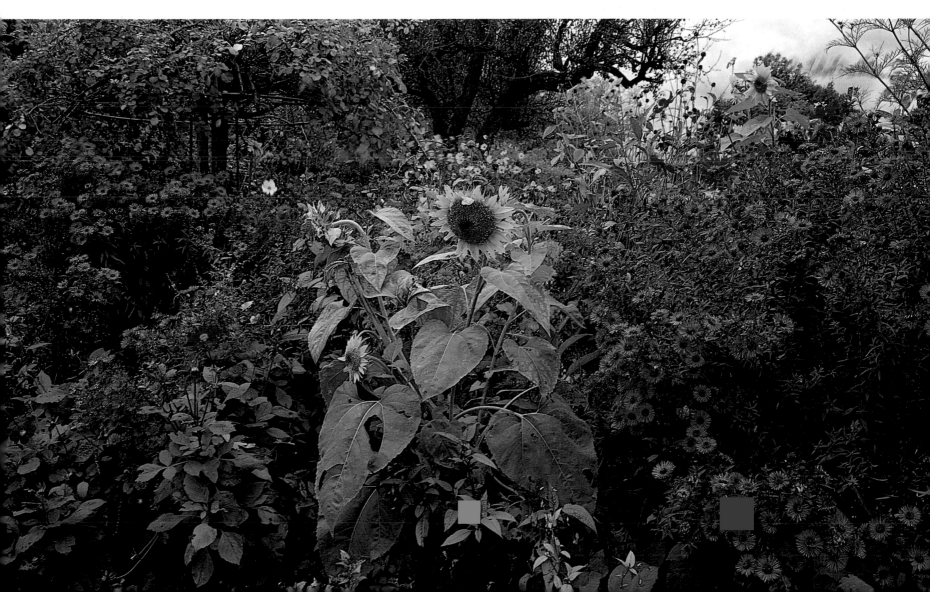

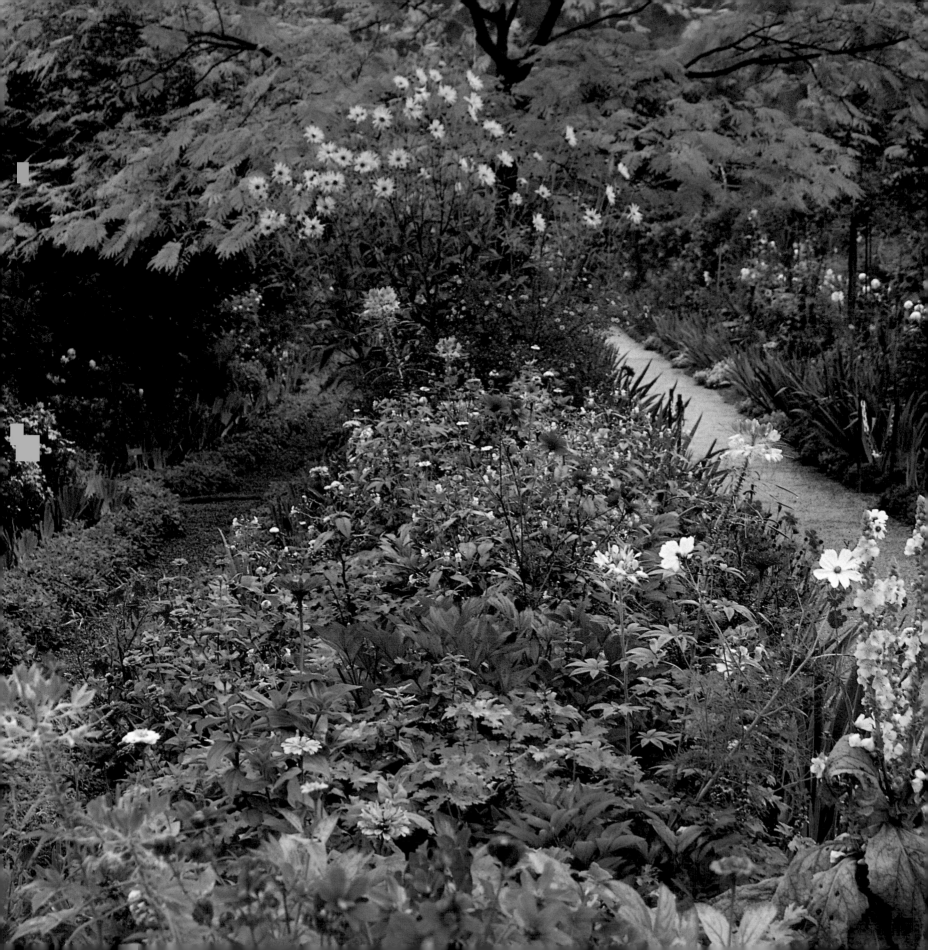

RIGHT *A photograph of the orchard probably taken by Forestier in 1920 shows clumps of sunflowers staked and tied and growing in squares cut out of the grass.*

LEFT *A golden spreading* Albizia julibrissin *hovers protectively over a mixed bed that includes* Cosmos bipinnatus *'Versailles Rouge,' a mix of zinnias, and the prolific* Helianthus rigidus.

and the journal, he adds that he would be "overcome with joy" if Godefroy could find the longed-for sunflowers. Monet later located one species which was on its way from Ghent in Belgium. Being a true friend he sent some to Caillebotte: "I have sent you today to Argenteuil station a small pot containing a *Helianthus latiflorus* – do you know it? – it's one of the most beautiful, which grows to three meters. It spreads easily, three or four plants together make a good clump . . ."

Monet's sunflowers also enthralled and dazzled his visitors. Mirbeau, in his purple prose, described "vertiginous sunflowers rotating their yellow disks" and "towering harpalium pouring with inexhaustible florescence." Truffaut, less effusively, noted the effects of fall with the "gigantic *Helianthus sparsifolius* whose golden flowers rained blossom above the thousands of clumps of asters."

In 1920 Monet's enthusiasm for sunflowers was still unabated. Walking around the garden with Forestier, Monet stopped and pointed to yet another variety. "It's a new plant," Monet told him, "a large perennial sunflower, *Helianthus sparsifolius*, a hybrid of *Harpalium rigidus* and the big annual sunflower." He was able by then to obtain new varieties locally, and this one had been bred in France by the nurseryman Nonin. By now Monet planted his annual and perennial sunflowers not only where one would expect to find them – in the borders – but also where one would not – in the orchard. A photograph probably taken by Forestier during that visit

shows this curious phenomenon clearly. Planted in rough grass among some irises are clumps of *Helianthus × multiflorus*. They were planted in perfect 2-foot squares cut out of the turf. In each square, clumps of sunflowers staked with bamboo canes and tied all around the outside with string can be seen. What possessed Monet, with his yearning for naturalism in his garden, to plant these ungainly specimens with their corsets of stakes and string? Perhaps he wanted to experiment and see how their colors looked beneath the dappled light of an orchard. Whatever the reason, it would have been to do with esthetics.

There were always contradictions, always surprises. For all his reported dislike of artifice and of the lush bedding annuals favored by many contemporary gardeners, Monet regularly planted the island beds directly in front of the house with standard roses underplanted with red geraniums, a scheme that owed everything to turn-of-the-century fashion and nothing to the revolutionary garden that lay beyond. Then suddenly, one year, Forestier noted that Monet had combined *Papaver nudicaule*, argemones, and lavateras in a haphazard planting in the same beds – a complete about-turn that appears never to have been repeated. Yet another contradiction was reported by Forestier. Despite his apparent abhorrence of bedding plants, Monet is said to have planted a bedding scheme of that municipal favorite, *Salvia splendens*, that "lit up a side of the house with the scarlet flames of its fieriness."

Autumnal golds and oranges do not mean the end of the blues, mauves, pinks, and whites in the garden. Dominating the blue borders are perennial blue asters – *Aster novae-angliae* – and the white *A. laevis* – all flowering with the same vigor as in Monet's time. Forestier mentioned another aster, "*Callimeris [Kalimeris] incisa*, whose thousand white flowers among the green dust of the fine foliage are not heavy enough to bend their fragile stems." In the garden today the rich mauve-blue flowers of *Solanum rantonnetii*, the mallows, and the *Salvia* 'Indigo' among others provide a harmonious backdrop for the blue and white asters which will be followed in October by the wooly, fluffy species asters found in the garden when restoration began. These are direct descendants of Monet's original perennial asters.

OPPOSITE Hibiscus syriacus *(top left) grows near the Japanese bridge.* Solanum rantonnetii *(top right) is used for its long-flowering quality and airy voluminosity.* Heliotropium arborescens *syn.* H. peruvianum *(center left) adds its scent to the fall garden. Monet massed together wide swathes of the long-lasting* Cleome hassleriana *(center right) much as he planted his irises.* Cosmos bipinnatus *'Sensation' (bottom left) flowers prolifically. The autumn-flowering* Crocus speciosus *(bottom right) grows on the large east lawn.*

BELOW *An informal tangle of unnamed asters, the purple* Dahlia *'Lilac Time' and* Solanum rantonnetii *flourishes in a wild-looking corner of the garden.*

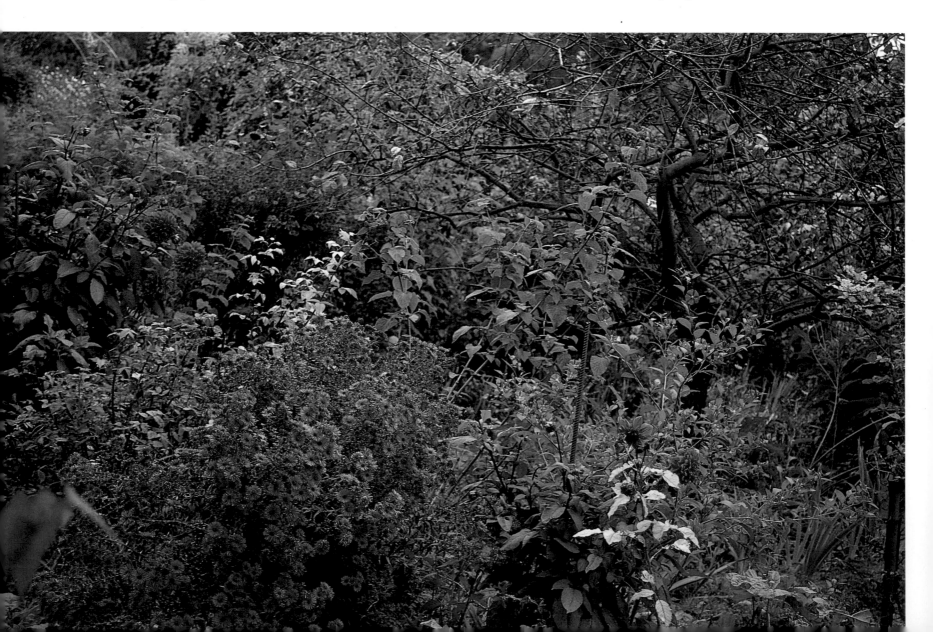

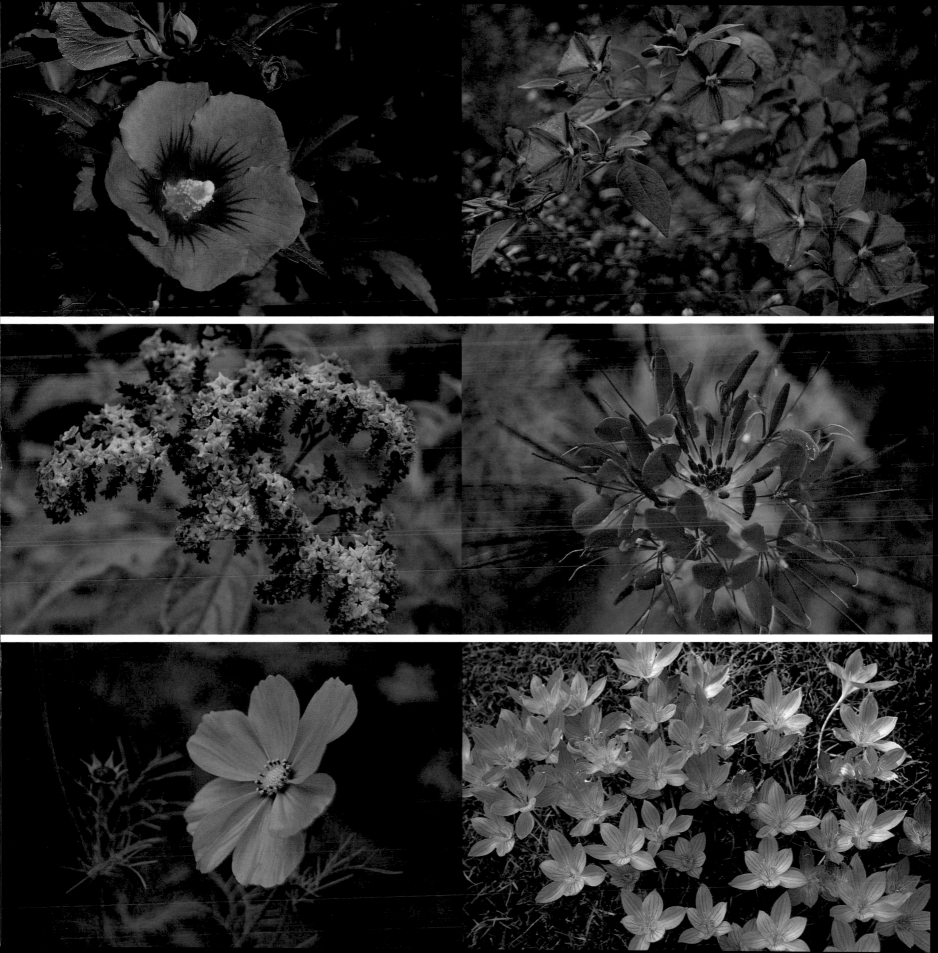

If water lilies were Monet's last love, then dahlias were certainly his first. He grew and painted them in all his gardens. Together with the earlier-flowering gladioli which Monet also grew and painted, dahlias are the autumn staples of every French *jardin rustique*. If they grow nothing else, French country-dwellers often have a token clump of dahlias, however straggly, somewhere in the front yard or by the roadside. Although considered unfashionable now by many gardening cognoscenti, dahlias were prized and coveted by Monet, Caillebotte, and Mirbeau, and this trio regularly and readily exchanged varieties and sought particular cultivars most assiduously. Monet sounded surprised and a little piqued when the Argenteuil nurseryman Godefroy failed to produce his *"fameux dahlia Duc de Constantin"* that Monet had asked for. *"C'est décidément un drôle de type* [a funny chap]," Monet complained to Caillebotte. "Has he given it to you?" The 'Duc de Constantin' dahlia has never been traced, nor is it clear whether Monet ever did get hold of it, but another of his favorites, *Dahlia* 'Étoile Digoinaise,' was much in evidence at Giverny. Georges Truffaut observed that "Autumn begins in September with some very special effects, obtained by numerous plantings of dahlias, particularly the many varieties of Cactus dahlias and the original new dahlias obtained from the sowings of 'Étoile de Digoin.' They are dahlias with long thin petals, resembling a starfish, light and gracious, which are very fashionable now."

LEFT *An engraving of the "star" dahlia 'Étoile Digoinaise' or 'Stella,' much used by Monet at Giverny.*

RIGHT *Pink cosmos alternates with the bicolored pink and orange Cactus dahlia 'Decorose' the whole length of this bed. In the background a weeping willow that was damaged in a cyclone some thirty years ago now stands firm.*

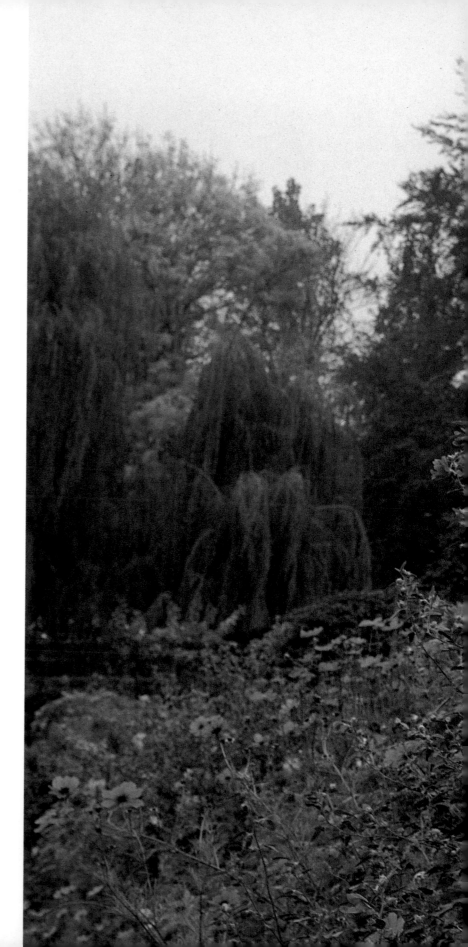

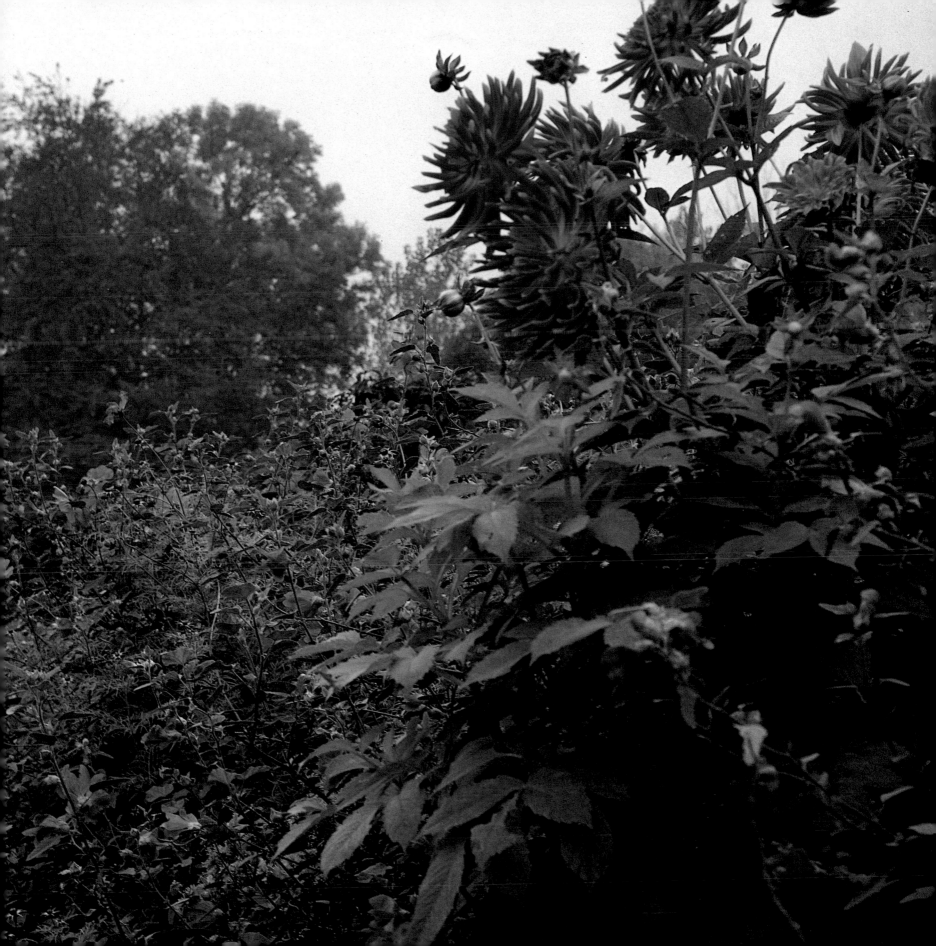

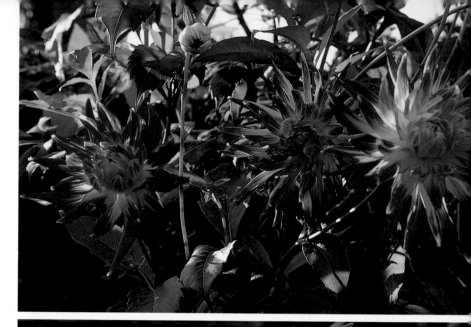

The dahlia appeared spontaneously in the garden of an amateur enthusiast around 1906. He passed tubers on to two nurserymen, each of whom gave it a different name – Monsieur Martin of Digoin in Saône-et-Loire christened it 'Étoile Digoinaise' and Monsieur Rivoire of Lyons called it 'Stella' – before it was released commercially around 1920. The flowers were interesting because of the way the edges of the petals furled over, rather like some exotic pasta shape, emphasizing its star outline. Vahé has been looking for this variety for many years, but without success. Graines Baumaux, the French dahlia specialists, reports that these "star" dahlias are now available only in Japanese and American nurseries. Single dahlias of this type had their fans among gardeners such as Monet, but they fell from popularity because of their over-long stems and over-abundant foliage. They also proved too short-lived for professional growers: the cut-flower trade prefers double flowers which, because they are sterile, do not rush to set seed and so are longer-lasting.

Giverny today has a huge range of varieties of dahlias, as if the blandishments of the catalogs as to their good performance value have been impossible to resist. Some of the color selections seem rather brash – also often a result of ordering by catalog. Each of the countless varieties is now represented by a mere handful of plants, which creates a major task for the garden staff in keeping tabs on them all. In the fall two gardeners are charged with the job of going around the garden double-checking each dahlia plant so that there is no error in labeling. The performance of any varieties acquired that year is evaluated at the same time. The scale of the operation has expanded since Monet's time, but the business of tending dahlias remains unchanged. We find an echo of earlier times in a letter from Monet to Alice in October 1886, reminding her to label the dahlias while the different varieties are still recognizable and before they are cut down by frosts.

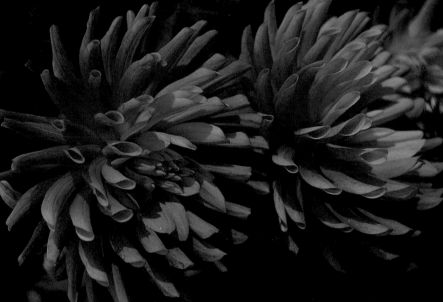

Gilbert Vahé himself is in charge of the complicated procedure of keeping tabs on the many varieties of dahlia grown at Giverny.
NEAR RIGHT *Cactus dahlia 'Jolie Normande'(above); Cactus dahlia 'Aumonier Chandelon' (center); Collerette dahlia 'Libretto' (below).*
CENTER RIGHT *Cactus dahlia 'Scarlet Star' (above); Cactus dahlia 'Hayley Jayne' (center); Medium Decorative dahlia 'Lilac Time' (below).*
FAR RIGHT *Giant Decorative dahlia 'Emory Paul' (above); Semi-cactus dahlia 'Promise' (center); Orchid-flowering dahlia 'Jescot Julie' (below).*

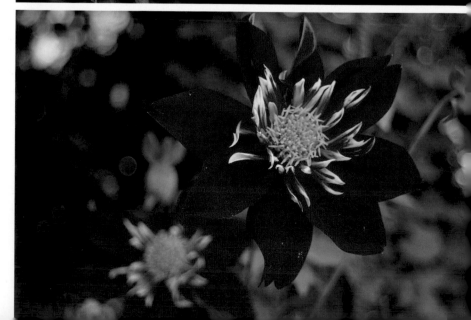

152

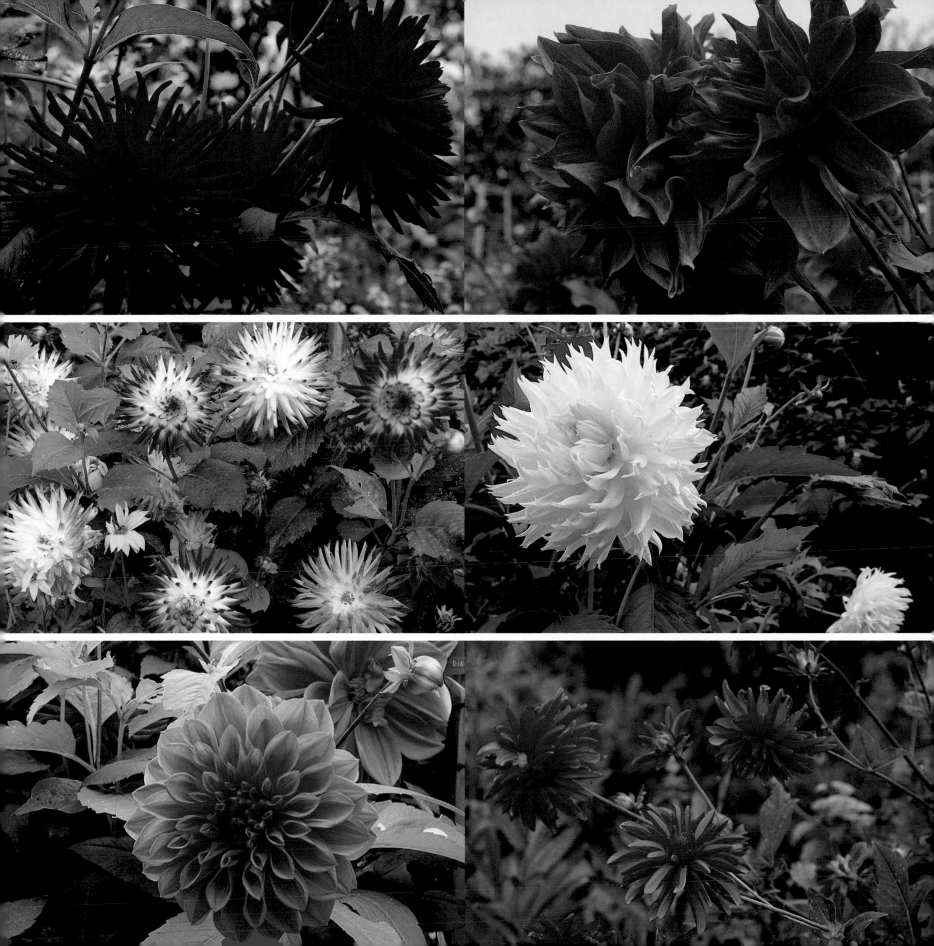

As the days become shorter and the nights colder, another dramatic color effect gets under way. The climbers that clad the garden's verticals turn color, and walls that were green become red, orange, and yellow, making a fiery background to the flowers in the garden. The leaves of the Virginia creeper (*Parthenocissus quinquefolia*) that now only covers a small part of the house take on their distinctive deep red autumnal coloring and make a vibrant impact against the pink stucco of the walls. They also clothe the entire façade of the third studio built in 1916. In Monet's day the *vigne vierge*, as it was called, swathed much of the house and was also draped across the roof of the veranda. It must have made an amazing spectacle in the fall. Today's more modest growth is easier for the gardening team to manage: the self-clinging creeper can reach some 70 feet, but is kept strictly within bounds at Giverny. It is not trimmed until the last Monday in the season, so that its colorful foliage fulfills to the last moment its role as harmonizing backdrop to the red, purple, and yellow flowers in the garden.

Throughout the fall, the gardeners spend less and less time in the flower garden and more and more in the service areas where the seasonal cycle begins again with next year's plantings. All through September and October, the biennials are gradually planted out from greenhouse to nursery fields, where talk among the gardeners is often of politics. As in all gardens, the lower temperatures that fall brings begin to slow the plants' growth. By mid-September the gardeners no longer have to cut back the annuals or perennials to prevent them from spilling over onto neighboring plants. Instead they spend the mornings deadheading and weeding, while the under-gardeners keep the garden clear of fallen leaves. The afternoons are spent weeding the nursery fields where invasive weeds are quick to appear.

All the while, Giverny waits in suspense to see what this year's weather will bring, wondering how the performance will close. Will there be a sudden, abrupt finale caused by early frosts, or will the garden gently fade out? It has always been impossible to predict. When he was away from Giverny at this time of year, Monet was intrigued by the same questions. Writing to Alice to give instructions about marking the tender plants and collecting seeds, he would ask as well whether there were any flowers left in the garden.

Autumn is also harvest time. As if to confirm that he was his own gardener, Monet told Léon Lebret – the gardener who had replaced Félix Breuil – which seeds he wanted saved for next year.

Some would be for Monet's friends. "If there's something of mine you want," wrote Monet to Caillebotte, "*ne vous gênez pas* [don't be afraid to ask for it]." At Giverny today, the gardeners collect apples rather than seeds. The apples are stored in areas cordoned off to the visiting public. There are never any left to pick where the public are allowed because, as one gardener says knowingly, "*les Anglais adorent les pommes.*" The garden staff are always being asked by visitors which varieties of apples they grow. When Gérald van der Kemp came to Giverny, he brought several old varieties of apple with him from Versailles, where they were grown in the Potager du Roi. Among them are varieties traditionally grown in France such as 'Bénédictin' ('Bennet Apple'), 'Reinette Blanche du Canada,' 'Reinette Grise du Canada' ('Royal Russet'), 'Reine des Reinettes' (syn. 'King of the Pippins'), and the less well-known 'Calville Blanche d'Hiver,' and 'Calville Rouge d'Hiver.' Van der Kemp also introduced 'Golden Delicious' and 'Richard' to the garden, while 'Granny Smith,' the American reds 'Starking' and 'Starkrimson,' as well as 'Belle de Boskoop,' a popular Dutch variety, are also grown. Once picked, the apples are stored every winter near the dahlias in the cellar storeroom, ostensibly for the *conservateur* himself, but the gardeners help themselves all winter long.

Other fruits grown include the well-known 'Doyenné du Comice' pear and some cooking pears that no one knows the name of. A fig tree in the hen yard produces fruit; however, a singular lack of sexual chemistry between the male and female kiwi-fruit plants (*Actinidia deliciosa*), grown out of the public eye along the west wall of the garden, means that they have so far failed to produce a single offspring.

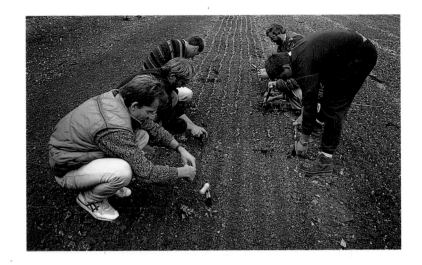

OPPOSITE *Jean-Luc Lerenard cuts a piece of bamboo from the water garden (top) and attaches it to a scythe (center). While he steadies the ladder, Rémi Lecoutre cuts back the Virginia creeper on the wall of the third studio (below).*

RIGHT *Planting, clearing up, and harvesting are important fall tasks. Six of the gardeners plant out biennials in the nursery fields (top). Jean-Marie Avisard sweeps up leaves in the water garden (center). This luscious-looking apple is ready to harvest (below). No one knows its name, and despite not being very tasty, it disappears during the winter from the cellar where it is stored.*

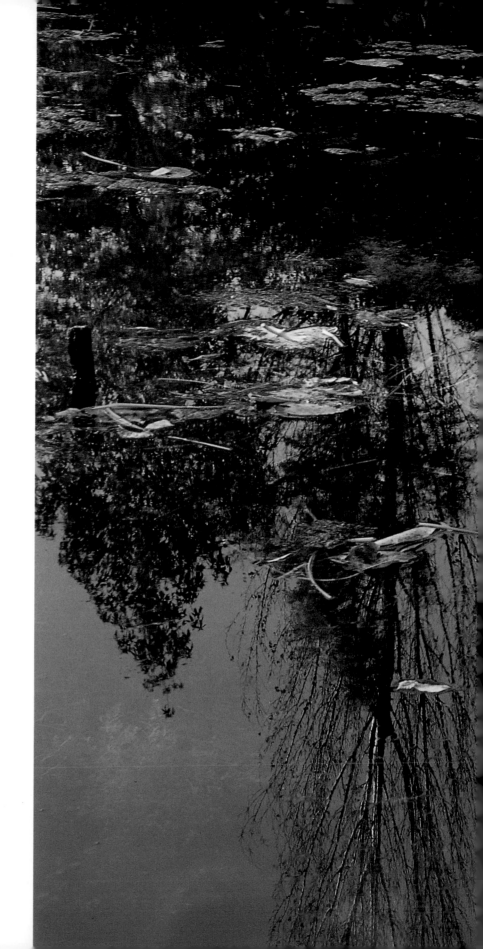

In the water garden, the large trees and shrubs that have encircled the pond like a discreet green wallpaper now come into their own and distinguish themselves individually as their colors turn. And for once, the eye does not focus solely on the surface of the pond and the bridge, but takes in the wider view – the panorama of dark reds, rust and oranges that is now reflected in the water.

This waterscape with its fiery autumnal colors fascinated Monet toward the end of his life. Nearly blind, he would be found at the water's edge, long after his water lilies had finished flowering, absorbed with the red garden before him. Whether the abstract paintings he produced at this time were the first steps to modern art, or whether – as Clemenceau claimed – he just painted what he saw (which was not very much), he caught the whole energy of the autumn garden in its last gasp. It is impossible to distinguish specific trees in his paintings, but we know the weeping willows would be melting into gold, and the aspens, liquidambars, and poplars would all be turning their particular shades of red, yellow, and orange, a combination of colors Monet had worked and reworked all his life.

As with every part of Giverny, Monet's vision of the water garden encompassed both these grand pictorial effects and more down-to-earth gardening details. While he might enjoy the occasional pattern created by autumn leaves floating on the water, his gardener's pragmatism would have made sure not too many leaves landed in the pond, to poison the water as they decayed. The gardeners would be set to work to clear them, just as they would have removed excess blanket weed or filtered off floating carpets of duckweed brought in on the feet of visiting water birds.

Monet's concern for keeping the surface of the water clear was renowned: once his water lilies had become established, the gardeners also had to keep their leaves trimmed to form discrete floating rafts rather than allowing them to make the continuous carpet that they can so easily become. (It must be remembered that these were the days before the muskrats adopted the unofficial role of keeping the water lilies in check.)

Mirrored in the water are multi-colored liquidambars (Liquidambar styraciflua)*, a tall, slender poplar* (Populus nigra 'Italica')*, and an evergreen laurel* (Prunus lusitanica)*. This upside-down world fascinated Monet.*

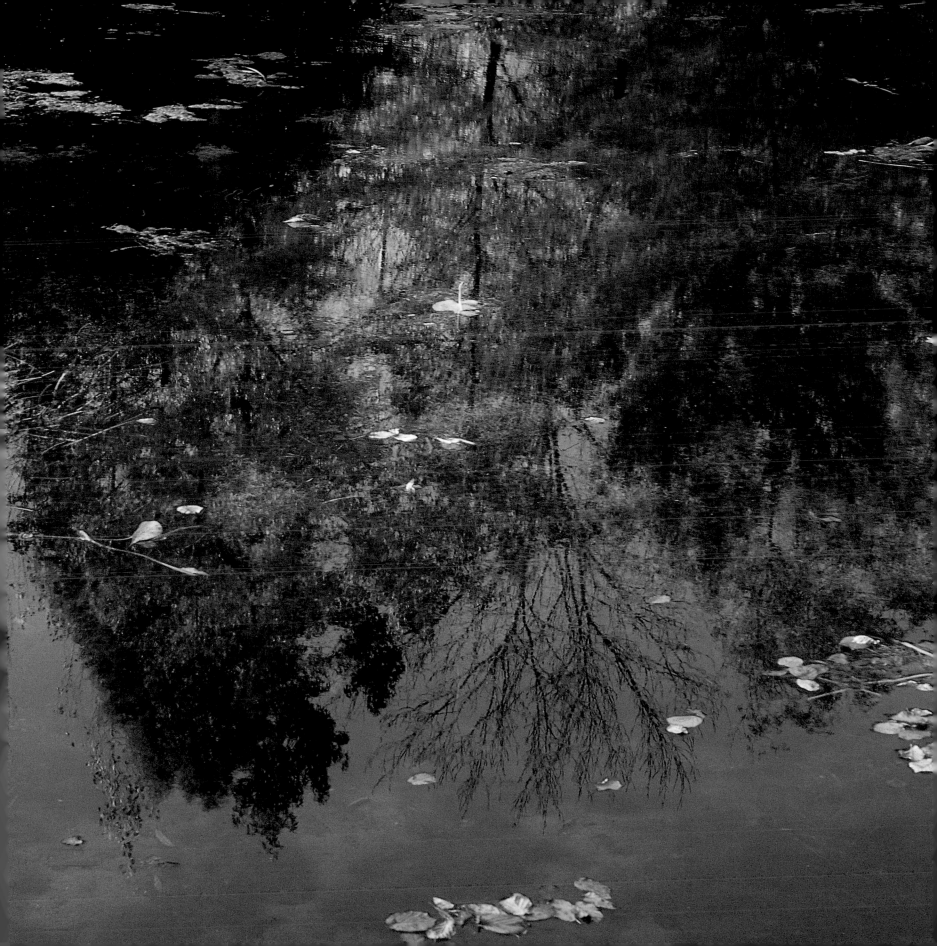

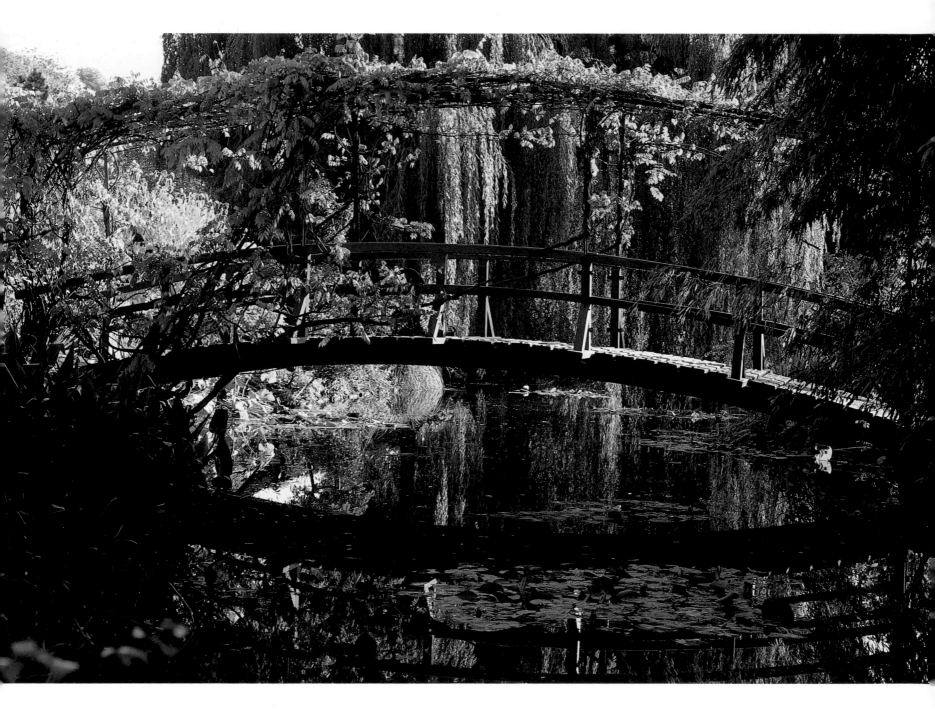

The bridge, inspired by the Japanese woodblock prints that decorated Monet's house, started life without the overhead trellis. Added ten years later, it provided yet another layer of reflection to the pond. Monet painted it over and over during his last years, continually distilling it into its essential elements until he was left with just the arch of the bridge and a furore of greens, a process which many critics and art historians heralded as the beginnings of abstract art but which Clemenceau said was Monet just painting what he saw.

The surface of Monet's pond appears like a mirror in one kind of light and translucent in another. Monet studied these subtle variations of the water as obsessively in his later years, as he had studied atmosphere and light in earlier ones. The idea of a world reflected fascinated him. He once told Sacha Guitry that in order to understand the composition of a picture he was about to paint, he first needed to see it upside-down, and would bend over with his head between his legs to contemplate his motif before putting anything on canvas. Pure whimsy though this may be, it is an old method of assessing the composition of a picture.

Monet's concern with the appearance of his water garden was mirrored by his attention to its health and well-being. From the outset, in 1893, when he obtained permission to divert water from the Epte to fill his pond, Monet sounded like a model water gardener. His enthusiasm for this new project and his capacity for detail shine forth from the archives. Although he maintained he had chosen plants from a catalog "off the top of his head," his early orders included – as well as the water lilies – ornamental waterside subjects and emergent plants with attractive floating leaves, as well as aquatics such as *Myriophyllum aquaticum* (listed by Monet under its old name of *M. prosperinacoides*) whose submerged feathery foliage serves as an oxygenator.

A dispatch note from the firm of Latour-Marliac to Monet in April 1894 – the first season for his new pool – reads like a list of basic essentials that any new pond-owner might compile. The order contained some fifty francs' worth of plants, dispatched in four packages to the rail station at Vernon. It begins:

3 *Polygonum amphibium, à 50 centimes*	1f. 50c.
3 *Trapa natans, à 50 centimes*	1f. 50c.
3 *Trapa verbenensis, à 1 franc*	3f. 00c.
3 *Arundinacea picta, à 40 centimes*	1f. 20c.
3 *Caltha polypetala, à 60 centimes*	1f. 80c.
3 *Carex folliculata, à 75 centimes*	2f. 25c.

It ends with familiar species of orontium, pontederia, sagittaria, and saururus. Monet's polygonum is today's *Persicaria amphibia*, the amphibious bistort; his *Trapa natans* is water chestnut, while the arundinacea is perhaps the white-striped gardener's garters or canary reed grass (*Phalaris arundinacea* var. *picta*), one of several grassy-leaved plants for the waterside. *Caltha polypetala* still grows in the water garden – one of only a handful of Monet's plants that are to be found there today. Now there is a different species of

pickerel weed – *Pontederia cordata* – and the myriophyllum and a sagittaria are grown as oxygenators in the greenhouse pool. Otherwise, it is only in the water lilies – and the reflections – that Monet's spirit still reigns over the water itself.

The Latour-Marliac order was one of the first of many over the years for both the pond across the road in the water garden and the indoor pools in Monet's greenhouses. Some of his purchases would have been experimental, Monet simply indulging his fancy for novelties or seeing if a certain water-garden plant would be able to withstand winter temperatures outdoors. Then there were the occasional dramas of flooding, after which immense mopping-up and replanting operations had to be undertaken, resulting in further orders being placed.

In Monet's day a whole team of gardeners under *chef* Félix Breuil looked after the water garden. Of course, in its infancy, a great deal of work would have gone into establishing the major planting patterns. The soil, however, did not need much work as it had a completely different character from the dry, alkaline soil of the flower garden across the road. With humus provided by the many trees, and the silt deposits left by the stream, the soil was very accommodating for the acid-loving plants that were to grow there. And Monet continued to add to the water garden and adjust the planting throughout his life. There was the building of the Japanese bridge in 1895, the enlargement of the pond during 1901–2, the arrival of the tree peonies from Japan around 1904, and the addition of new roses as and when Monet spotted them at a rose show.

Simply maintaining a garden like this must have taxed the gardeners. Plants that thrive in lush waterside conditions do not stand still – they have a tendency to invasiveness, and the gardener has to step in to cut them back and restore the intended picture, just as constantly happened with the water lilies. And with Monet's emphasis on the precise visual effects he had in mind, this grooming process would have been all the more fastidiously attended to.

Today in the water garden, just as in the Clos Normand, autumn's colder weather slows growth and reduces the gardeners' need for constant trimming back to curb plants' invasiveness. But time saved here is offset by the need for long sessions of leaf-sweeping on paths and lawns, as well as raking leaves from the water's surface to preserve its mirror-like appearance right up until the day when the garden finally closes its doors to the public. Even so, one gardener – Jean-Marie Avisard – generally manages the water garden single-handed today: a larger team assembles only for the three-day task of clearing and cleaning the pond floor in spring.

Since Monet did not have to share his garden with the hundreds of thousands who visit it each year, those who come to see it today have to accept certain anomalies. When Félix Breuil described how the edges of the pond were left grassy so that people could "admire the decorative effect," he could not have anticipated how ironical that remark would turn out to be. Now the grass is so decimated by the crowds that the banks of the pond have to be densely planted to keep people off. But even this is sometimes not enough of a deterrent, and plants are still trampled underfoot by visitors determined to take their photos. There is even talk of having to extend the use of the green and white chains to the paths in the water garden to prevent people there from walking where they should not.

The other anomaly at Giverny is that most visitors want to be dazzled more than they want authenticity. It is only the few purists who wish to see the garden as it was in Monet's day with some beds in flower for just a few weeks of the year and positively dull the rest of the time. The paying public expects a show, so there is constant pressure on the gardeners to provide one. Without the public, there would be no house and no garden. Compromises are inevitable.

ABOVE *The rose arches in the water garden that Monet painted so many times blend with the hills in the background.*

RIGHT *Fifille, Giverny's resident star, was born there in the year the garden was opened to the public. After fourteen years of posing for the camera, she is an accomplished professional.*

160

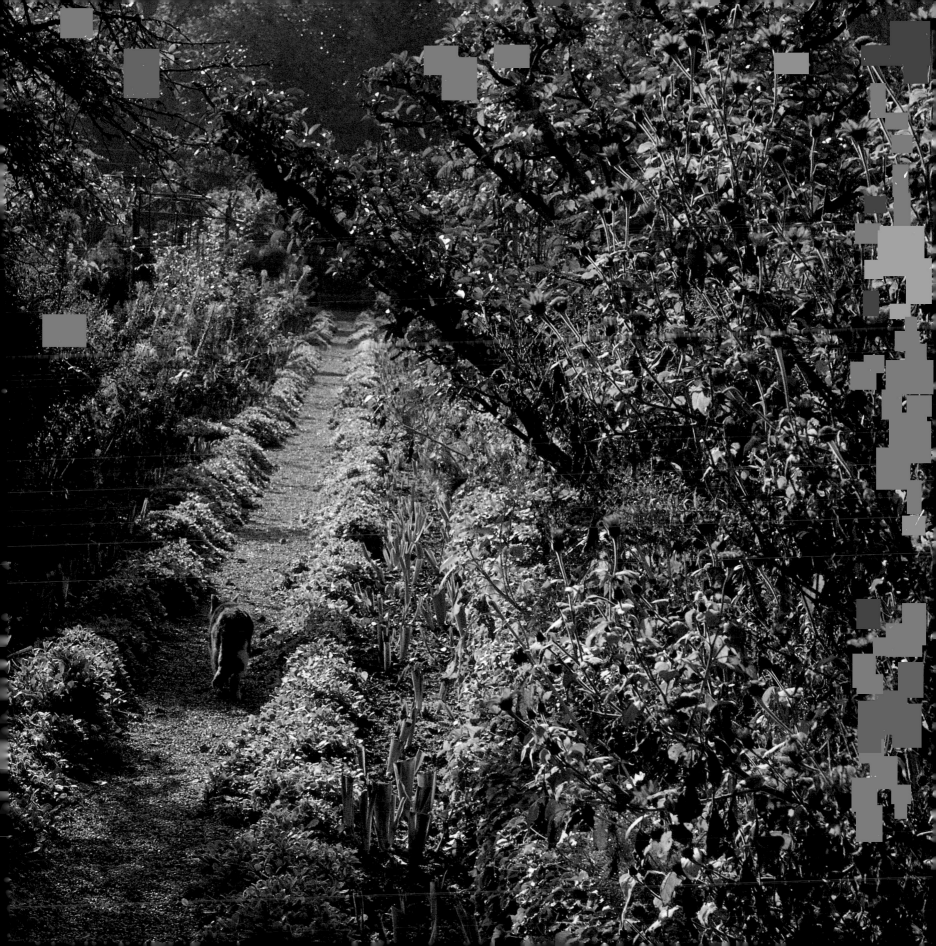

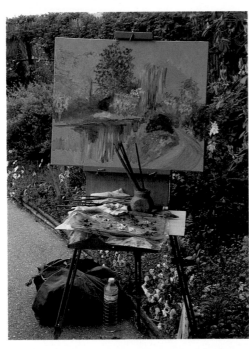

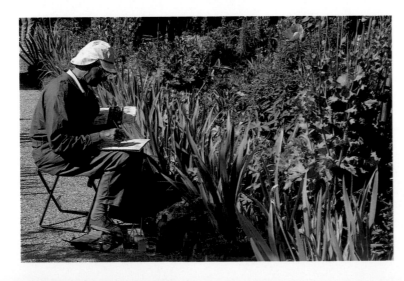

Visiting the garden

The character of a house and garden depends on the people who live and work there. In Monet's day, it was the Monet household that determined the style and atmosphere of the place. Today, gardeners and caretakers, the *conservateur,* and the administrative team are the ones who shape Giverny, bringing to their work much love, devotion, and industry. While they aim to keep the spirit of Monet at Giverny, they also bring something of themselves to it. The pilgrims who come from all over the world are many and varied. Giverny now belongs to them and to those who care for the place.

Giverny is situated 34 miles northwest of Paris on the A13. If you are arriving by car, take the exit signposted Giverny/Bonnières-sur-Seine. The nearest rail station is Vernon, a one-hour train journey from the Gare Saint-Lazare in Paris. Between April 1 and October 31 the garden is open 10.00 -18.00 every day except Mondays, when it is only open to people wishing to paint. If you wish to paint, telephone the administrative office on (33) 32 51 28 21 in order to make an appointment. Groups visiting the garden should book in advance by telephone. From April 1 – October 31 the office is open six days a week, closed on Mondays. During the rest of the year the office is open five days a week, closed on the weekend.

Bibliography

BOOKS

Aitken, Geneviève, and Delafond, Marianne, *La Collection d'Estampes Japonaises de Claude Monet* (Bibliothèque des Arts, 1987)

Alphant, Marianne, *Claude Monet: Une Vie dans le Paysage* (Haza, Paris, 1993)

Bumpus, Judith, *Impressionist Gardens* (Phaidon Press Ltd, Oxford, 1990)

Claude Monet au temps de Giverny, exhibition catalogue (Centre Culturel du Marais, Philippe Piguet archives, Paris, 1983)

Clemenceau, Georges, *Claude Monet: les Nymphéas* (Paris, 1928)

Dallas, Gregor, *At the Heart of the Tiger: Clemenceau and his World* (Macmillan, London, 1993)

Decker, Michel de, *Claude Monet, Une Vie* (Librairie Académique Perrin, Paris, 1992)

Duroselle, Jean-Baptiste, *Georges Clemenceau à son ami Claude Monet* (Éditions de la Réunion des musées nationaux, 1993)

Elder, Marc, *À Giverny, chez Claude Monet* (Paris, 1924)

Fels, Marthe de, *La Vie de Claude Monet* (Paris, 1929)

Forestier, J.C.N., *Jardins: Carnets de plans et de dessins* (Paris, 1920)

Forge, Andrew, and Gordon, Robert, *Monet* (Abradale Press, Harry N. Abrams Inc., New York, 1989)

Geffroy, Gustave, *Monet, sa vie, son temps, son œuvre* (2 vols, Paris, 1922; new edition 1980, with an introduction by Claudie Judrin)

Gillet, Louis, *Trois Variations sur Claude Monet* (Librairie Plon, Paris, 1927)

Guitry, Sacha, *Cinquante Ans d'Occupation* (Presses de la Cité, 1993)

Henslow, T. Geoffrey, *The Rose Encyclopaedia* (Vickery, Kyrle & Co., London, 1922)

Hoschedé, Jean-Pierre, *Blanche Hoschedé-Monet: Peintre Impressioniste* (Rouen, 1961)

Hoschedé, Jean-Pierre, *Claude Monet, ce mal connu* (Geneva, 1960)

House, John, *Monet: Nature into Art* (Yale University Press, New Haven and London, 1986)

Howard, Michael, *Monet* (Bison Books, 1989)

Joyes, Claire, *Monet at Giverny* (Matthews, Miller Dunbar, 1975)

Joyes, Claire, *Claude Monet et Giverny* (Paris, 1985)

Joyes, Claire, *Claude Monet: Life at Giverny* (The Vendome Press, New York and Paris, 1985)

Metropolitan Museum of Art, *Monet's Years at Giverny: Beyond Impressionism* (Harry N. Abrams Inc., New York, 1978)

Mirbeau, Octave, *Correspondance avec Claude Monet* (Éditions du Lerot, 1990)

Murray, Elizabeth, *Monet's Passion* (Pomegranate Books, California, 1985)

Rewald, John, *The History of Impressionism* (Museum of Modern Art, New York, 4th revised ed., 1973)

Spate, Virginia, *The Colour of Time: Claude Monet*

Stuckey, Charles, ed., *Monet: A Retrospective* (Bay Books, New York, 1985)

Vernadoe, Kirk, *Gustave Caillebotte* (Yale University Press, New Haven and London, 1987)

Wildenstein, Daniel, *Monet, vie et œuvre* (Lausanne-Paris, Vol. I, 1974; Vols. II and III, 1979; Vol. IV, 1985; Vol. V, 1992)

ARTICLES

Alexandre, Arsène, "Le jardin de Monet," *Le Figaro*, August 9, 1901

Arnyvelde, André, "Chez le peintre de la lumière," *Je sais tout*, January 15, 1914

Bonnef, François, "Aux Rives de l'Huisne – Le Jardinier des 'Nymphéas,'" *Paris Normandie*, November 28, 1949

Breuil, Félix, "Les Iris pour bord de rivières, étangs et terrains humides," *Jardinage* No. 21, October 1913

Cabot Perry, Lilla, "Reminiscences of Claude Monet from 1889 to 1909," *American Magazine of Art*, March 1927

Forestier, J.C.N., "Le Jardin de Monsieur Claude Monet," *Fermes et Châteaux*, September 1, 1908

Gillet, Louis, "Après l'exposition de Claude Monet. Le testament de l'impressionisme," *La Revue des Deux Mondes*, February 1, 1924

Gimpel, René, "At Giverny with Claude Monet," *Art in America*, No. 15, 1926

Guillemot, Maurice, "Claude Monet," *La Revue Illustrée*, March 15, 1898

Gwynn, Stephen, articles in *Country Life*, December 17, 1932, December 31, 1932, October 7, 1933

Howard-Johnston, Paulette, "Une visite à Giverny en 1924," *L'Œil*, No. 171, March 1969

Kahn, Maurice, "Le Jardin de Claude Monet," *Le Temps*, June 7, 1904

Kuhn, Alice, "Claude Monet à Giverny," *La Femme d'Aujourd'hui*, August 10, 1904

Pays, Marcel, "Une visite à M. Claude Monet dans son ermitage de Giverny," *Excelsior*, January 26, 1921

Proust, Marcel, "Les Splendeurs," *Le Figaro*, June 15, 1907

Thiébault-Sisson, "Claude Monet," *Le Temps*, December 7, 1926; "Autour de Claude Monet, anecdotes et souvenirs," *Le Temps*, December 29, 1926; "Autour de Claude Monet, anecdotes et souvenirs, II," *Le Temps*, January 8, 1927

Trévise, Édouard Mortier, duc de, "Le pèlerinage de Giverny," *Revue de l'art ancien et moderne*, January–February 1927

Truffaut, Georges, "Le Jardin de Claude Monet," *Jardinage* No. 87, November 1924

Vauxcelles, (Louis Mayer, known as), "Un après-midi chez Claude Monet," *L'Art et les Artistes*, December 1905

Index

AUTHOR'S ACKNOWLEDGMENTS

This book on Monet's garden has been pieced together from many original sources, and if the stitching seems faultless it is because the work has been a true collaboration between a small group of people who have brought their intelligence and expertise to the project.

For the workings of the garden today, I have Rémi Lecoutre, in charge of the east side of the garden, to thank for all of it – techniques, plant names, anecdotes. He has patiently replied to thousands of questions and takes great pride in the garden.

To my editors Hilary Hockman and Penny David who between them have skillfully cut, ironed, polished, and woven it all together with imagination and a lightness of touch that is much appreciated. Penny David, a renowned gardening editor, brought her skills to the "seasons" chapters while Hilary Hockman, always seeking to "beautify" the language has done a wonderful job editing the "history" chapter and captions and overseeing the whole.

And if the visuals are exciting and effective, it is thanks to the designer, Anne Wilson, who selected all the archive and color photographs and thoughtfully and creatively married text to pictures. To Dr. Tony Lord, the Lord god of Latin who, with Piers Trehane, has supplied all the botanical nomenclature for this book, and without whom it would all be wrong.

And lastly, to "mon capitaine," Erica Hunningher who, from the bridge, watched over us all and steered the project safely into port.

My thanks also go to: the family of Gustave Caillebotte who allowed me access to Monet's letters to Caillebotte; Silvie Brame of art dealers Brame & Lorenceau who painstakingly deciphered Monet's handwriting and who has requested we credit the unpublished letters between Gustave Caillebotte and Monet, "Private Collection – Courtesy Brame & Lorenceau, Paris" and Kirk Varnedoe who put me in touch with Brame & Lorenceau; the conservateur of Giverny, Gérald van der Kemp, and his wife Florence, for granting me an interview; Mme. Claudette Lindsey, the director of the garden, for allowing me to consult the library and the Wildenstein Catalogues, and her staff, Mmes. Wallays and Rousseau; Graham Rose who put me in touch with Stapeley Water Gardens, who now own Latour-Marliac, and their director Barbara Davis; M. Koffinet; Mme. Jouffret of the Bibliothèque Nationale; André Eve and Peter Beales who have helped with queries on the roses; Bruno Goris, my private horticultural "service de renseignement;" my ever-helpful father, Harvey Jolly, who tracked down the Félix Breuil article for me and the elusive Hoschedé book, Monet, ce mal connu; Claire Joyes and her husband Jean-Marie Toulgouat for their unfailing courtesy and good cheer; Philippe Baumaux of Graines Baumaux who sent me information on the 'Étoile de Digoin' dahlia; Mme. Lamy of the Bibliothèque Municipale de la Ville de Rouen for the photograph of Félix Breuil; and lastly, the Bibliothèque Nationale and the Bibliothèque Forney for allowing me access to their books and periodicals and providing me with the backbone of the history of the garden.

My thanks as ever, to my two square-eyed children, Molly and Rupert, my two unwalked dogs, and to Peter who has patiently put up with all the vicissitudes of the making of this book.

All the photographs were taken with a Leica R5 camera and lenses, and with Fuji Velvia 50 ASA film.

RIGHT *Thanks to the "worker bees" without whom there would be no garden.*

PUBLISHERS' ACKNOWLEDGMENTS

The Publishers would like to thank M. François Daulte, Penny David for the index and Maggie McCormick and Patti Taylor for help with the Americanisation.

Artwork Joanna Logan
Horticultural Consultants Tony Lord, Piers Trehane

Editors Hilary Hockman, Penny David
Editorial Director Erica Hunningher
Art Director Caroline Hillier
Production Annemarieke Kroon
Picture Research Sue Gladstone

PHOTOGRAPHIC ACKNOWLEDGMENTS

The Publishers have made every effort to contact holders of copyright works. All copyright-holders we have been unable to reach are invited to contact the Publishers so that a full acknowledgment may be given in subsequent editions. For permission to reproduce the paintings and photographs, and for supplying photographs, the Publishers thank those listed below.

(A = above, B = below)
4 Bibliothèque Nationale de France, Paris; 6 George Eastman House, New York; 14 Archives Toulgouat/ARTEPHOT, Paris; 16 The Kreeger Museum, Washington, D.C.; 18 © The Detroit Institute of Arts, 1995, City of Detroit Purchase; 20 © 1995 Board of Trustees, National Gallery of Art, Washington, D.C. (Ailsa Mellon Bruce Collection); 24A Archives Toulgouat/ARTEPHOT, Paris; 24B Collection Musée Marmottan/Studio Lourmel, Paris; 25 Österreichische Galerie Belvedere, Vienna; 27 Sterling and Francine Clark Art Institute, Williamstown, Massachusetts; 30 Sygma, London; 35 Bibliothèque Municipale, Rouen; 40 Musée d'Orsay, © photo R.M.N.; 42 Archives Toulgouat/ARTEPHOT, Paris; 43 The Dayton Art Institute, Dayton, Ohio (Gift of Mr. Joseph Rubin); 44-45 Kunsthaus Zürich, Zürich; 46 Musée Marmottan; 46-47 Musée Marmottan; 48 Bibliothèque Nationale de France, Paris; 54 Archives Toulgouat/ARTEPHOT, Paris; 58-59 Private collection; 121 Sygma, London; 133 Bibliothèque Nationale de France, Paris; 147 Bibliothèque Nationale de France, Paris